# PRINT/OUT

# PRINT/OUT

## 20 YEARS IN PRINT

**Christophe Cherix**
**with Kim Conaty and Sarah Suzuki**

**The Museum of Modern Art, New York**

Published in conjunction with the exhibition *Print/Out*, at The Museum of Modern Art, New York, February 19– May 14, 2012, organized by Christophe Cherix, The Abby Aldrich Rockefeller Chief Curator, Department of Prints and Illustrated Books.

Major support for the exhibition is provided by MoMA's Wallis Annenberg Fund for Innovation in Contemporary Art through the Annenberg Foundation.

The Museum acknowledges generous funding from Anna Marie and Robert F. Shapiro, Sue and Edgar Wachenheim III, and Mary M. Spencer.

Additional support is provided by The Junior Associates of The Museum of Modern Art.

Produced by the Department of Publications, The Museum of Modern Art, New York

Edited by Libby Hruska
Designed by Mevis and Van Deursen, Amsterdam
Production by Matthew Pimm
Printed and bound by Brizzolis, S.A., Madrid

This book is typeset in Futura. The paper is 130 gsm and 90 gsm Munken Polar.

Library of Congress Control Number: 2011944462
ISBN: 978-0-87070-825-1

Published by
The Museum of Modern Art
11 West 53rd Street, New York, New York 10019
www.moma.org

Distributed in the United States and Canada by ARTBOOK | D.A.P.
155 Sixth Avenue, 2nd Floor, New York, New York 10013
www.artbook.com

Distributed outside the United States and Canada by Thames & Hudson Ltd,
181 High Holborn, London WC1V 7QX
www.thamesandhudson.com

Printed in Spain

Cover: Martin Kippenberger. *Content on Tour* (detail, shown here with overlay of screened dots). 1992. Screenprint mounted on plywood with unique alterations, 70 7/8 x 59" (180 x 150 cm). Estate of Martin Kippenberger, courtesy Galerie Gisela Capitain, Cologne. For full reproduction, see p. 35

# Contents

# Foreword

Periodically, the Department of Prints and Illustrated Books embarks on a seemingly straightforward project: to present an exhibition reflecting on the state of contemporary printmaking. The last two iterations—Riva Castleman's *Printed Art: A View of Two Decades* (1980) and Deborah Wye's *Thinking Print: Books to Billboards, 1980–95* (1996)—surveyed roughly their preceding two decades, investigating how artists have pushed printmaking's boundaries and also revisited traditional techniques. *Print/Out*, organized by Christophe Cherix, The Abby Aldrich Rockefeller Chief Curator of the Department of Prints and Illustrated Books, follows the models set by his predecessors while also revealing the challenges of organizing any medium-based survey today.

Recognizing the increasing fluidity with which artists move among mediums—from film to sculpture, photography to printmaking, painting to drawing—*Print/Out* focuses on the myriad roles that printed materials play in contemporary practice. Indeed, one would be hard-pressed to find an artist in this exhibition who self-identifies primarily as a "printmaker," although each has used the medium in significant ways. This publication, and the exhibition it accompanies, presents an extraordinary range of material, from Rirkrit Tiravanija's multiples of curry tins to SUPERFLEX's participatory lamp production workshop. It also features artists who have rarely been included in print-specific exhibitions, such as Trisha Donnelly and Daniel Joseph Martinez.

This exhibition draws substantially from the Museum's preeminent collection of more than fifty thousand prints and illustrated books. Bold acquisition strategies over the past several years, which would not have been possible without the confidence and generosity of our Trustees and patrons, have significantly expanded the breadth and depth of our contemporary holdings. The Committee on Prints and Illustrated Books, currently chaired by Edgar Wachenheim III and previously by Anna Marie Shapiro (from 1998 to 2006) and the late Joanne M. Stern (from 1973 to 1998), has enthusiastically supported the acquisition of a great number of works included in the present exhibition. I am also grateful to the Print Associates for their long-standing commitment to the Department. Our collection of prints and books has always ranked as a leader in its field, and, thanks to the broad vision of our curators and these crucial supporters, it continues to hold this place today.

On behalf of the Trustees and the staff of The Museum of Modern Art, I would like to take this opportunity to acknowledge the lenders to this exhibition, who have graciously agreed to part with their works for this presentation. I express my deep gratitude to the Annenberg Foundation for the support of MoMA's Wallis Annenberg Fund for Innovation in Contemporary Art. We are also very grateful for generous funding from Anna Marie and Robert F. Shapiro, Sue and Edgar Wachenheim III, and Mary M. Spencer. My additional thanks go to The Junior Associates of The Museum of Modern Art. Without these partners, this exhibition would not have been possible. Above all, I want to thank Christophe Cherix for his skillful and insightful organization of this exhibition and catalogue.

—Glenn D. Lowry
Director, The Museum of Modern Art

## Acknowledgments

*Print/Out: 20 Years in Print* follows two important exhibitions organized by previous chief curators of the Department of Prints and Illustrated Books: Riva Castleman's *Printed Art: A View of Two Decades* (1980) and Deborah Wye's *Thinking Print: Books to Billboards, 1980–95* (1996). My foremost gratitude goes to my predecessors for establishing these stimulating models that call not only for regular assessments of the ever-changing field of printmaking, but also for a constant evaluation of our collection of prints and artists' books.

As is now customary in this series of exhibitions, the majority of works comes from the Museum's own collection. Many were acquired in recent years with this particular project in mind, and for this I am extremely grateful to the Committee on Prints and Illustrated Books for their generosity, trust, and openness to sometimes very challenging projects. I extend particular thanks to the chair of our Committee, Edgar Wachenheim III, whose commitment to our department and to the Museum as a whole is nothing short of extraordinary. The activities of the Committee have been supported by the Print Associates, who have provided key funding for acquisitions. We very much appreciate the enthusiasm and friendship of current co-chairs Richard J. Gerrig and Linda Barth Goldstein, as well as that of all the members, past and present.

I also thank the members of the Board of Trustees of The Museum of Modern Art, led by Jerry I. Speyer, Chairman, and Marie-Josée Kravis, President. As a department, we have been fortunate to receive their generous attention and marks of encouragement on multiple occasions during the realization of this project.

This volume features ten sections that highlight recent printed projects by artists or publishers whose practices emblematize particular approaches to the print medium today. A far denser and more diverse picture, however, is offered in the book's intervening pages, which exemplify the even broader range of artists and practices active in the field. My deep thanks go to our catalogue designers, Armand Mevis and Linda van Deursen, for their graphic treatment that gave these concepts visual form. I am equally grateful for their dedication to realizing the complexities of this design.

An exhibition and publication of this scope draw upon the knowledge, generosity, and time of a great many individuals at The Museum of Modern Art, as well as numerous outside collaborators and colleagues. I extend my gratitude to the institutions and individuals who generously loaned work to this exhibition, allowing us to present several projects of great importance within the show. I thank Claire Hsu and Anthony Yung, Asia Art Archive, Hong Kong; Marianne Boesky and Adrian M. Turner, Marianne Boesky Gallery, New York; Gisela Capitain and Lisa Franzen, the Estate of Martin Kippenberger, Galerie Gisela Capitain, Cologne; Jacob Samuel, Edition Jacob Samuel, Santa Monica; and Darcy Alexander, Pamela Caserta, and Lynn Dierks, Walker Art Center, Minneapolis. I am grateful to the private collectors who parted with works in their collections, including Philip Aarons and Shelley Fox Aarons, Seth and Cori Berger, Martin and Rebecca Eisenberg, Marie-Josée and Henry Kravis, Michelle Levy, John Silberman and Elliot Carlen, and Sarah and Gary Wolkowitz.

Special recognition goes to artist Ellen Gallagher, who co-organized with associate curator Sarah Suzuki a section of *Print/Out* around her project *DeLuxe*. Gallagher and Suzuki's presentation, titled *Printin'*, offers a unique opportunity to see the sources and inspirations at play in this ambitious work. Gallagher's section in this volume provides a glimpse of the extraordinary range of material included in the show. On behalf of Gallagher and Suzuki, I express our gratitude to the generous lenders to this portion of the exhibition, including Philip Aarons and Shelley Fox Aarons; Amsterdam Museum, Amsterdam;

Edgar Cleijne; Sadie Coles HQ, London; The Suzanne Geiss Company, New York; Alice Kosmin; Lombard-Freid Projects, New York; Lucy McKenzie; The National Maritime Museum, Greenwich; New Zealand Film Archive Ngā Kaitiaki O Ngā Taonga Whitiāhua, Govett-Brewster Art Gallery; Martha Rosler; The Studio Museum in Harlem, New York; Wolfgang Tillmans; Arthur Wood, Jr.; Craig Yoe; and Matthew Zucker.

Our research was greatly aided by the critical assistance of estates, galleries, and other institutions. My thanks go to Lisa Franzen at the Estate of Martin Kippenberger, Galerie Gisela Capitain, and Allison Hemler and John Connelly at the Felix Gonzalez-Torres Foundation, Andrea Rosen Gallery, for helping us answer detailed questions about these late artists' projects. Bill Goldston of Universal Limited Art Editions hosted me at the studio and graciously provided me with information on the technical processes involved in several of the works in *Print/Out*. I owe a debt of gratitude to the organizers of the 2010 exhibition on Edition Jacob Samuel, Cynthia Burlingham of the Hammer Museum, Los Angeles, and Leslie Jones and Britt Salvesen of the Los Angeles County Museum of Art, who provided us with an essential overview of Samuel's work and generously shared their research with us. Jacob Samuel, too, deserves my foremost thanks, along with artists Gert and Uwe Tobias, who together agreed to produce a new portfolio during the time of *Print/Out* and to let us follow its production in the show. I would also like to recognize Teresa Jaynes and José Roca, who were involved in the organization of the print triennial Philagrafika in Philadelphia in 2010, and Paul Capetola, Rebecca Mott, and Caitlin Perkins, who graciously assisted us with many questions relating to their presentation of SUPERFLEX's *Copy Light/Factory*. For their help with cataloguing, securing images, and facilitating our correspondence with the artists in the exhibition, I extend my thanks to Florence Bonnefous and Hélène Retailleau, Air de Paris; Hannah Hoffman, Gavin Brown's Enterprise; Casey Kaplan and Loring Randolph, Casey Kaplan Gallery; Natalia Sacasa and Caroline Burghart, Luhring Augustine Gallery; Heather Monahan, The Pace Gallery; and Pascal Spengemann, Taxter & Spengemann Gallery.

In 2011 I had the opportunity to present this project in two public talks, one in February and the other in November. I thank assistant curator Karen K. Butler for the invitation to lecture in St. Louis at the Mildred Lane Kemper Art Museum, Sam Fox School of Design & Visual Arts, Washington University, for the first of these talks. I am also grateful to the International Fine Print Dealers Association, in particular executive director Michele Senecal and board member Armin Kurz, for the opportunity to engage in a public conversation with writer and critic Faye Hirsch during the 2011 Print Fair in New York.

This project is deeply indebted to the extraordinary staff at the Museum. Glenn Lowry, Director, and Kathy Halbreich, Associate Director, have offered enthusiasm and support from the start, and my colleagues across the curatorial departments provided counsel and feedback at different points along the way. Chief Curator Emerita Deborah Wye deserves a special mention. She asked me to begin thinking about this project when I first joined the Museum in 2007, and she has been a trusted colleague, invaluable ally, and friend ever since.

I am grateful to a number of MoMA colleagues responsible for the practicalities of exhibition planning and organization, particularly Ramona Bannayan, Deputy Director of Exhibitions and Collections, and Maria DeMarco Beardsley and Carlos Yepes, assisted by Jessica Cash, in the Department of Exhibitions. Registrars Sydney Briggs, Jennifer Wolfe, and Corey Wyckoff, provided crucial coordination, and their efforts were matched by Rob Jung and Sarah Wood, who supervised the installation team, ensuring a smooth process along the way. In Exhibition Design and Production, I am thankful to Jerome Neuner and David Hollely, who helped us find creative solutions for the more complicated aspects of the show, and to Peter Perez, in the frame shop, who, as always, spared no effort to make sure that the selected works would

look their best. My thanks go to Julia Hoffmann, Samuel Sherman, August Heffner, and Claire Corey, in the Department of Graphic Design, for their thoughtful handling of the exhibition's graphics.

We also relied heavily on our generous colleagues in the Library for our research, and Milan Hughston, Jennifer Tobias, and David Senior were always eager to help us find exactly what we needed. Cora Rosevear and Lily Goldberg kindly facilitated the loans of works from the Department of Painting and Sculpture. Other key staff members who deserve my thanks for the presentation of this exhibition are Michael Margitich, Todd Bishop, Lauren Stakias, Heidi Speckhart, and Claire Huddleston, Department of Development; Allegra Burnette, Creative Director of Digital Media; Nancy Adelson, Associate General Counsel; Zoe Jackson, Marketing Manager; and Kim Mitchell with Paul Jackson, Department of Communications. In the Education Department, I was fortunate to work with Wendy Woon, Deputy Director, and Pablo Helguera, Director of Adult and Academic Education, as well as Laura Beiles, Sara Bodinson, Sarah Kennedy, Stephanie Pau, and Sheetal Prajapati on our programming and interpretive materials.

For the realization of the catalogue, I express my gratitude to a number of individuals in the Department of Publications, including Christopher Hudson, Kara Kirk, David Frankel, and Marc Sapir. Editor Libby Hruska's thoughtful and meticulous approach enabled us to present a range of topics in a clear, consistent fashion. Matthew Pimm oversaw the book's printing and ensured that the reproductions seen here are of the highest quality. I also thank intern Amber Moyles for her contributions. Outside the Museum, proofreaders Lynn Scrabis and Susan Richmond and transcriber Andrea Merkx provided critical assistance with this publication. Lionel Bovier, director of the publishing house JRP/Ringier, read and offered valuable criticism on earlier drafts of the texts presented here. For our cataloguing and photography of the many new acquisitions in this exhibition and book, the teams in both Imaging Services and Collections and Exhibitions Management Systems were indispensable. Erik Landsberg, Head of Collection Imaging, as well as Robert Kastler, Roberto Rivera, and photographers Peter Butler, Thomas Griesel, Jonathan Muzikar, and John Wronn handled all of the collection photography. Digital image archivist Jennifer Sellar helped to organize these hundreds of images, and Jeri Moxley, Manager of CEMS, and coordinator Kathryn Ryan facilitated our use of them.

This exhibition and publication were truly an undertaking of the entire staff in the Department of Prints and Illustrated Books. Associate curators Starr Figura and Sarah Suzuki, assistant curators Judy Hecker and Gretchen Wagner, and curatorial assistant Kim Conaty have worked over the last several years to forge and maintain relationships with the artists and publishers of our time, while consistently seeking out the most significant projects being made in the medium. Their contributions are abundantly visible in these pages and on the walls of the exhibition. For their patient and dedicated assistance to the cataloguing and care of the works for this show, I am extremely grateful to Katherine Alcauskas, Emily Edison, and Jeff White. Department manager Sarah Cooper and assistant Alexandra Diczok have provided crucial administrative and organizational resources, keeping track of correspondence, busy travel schedules, and the day-to-day activities within the department. Two excellent Louise Bourgeois Twelve-Month Interns, Alexander Fang and Lotte Johnson, contributed greatly to the research and production of this publication. Our colleagues in Paper Conservation, specifically Karl Buchberg, Brenna Campbell, Scott Gerson, and Erika Mosier, have also been instrumental in the care, cataloguing, and treatment of our collection.

Two collaborators, previously mentioned, deserve to be further recognized for their exceptional contributions to this project. Sarah Suzuki traveled far and wide in our research phase, provided contributions to the publication, and also oversaw Jacob Samuel's

portfolio with Gert and Uwe Tobias made on the occasion of the exhibition. As co-organizer of *Printin'*, she has enabled that show to take shape as a truly impressive venture. Her deep knowledge of the field coupled with her organizational abilities and tremendous grace have made her an integral part of this project. I am particularly grateful to Kim Conaty, who has worked with me as a trusted colleague on my exhibitions and projects at the Museum since 2008, for having been such a tremendous help in the complex realization of this exhibition and catalogue. In addition to her thoughtful contributions to the book, she managed the publication as a whole, coordinating on my behalf the many aspects of its production, editing, and design. For the exhibition, she ensured that the project always stayed on track, asking the right questions at critical moments, liaising with our colleagues in other departments, and always keeping in close touch with the artists, publishers, and additional figures involved.

On a more personal note, I owe infinite gratitude to my wife, Amy O'Neill, who from the very start provided me with insights and advice both on the publication and the exhibition. Our newborn son—Paul Emile Cherix—is a constant reminder of the importance of preserving the art of today for the generations to come.

My final gratitude and admiration go to the artists, publishers, and printers featured here, many of whom made themselves available for interviews, visits, and conversations during the planning of this project. This show is dedicated to their extraordinary contributions to the art of our time.

—Christophe Cherix
The Abby Aldrich Rockefeller Chief Curator of
Prints and Illustrated Books

# PRINT/OUT

Christophe Cherix

Since the Renaissance, prints have enabled artists to disseminate their works and ideas throughout the world. Prints, like photographs and, to a lesser degree, cast sculpture, have the unusual capacity to exist in multiple places at the same time. This particular function has always fascinated artists, from Albrecht Dürer, who used prints to impose his style throughout Europe at the end of the fifteenth century, to Joseph Beuys, who asserted in 1970, "I'm interested in the distribution of physical vehicles in the form of editions because I'm interested in spreading ideas."[1]

A print can be a reproductive or unique object. It can be used to translate an image from another medium—painting or sculpture, for instance— or can stand as a singular mode of expression. Over the centuries, printing techniques have evolved considerably, with new methods of multiplication regularly added to an ever-growing list of available tools. During the nineteenth century, the advent of photography and, later on, the development of commercial lithography threatened the tradition of hand-pulled prints, which were not able to compete with the exactitude of photographic reproduction or the cheap costs associated with newly automated means of production. Many artists began to take advantage of these new techniques, considering the potential of the offset press and other innovations for creating works like posters and broadsides to resonate with the contemporary urban environment. But these technical advances never sidelined traditional printmaking; instead, publishers began to limit the number of proofs pulled from a plate or a stone, in order to establish a viable economic market for such works.

Although some techniques fell out of fashion, such as woodcut in the eighteenth century, they were rarely replaced. During the nineteenth and twentieth centuries, many artists deliberately chose to transfer images through techniques that were considered archaic or outdated. Artists in the late nineteenth century, working in a style referred to generally as Gothic Revival, took inspiration from medieval models from as early as the twelfth century, for example, showing a keen interest in woodcut at a time when lithography had taken hold as the booming industry of the period. Despite its technical obsolescence, woodcut remained popular in the first decades of the twentieth century through the work of the German Expressionists, who valued not only its associations with history but, more importantly, its limited and more primitive modes of representation.

Throughout the twentieth century, the print medium maintained its relevance alongside a number of technical advances, such as the invention of screenprinting and offset printing, which offered cheaper, more efficient means of production. Many artists chose to continue working with traditional techniques, reflecting on the creative capacities of the process itself. Pablo Picasso, for instance, developed his prints through numerous states, which often became the subjects of separate editions. At the same time, strong partnerships were initiated between publishers, printers, and artists, enabling artists to draw on the technical expertise of others and encouraging a more experimental approach to the medium.

The 1960s and 1970s saw what Riva Castleman referred to as a "renaissance in printmaking,"[2] with artists rediscovering older techniques like hand lithography and also exploring new methods, for example, for transferring photographic images. Concurrent with this sense of revival in one medium, however, was a broader challenge posed by a new generation to the notion of artistic categories altogether. Artists began to question traditional distinctions between mediums, creating works that couldn't be clearly associated with any one of them. If more artists began to incorporate print processes in their work, they often did so as part of a larger practice, considering prints to be on equal footing with, for example, drawings or photographs.

The outcome of this shift is curiously twofold: while printed works have proliferated exponentially as part of a wide range of artistic

practices, their traditional systems of production have not. As Deborah Wye noted already in 1996, "Many print publishers during the 1980s and early 1990s had established their businesses well before that period—if not in the early years of the print boom, then soon after."[3] Few new print workshops solely dedicated to the medium have emerged in recent years. Today, computers, imaging programs, and printers have simultaneously become so advanced and user-friendly that artists can turn their studios into state-of-the-art printing centers, even with limited space and funds. As a result, seeking the technical expertise of master printers and their traditional apparatus has become less of an obligatory step, and artists have taken advantage of the broad availability and accessibility of new printing tools, allowing them to incorporate the medium seamlessly into their work. Prints have become so ubiquitous, in fact, that they appear to have been almost fully absorbed into contemporary art practice in general.

Many recent international contemporary print surveys have, not surprisingly, struggled with how to define this increasingly changing field. Some have taken an inclusive approach, arguing that the print medium covers a much wider range of activities than in the past, from installation and film to collage and sculpture.[4] Others have called for a historical revision, identifying examples of printed works not typically included in the history of the medium, such as Conceptual art documents, and tracing their reception by an emerging generation of artists.[5] In the end, neither is a fair survey, as one stretches the definition of the medium to the point of being almost unrecognizable and the narrow focus of the other doesn't fully represent for the manifold modes of expression in printmaking.

*Print/Out* embraces the versatile, global, and even muddled nature of contemporary art in the last two decades. The earliest selected works coincide with the geopolitical transformations of the late 1980s and early 1990s, which the fall of the Berlin Wall and the Tian'anmen Square protests in 1989 came to symbolize. This moment provides an emblematic point of departure for examining the contemporary development of the print medium, which, because of its reproducibility and potential for distribution, has often been linked to social change movements. The show focuses on roles that prints have served in the past and how artists have developed these ideas further in some of the most innovative art practices of our time. Over the last two decades, artists with no prior experience with printmaking have produced truly ambitious printed projects, often integrating newly available technologies with traditional techniques and choosing to work independently. Moreover, both long-established print publishers and newcomers have sought to attract these artists in order to explore new approaches to printmaking. The result is a much more diverse field, in which artists and publishers cross traditional boundaries with great fluidity. Some of the most remarkable printed projects published recently both expand the definition of the medium and play a vital role in artistic practice today.

### A Flickering Memory

Historically, prints played an important role in documenting and testifying to the existence of other works of art, but this "reproductive" function often led to their secondary status. In the latter half of the twentieth century, this same function took on a new importance within an increasing number of art practices. Prints and multiples offered the possibility to reactivate past events, ephemeral works, or interactive pieces, to keep them alive in a constantly changing environment. Many artists, from Joseph Beuys and Marcel Broodthaers to Edward Ruscha and Andy Warhol, have given to their prints and multiples a key conceptual role throughout their work. Beuys, for example, defined his use of the multiple as "a sort of prop for the memory . . . in case something different happens in the future."[6] In this way, a multiple could be seen

as an object liberated from its initial context of presentation and capable of translating the artist's intention in a different time and place, as Beuys described, "like an antenna which is standing somewhere and with which one stays in touch."[7]

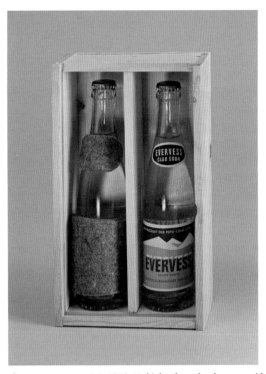

Joseph Beuys. *Evervess II 1*. 1968. Multiple of two bottles, one with felt, in wooden box with rubber stamp additions, box 10 13/16 x 6 7/16 x 3 7/16" (27.4 x 16.3 x 8.7 cm). Publisher and fabricator: Galerie René Block, Berlin. Edition: variant outside the edition of 40. The Museum of Modern Art, New York. Riva Castleman Endowment Fund, Donald B. Marron Fund, and Harvey S. Shipley Miller Fund, 2005

Prints and multiples are ideal vehicles in practices based in active systems of participation, reflection, and perception. Since the early 1990s, Rirkrit Tiravanija (pp. 89–99) has developed an approach that consciously tries to move beyond the art object, turning art galleries into social spaces by, for example, preparing meals to be shared with others instead of exhibiting artworks. As the artist has explained, "I learned from the mistake of Beuys, which was to make too many relics."[8] While Beuys's objects are indeed often directly linked to past actions or accompanied by instructions—such as *Evervess II 1* (1968), which consists of two bottles of water and the request that the owner "drink the contents of bottle II and throw the cap as far away from [himself/herself] as possible"[9] —Tiravanija's multiples encourage openended situations in which the viewer remains free to make his or her own choices. One of the artist's first multiples, *Untitled (rucksack installation)* (1993; p. 96), is a backpack filled with cooking utensils, supplies for camping, and a large folded map. The map—the first of many that the artist would produce—is, as Tiravanija recalls, "more of a 'mental map,' in the words of Franz Ackermann. It leads you to different things and to different places, but where you go is never decided. It's a kind of a counter map."[10] For Tiravanija, unlike for Beuys, not everyone is an artist, but art makes the viewer "more active" by "think[ing] like an artist."[11]

Another artist who embraced printmaking as a way to record and reflect on his life and work is Thomas Schütte. Schütte had been making watercolors since the early 1980s in an almost diaristic manner, offering a window into his thought process and psyche. In 2000 he instead began working exclusively on etchings, a technique he had never used in the past. As curator Ulrich Loock has explained, "Since his drawings and watercolors have become commodities, which is to say, since there has existed a market for the pages of his journals . . . he has ceased, or virtually ceased, to produce them at all. The production of individual sheets has been replaced by the production of printed graphic works."[12] Between January and December 2001, Schütte produced the

portfolio *Wattwanderung* (*Low Tide Wandering*) (2001; pp. 42–43, for example), a series of 139 etchings divided into thirty chapters. The work's title alludes to the artist's walks on Germany's North Sea beaches at low tide—moments for him charged with contradictory feelings of emptiness and of great fertility, as the sand swarmed with organisms.[13] The series can be seen as a lexicon of the artist's work and thoughts, but it is invaded as well by current events, such as that year's attacks on the World Trade Center in New York. One etching shows the sketch of a building with just two words, "HOLY SHIT," while another depicts a crowned figure under the ironic heading, "WE ARE THE KINGS." Schütte's decision to use an artistic process both unfamiliar to him and technically traditional was a way to move away from the computer age and "switch to the opposite direction" during a time that he felt to be depleted of energy and ideas.[14] The poignancy and force of *Low Tide Wandering* derive from its inherent oppositions—private versus public, past versus present—which are further drawn out through the work's installation: the prints are hung from strings or wire, crisscrossing the space at just above eye level, and this architecture of paper simultaneously entraps and immerses the viewer in the artist's thoughts.

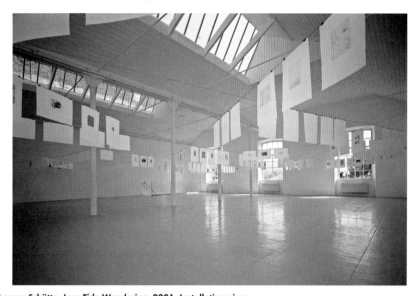

Thomas Schütte. *Low Tide Wandering*. 2001. Installation view, Galeria Tucci Russo, Torre Pellice, Italy, 2002

*Fade to Black* (2003; pp. 166–67) is a series of fourteen posters by Philippe Parreno printed in phosphorescent ink on white paper. Each recounts a past event or ephemeral work organized by the artist in collaboration with some of his contemporaries, such as Tiravanija, Liam Gillick, and Pierre Huyghe, who have shared with him since the early 1990s a similar theoretical approach—referred to as "relational art"—that advocates open-ended inquiry and active exchange among artists and with the public. One of the posters, *Argentina vs. Netherlands 1978, Medina 2003*, refers to a 2002 workshop that Parreno gave in Medina, Argentina, in which he screened the 1978 World Cup soccer final and then asked the students "to replay the game in the school-yard like they would have with a classical theatrical play."[15] Describing another poster, *The Day After, Kitakyushu, 2003*, the artist explained: "I rented an advertisement truck that was driven through the city in Kitakyushu [Japan] in 2003 during a political campaign. A post-apocalyptic speech was broadcast in the streets, introducing a series of alternative ideas to the campaign and suggesting the condition of a fiction."[16] When the posters are shown in an exhibition, they are presented in a space in which the lights are programmed to go on and off at regular intervals, producing the strange effect of seemingly blank, white sheets, whose imagery suddenly emerges as the phosphorescent ink glows vibrantly in the darkness. The images repeatedly fade in and out of sight. Revisiting a formative decade for the artist, *Fade to Black* acts like a paradoxical archive or, in Parreno's own words, a "flickering memory"[17] of his artistic practice.

## A Kind of Double Kitsch

The German painter Martin Kippenberger often used appropriation as a method to produce new work: integrating a painting by Gerhard Richter into one of his sculptures,[18] co-opting Picasso's last wife and favored model, Jacqueline, for a series of paintings titled *The Paintings Pablo Couldn't Paint Anymore* (1986), or simply turning his old work into new art. In 1989 Kippenberger asked one of his assistants to make a series of paintings based on a selection of his previous works. The new renditions, according to Kippenberger, were "too good,"[19] though, and he decided to have them destroyed. What might have been an abrupt end to a short-lived project, however, was in fact just the beginning. A number of works were produced at the time and in the immediate aftermath of this act of self-vandalism, including a series of photographs capturing each of the paintings before its imminent destruction (1989–90); a group of drawings made after the paintings (1991); three container-sculptures, filled with the smashed-up, discarded paintings (1991); and *Inhalt auf Reisen* (*Content on Tour*) (1992; pp. 29–39), a screenprint series based on a photograph of the inside of one of the containers. Kippenberger ironically referred to the set of photographs, titled *Heavy Burschi* (*Heavy Guy*), as turning his paintings into "a kind of double kitsch"[20]—an appropriation of an appropriation.

In recent years, much critical writing on the print medium has focused on how prints often build upon subjects first expressed in other mediums. Print specialist Jeremy Lewison, for example, has examined the work of several contemporary printmakers in terms of translation, appropriation, and re-presentation, invoking the work of Jake and Dinos Chapman, whose prints make use of etchings by Goya, and Damien Hirst, whose screenprinted portfolio *The Last Supper* (1999; p. 41, for example) is based on pharmaceutical packaging.[21] Visual and cultural studies professor Ruth Pelzer-Montada, in her essay on Hirst's work, has taken these ideas further and proposed the concept of "citationality," implying that the subject—the print, in this case—is constituted through the citation and, for this reason, typically attempts to conceal the fact of the repetition.[22] *The Last Supper*, as Pelzer-Montada has noted, does not hide its citationality, but rather makes two significant alterations to the drug packaging: replacing the logos of the pharmaceutical companies with the artist's name, and switching out the drug designations for popular foods. In the print *Sandwich* (p. 150), the words "Sandwich" and "Hirst" replace the HIV drug name Invirase and its manufacturer, Roche, although the design of the packaging itself is faithfully copied. Twenty-five years earlier, Marcel Broodthaers had used similar methods in his diptych *Les Animaux de la ferme* (*Farm Animals*) (1974), an offset that reproduced an old didactic chart of cattle types, but substituted the names of each species with those of automobile manufacturers, such as Chrysler, Fiat, and BMW. Conflating cows with cars, or ordinary foods with potent chemicals, both of these projects juxtaposed elements normally kept apart. Hirst's appropriated design creates a visual slippage between his prints and the original drug packaging. The artist's almost imperceptible alterations allow the compositions in *The Last Supper* to serve as shells, templates into which any text can be inserted.

Prints can generate works in which the line separating original from copy, or real from fake, can be almost totally blurred. For the 2009 Venice Biennale, Aleksandra Mir (pp. 189–95) published one hundred postcards in an edition of ten thousand copies each, to be freely distributed to the public.[23] The postcards, boldly bearing the city's name in various languages ("Venice," "Venezia," "Venedig"), look at first glance to be traditional tourist souvenirs, but upon further inspection the links to the Italian city disappear, as the subjects presented—from snowy landscapes to industrial views and skyscrapers—are actually stock images taken from other parts of the world. For this project, titled *Venezia* (*all places contain all others*) (2009; opposite and p. 194),

Mir encouraged visitors to use the postcards, negotiating with the Italian postal service to have official mailboxes installed within the exhibition grounds and to sell stamps at the Biennale's café. Her aim, in part, was to advocate for an open world, without physical or symbolic borders. The artist has recalled, "My idea was to create an opportunity for circulation, otherwise it was going to be just an art gesture. You could take [the postcards], write them, buy the stamps, postmark them, and get the Venice stamp on it."[24] As a printed work, *Venezia (all places contain all others)* goes beyond simply appropriating a type of imagery or a type of fabrication by also infiltrating a mode of distribution.

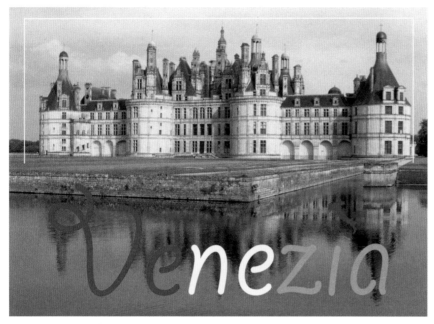

Aleksandra Mir. Postcard from *Venezia (all places contain all others).* 2009. Series of one hundred postcards, each 4 1/4 x 6" (10.8 x 15.2 cm). Publisher: the artist, Palermo. Printer: Ringier, Zurich. Edition: 10,000 each (1,000,000 total). Courtesy the artist

### Original Copies

With the development of scanning and imaging technologies, high-resolution digital files can now constitute artworks in their own right, or be seen as "original copies," as art critic Joanna Fiduccia has described. Fiduccia has written, "Walter Benjamin's prognostication that 'the work of art reproduced [will] become the work of art designed for reproducibility' is satisfied to the point of its inversion: reproductions, and in particular their technological means, have designed the work of art as reproduction, establishing a distinction between original and origin, authenticity and uniqueness. The picture has retreated into the zero dimension of the digital image."[25] Prints, of course, are heavily implicated in this argument. Printing matrices share numerous attributes with digital files, predominantly their potential for replication and their lack of aesthetic qualities as objects. Copperplates and lithographic stones, for example, deliver images onto another support through a transfer process, not unlike the process of using a digital file to print an image. Over the last two decades, artists have made use of such files at an exponential rate.

Transfer techniques like photocopy and stencil have played a significant role since the 1980s in the work of Christopher Wool, an artist who gained recognition for his paintings composed of words or short sentences. For Wool, the types of accidents potentially found in reproductions—like a loss of focus, or white spots from a photographic flash—can generate new works. In his often self-designed catalogues, for example, the artist typically foregoes professional photographs of his work in favor of casual shots from gallery installations or even studio views, photocopies of photographs, and details. Over the last

twenty years, Wool has mixed various techniques in his paintings, including spray painting and screenprinting, combined with the use of brushes and rollers. The artist first used screenprinting to import ready-made motifs, such as decorative patterns or flowers, into his paintings. Since the early 2000s, as curator Julia Friedrich has noted, Wool "no longer appropriates foreign material in the way he did in the word paintings . . . or in the pattern paintings. . . . He has begun rather to appropriate his own pictures."[26] In these works, the artist prints digitally manipulated images of earlier work on canvas, to which he applies various paint additions and often turpentine, a well-known solvent for thinning oil paints (see below). Wool has also been making unique screenprints since 2006, in which the artist relies solely on digital manipulation to create the final compositions (p. 61, for example). As painter Josh Smith has noted, "When the needs arise, Wool is not reticent to use Photoshop as a type of turpentine as well."[27] The resulting prints are absolutely flat, in subtle contrast to the paintings. The prints stand as "new originals," relegating the artist's earlier paintings to the category of source material—but for a brief instant only, as these originals are themselves destined for appropriation.

Christopher Wool. *Untitled*. 2007. Enamel on linen, 9 x 9'
(274.3 x 274.3 cm). The Museum of Modern Art, New York.
Nina and Gordon Bunshaft Bequest Fund, 2010

Kelley Walker has similarly developed an artistic practice that combines printing techniques and digital manipulations. Some of his early work, such as *The Marantz Turntable* and *Pioneer*, both from 2002, consist of digitally altered images of turntables, sold in the form of a printed poster and a digital file saved on a CD-ROM. An accompanying note explains that "Kelley Walker invites you, the owner, to modify, reproduce and disseminate the image as often as you like. You may thus create reproductions and deviations of the image. . . . Likewise, the image can be printed at any scale and on any material you choose."[28] This strategy allows Walker to include the collector in the artistic process, inviting him or her to interact directly and openly with the work.[29]

In a recent piece, Walker pushed these ideas further, maintaining an interactive element,[30] while experimenting with more complex forms of digital manipulation. *Andy Warhol Doesn't Play Second Base for the Chicago Cubs* (2010; opposite and pp. 46–47, for example) appropriates an advertisement from a Pioneer electronics magazine campaign of the early 1970s, showing Warhol sitting on a speaker next to a stereo.[31] Through this subject, Walker highlights a moment in which media

culture and art seem to collide, as Warhol famously aspired to be both a superstar and a radical figure in the art world. Using the advanced computer modeling program Rhino, Walker transformed the two-dimensional printed advertisement into three-dimensional virtual objects. In thirty-nine total images, screenprinted on individual panels, Walker produced seven different groupings depicting various sequences of the page being turned. In the images themselves, the artist has digitally "cut" a small circular shape from the page, and this portion of the image remains in place, even as the rest of the page seems to revolve around it.[32]

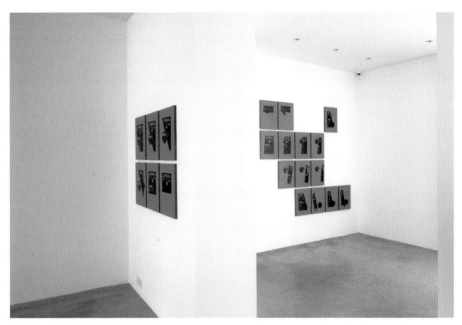

Kelley Walker. *Andy Warhol Doesn't Play Second Base for the Chicago Cubs.* 2010. Installation view, Galerie Gisela Capitain, Cologne, 2011

For the work's fabrication, Walker imitated the offset printing process typically found in magazines—the four-color separation using cyan, magenta, yellow, and black—in screenprint. The final printed images carry a richness and depth absent from the flatness of the magazine reproduction, reinforcing the notion that our media-saturated environment can alter our perception of images. At the same time, the scanning and subsequent modification of the images mimic the now standard process for art reproductions in catalogues or on the Internet. While new scanning technologies can give the illusion of perfect reproductions, capturing details that would otherwise be invisible to the naked eye, Walker's work reminds us that these same techniques often fragment and objectify the picture plane, and can turn images from the past into objects of endless reproducibility.

Transferring images from one support to another was part of Robert Rauschenberg's practice throughout his career, starting as early as the late 1950s. During those years, Rauschenberg sought to integrate "actual elements from the everyday life,"[33] and, in accordance with this approach, he kept the appropriated images intact, adjusting only their cropping, format, and placement on the sheets. *Thirty-Four Illustrations for Dante's Inferno* (1958–60; p. 22), for example, is a set of illustrations combining gouache and watercolor interventions with direct transfers of images and texts found mostly in contemporary newspapers and magazines. In Rauschenberg's last printed project, *The Lotus Series* (2008; pp. 205–15), completed just before his death, the artist took a different tack. This series of large-scale prints, based on photographs taken by the artist in China in the early 1980s, demonstrates his keen understanding of how new technologies alter our perception of the world. The final prints were created from digitally restored images, as the original negatives from his trip had been lost and the surviving proofs had faded considerably. Rauschenberg began by transferring the digital images onto boards, then scanned and finally printed them on a high-resolution plotter. He abandoned all brushwork

in this series, opting simply to juxtapose different images on each sheet. The final work captures a remarkable tension between the old photographs and their technically advanced printing more than two decades later, offering a fascinating reflection on how Rauschenberg, in the last months of his life, caught up with a younger generation of artists, such as Wool and Walker, who had themselves been so deeply indebted to his early work.

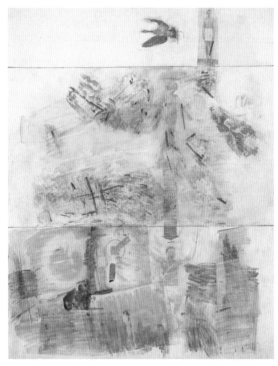

Robert Rauschenberg. *Canto II: The Descent* from *Thirty-Four Illustrations for Dante's Inferno.* 1958. Solvent transfer, gouache, pencil, and colored pencil on cut-and-pasted paper on paper, 14 3/8 x 11 3/8" (36.7 x 29.1 cm). The Museum of Modern Art, New York. Given anonymously, 1967

### Supercopy

In the 1990s, Ai Weiwei published a series of volumes known as *The Black Cover Book* (1994), *The White Cover Book* (1995), and *The Grey Cover Book* (1997) (pp. 49–59). Ai, who lived in the United States between 1981 and 1993 before moving back to China, conceived of *The Black Cover Book* in 1994 together with Beijing-based curator Feng Boyi and coeditors Xu Bing and Zeng Xiaojun. Their principal intention was to make available to their fellow Chinese artists information about Western contemporary art practices that was otherwise censored under the Communist government. That first volume and the ones that followed include interviews between artists, translations of important essays of art criticism, artists' interventions, and reproductions of iconic artworks, such as Marcel Duchamp's *Fountain* (1917), Joseph Kosuth's *One and Three Chairs* (1965/70), and Jeff Koons's *Rabbit* (1986). Called by Beijing-based curator and publisher Philip Tinari "the most influential art publication to appear since Tian'anmen,"[34] Ai's books, which were published in editions of three thousand copies each, quickly spread throughout China without any official form of distribution. The publication of these books was itself a political act, but perhaps the most significant achievement of these volumes lies in their distribution, which underscored the presence of a large and soon-to-be-organized underground artists' network.

Another project that foregrounds such an association of artists is the magazine *Permanent Food* (1996–2007; opposite and p. 165). The publication, initiated by Maurizio Cattelan and Dominique Gonzalez-Foerster, describes itself in its issues as "a non-profit magazine with a selection of pages taken from magazines all over the world" and a "second-generation magazine with a free copyright." For the first two issues, Cattelan and Gonzalez-Foerster asked more than one hundred

friends and colleagues to submit found, often altered images, to be used as the pages of the magazine. The third issue marked not only the departure of Gonzalez-Foerster and the enlisting of earlier contributor Paola Manfrin, an artistic director at an advertising agency, but also a shift in the magazine's constitution. From that point on, the issues were made almost exclusively of directly appropriated images or pages, culled from an increasingly broad, international contributor base. Cattelan and Manfrin often asked their original circle of contributors to then solicit additional participants.[35] Like Ai's books, *Permanent Food* was intended to spread a new form of information throughout the art world and simultaneously make visible—in this case through its editorial organization—an emerging generation of artists.

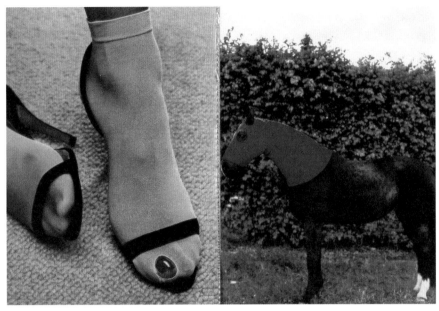

Interior spread from *Permanent Food*, no. 8. 2000-01. Magazine, 9 1/4 x 6 3/4" (23.5 x 17.1 cm). Publisher: Les Presses du réel, Dijon, France. Collection of Philip Aarons and Shelley Fox Aarons, New York

Edward Ruscha's artist books, which he published between 1963 and 1978, provide an interesting precedent for these types of publications, whose significance lies as much in their systems of production and broad distribution as in the objects themselves. Exclusively composed of documentary photographs organized around a specific subject, the books, such as *Twentysix Gasoline Stations* (1963), *Thirtyfour Parking Lots* (1967), and *Nine Swimming Pools* (1968), were modeled after commercial publications, sometimes even resembling advertising brochures. In an article submitted to an art journal in 1975, Ruscha ironically imagines an "information man," who, among other things, would give him information on the whereabouts of his books: "He could tell me possibly of all the books of mine that are out in the public that only 17 are actually placed face up with nothing covering them. 2,026 are in vertical positions in libraries, while 2,715 are under books in stacks. The most weight upon a single book is 68 3/4 pounds and that is in the city of Cologne, Germany in a bookshop. 58 have been lost; 14 totally destroyed by water or fire; while 216 could be considered badly worn."[36] For Ruscha it was the vast distribution of these small, cheap, and colorful publications—rather than an explicit circulation strategy with a political, social, or economic goal—that gave the project much of its meaning.

Beginning in 1990, the Vienna-based association museum in progress (1990– ; pp. 69–79) began organizing exhibitions that reached beyond the art world's traditional spaces, turning instead to existing modes of mass media, such as magazines and newspapers, billboards, television, and the Internet. By asking artists to intervene directly in these venues rather than in a gallery space, museum in progress has created a new model in which art is seen through its ability to combine forces with business and media structures, utilizing the tremendous reproductive power of the media to engage viewers directly through their

daily outlets of information. Having chosen to exist primarily in a series of ephemeral moments, museum in progress's enduring legacy is its innovative model that eschews physical objects in favor of images generated for reproduction.

SUPERFLEX, a Copenhagen-based artist group founded in 1993, has also explored the nature of reproducibility in its work. While it functions as a registered company, SUPERFLEX's goal is not financial profit, but rather the organization of initiatives committed to social and economic change. One of its overarching projects is called *Supercopy*, an umbrella term for a body of works that actively question international copyright laws. *Copy Light/Factory* (2008; pp.153–59), for example, operates as a workshop for producing simple cubic lighting structures bearing printed images of iconic (and heavily copyrighted) lamp designs —such as Poul Henningsen's PH Artichoke Lamp (1958) and George Nelson's Bubble Lamp (c. 1952). The workshop, which includes wooden frames, computers, and printers to be used in the fabrication process, offers participants a way to create new lamps that maintain their basic function and reference to historical design while avoiding copyright infringement. *Copy Light/Factory* concretely demonstrates how an object can be turned into an image of itself, thereby constituting a new original.

### A Stutter of Multiple Images

Throughout the twentieth century, the traditional processes of printmaking have allowed artists to play with various image layers in their work. Andy Warhol famously used screenprinting to that effect beginning in the 1960s. In *Vote McGovern*, a screenprint from 1972 made in support of George McGovern's presidential campaign of that same year, Warhol appropriated an image of McGovern's opponent, President Richard Nixon, and printed it with multiple screens in menacing and clashing tones, turning Nixon's visage into something sinister.

Techniques like screenprinting as well as photogravure and digital printing offer multiple ways to break down and alter photographic images. These processes enable, for example, straightforward transfers of images onto various supports, such as intaglio plates, screens, or computer files, which can then be deconstructed and reworked by the

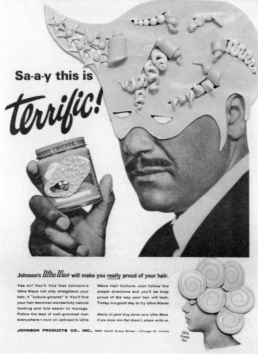

Ellen Gallagher. *Mr. Terrific* from *DeLuxe*. 2004–05. One photogravure and Plasticine from a portfolio of sixty prints, 13 x 10 1/2" (33 x 26.7 cm). Publisher and printer: Two Palms Press, New York. Edition: 20. The Museum of Modern Art, New York. Acquired through the generosity of The Friends of Education of The Museum of Modern Art and The Speyer Family Foundation, Inc., with additional support from the General Print Fund, 2004

artist. For her incredibly ambitious project *DeLuxe* (2004–05; pp. 109–19), a portfolio of sixty prints, Ellen Gallagher began with a selection of pages from issues of African-American magazines, such as *Ebony* and *Our World*, published around the time of the Civil Rights Movement. By cutting the pages apart and then collaging them back together, she created new layouts that were then transferred onto plates through photogravure. These plates served as both base layers for the prints and also surfaces to be further manipulated, as the artist continued to add and remove detail. Gallagher not only used myriad printing techniques, from lithography and drypoint to screenprint and digital manipulation, but went on to incorporate various additions, like Plasticine, velvet, and coconut oil, playing on the idea of ornament and adornment in African-American culture. In the plates, blonde wigs replace the traditional black; shadowy hairstyles in Plasticine resemble superhero helmets; eyes are extracted from faces or replaced by toy eyeballs; and portions of texts are entirely masked except for the letters "e" and "o." *DeLuxe* is characterized by an extraordinary grouping of techniques, turning the project into a veritable catalogue of the potential ways to subtract or add information to an image. Indeed, the only thing that distinguishes a page of *DeLuxe* from a unique collage by the artist is the very fact that every alteration had to be broken down into a series of precise steps that Two Palms Press, the printer and publisher, could replicate for each copy of the edition. As Gallagher noted, "What was exciting for me here was that what happens as whimsy in the drawings or as a decision made with an improvisational spirit (for example, when I would make a choice to blindfold characters or obliterate names underneath characters) would have to be structured so that it could be repeated twenty times. And it was exciting to see, repeated as language, something that was usually a one-to-one experience."[37]

Lucy McKenzie (pp. 169–79) has similarly created works in which image layers overlap and collide, drawing out a certain dissonance in her subjects. *Untitled* (for *Parkett* no. 76) (2006; p. 178) was realized, for instance, through multiple screens printed one after the other.[38] In the first combination of screens, McKenzie created an image that merges her facial features with the comic character Tintin, a young asexual journalist created by Hergé. This uncanny portrait, however, is altered again by the last screen, which gives the illusion that the print has been defaced with red graffiti, adding a cartoonish pair of breasts, thick glasses, and long teeth to the Belgian adventurer.

Digital technologies, which permeate the print world today, allow for much more complex image alterations. *Satin Operator* (2007; pp. 66–67, for example), a recent project by Trisha Donnelly, begins with the appropriation of a found photograph, presumably from the 1950s, of a young woman who seems to be dressed for a ball or a premiere. In each of the thirteen digital prints, the image of the woman is shown as if it has been mounted around a tube, which then progressively contorts, causing the photograph to rotate around it. The result is the impression of a fleeting image in a constant state of transformation. In a talk given by the artist the year before the making of *Satin Operator*, Donnelly mentioned the impact that the discovery of a found photograph had on her, which in many ways seems to relate to her prints: "The image cracked, split into a stutter of form and time . . . a stutter of multiple images connected to the original crack, not images that were referential in any way . . . not like a family of sides, but exactly like a family in its discomfort with their inevitable connection."[39]

If print has always been a medium of choice for artists seeking to manipulate images and alter existing source material, the last decade has seen a more complex level of intervention by artists, both technically and conceptually. This experimentation can be partially explained by the sudden availability of new technologies, but also by the progressive merging of mediums into a single field, in which drawings, prints, and photographs seem bound to share the same territory.

## Looking Ahead

As the field of printmaking has become increasingly open, artists from all backgrounds have been finding new ways to engage with it. Between 1999 and 2007, artists such as Donnelly, Gallagher, Hirst, Parreno and Schütte produced their most important contributions to the medium with little to no experience in their chosen technique. For them, the draw to printmaking did not come from any particular commitment to the medium but instead from necessity: it offered a pragmatic solution for creating works with a different function within their practices.

One result of the gradual broadening of the print world has been the changing role of the publisher. While traditional print publishers have continued to produce major projects and develop important collaborations with artists, many artists have chosen to self-publish their material, or to work with their galleries to manage production. Of the five artists mentioned above, only two worked with traditional publishers on the projects described in this essay—Hirst's *The Last Supper*, with Paragon Press, London, and Gallagher's *DeLuxe* with Two Palms Press, New York. For Schütte's *Low Tide Wandering*, for example, the artist chose to self-publish the work instead of pairing with an established publisher because he wanted to maintain the most economical and straightforward production process. On the contrary, Gallagher's *DeLuxe* would simply not have been possible without the active collaboration of Two Palms, which has the rare capacity to support complex projects often requiring both labor-intensive interventions and expertise in multiple techniques.

Other publishers have been defining new strategies to keep prints relevant in today's art world. Jacob Samuel (pp. 129–43), who founded his own printing and publishing studio in Santa Monica in the early 1990s, developed a portable aquatint box that enables him to work on the road, establishing improvised printshops directly in artists' studios. As he recalled of his early adventures, such as his project with Marina Abramović in her Amsterdam studio, "It's about working without a net, on the road, on the fly, and realizing, too, that by putting myself in the artist's studio I am deferring to them aesthetically."[40] Book publishers, like Salon Verlag in Cologne and Onestar Press in Paris, have similarly reached out to artists in order to revitalize their medium. Salon Verlag started a series for which selected artists were asked to choose their favorite book, which the publisher then subsequently reprinted with the addition of a new cover and an ex libris, or bookplate, specially designed by the artist.[41] Hans-Peter Feldmann, for example, chose a book on abstract art from 1953, while Mark Dion selected a how-to guide for the construction of a *Wunderkammer*, first published in 1701. For Salon Verlag, the act of republishing became itself an artistic pursuit.

While printmaking may very well lose its distinctiveness as a traditional artistic medium, many of its key characteristics—its reproducibility, capacity for distribution, and even its collaborative nature—remain essential to art-making. Looking at the vast range of extraordinary projects produced in the past two decades, it is perhaps not the disappearance of the print medium that we are witnessing, but rather the advent of a time in which prints will simply be called "art."

## Notes

1 Joseph Beuys, in Jörg Schellmann and Bern Klüser, "Questions to Joseph Beuys: Part I, December 1970," in Jörg Schellmann, ed., *Joseph Beuys: Multiples. Catalogue Raisonné of Multiples and Prints, 1965–1985* (Munich and New York: Edition Schellmann, 1985), 9.

2 Riva Castleman, *Printed Art: A View of Two Decades* (New York: The Museum of Modern Art, 1980), 6.

3 Deborah Wye, *Thinking Print: Books to Billboards, 1980–95* (New York: The Museum of Modern Art, 1996), 12.

4 A recent example of this curatorial mode is Philagrafika, the inaugural print triennial that took place in different locations throughout Philadelphia in 2010 and 2011, spearheaded by José Roca.

5 One example is the 2003 Ljubljana Biennial, in Slovenia, organized by this author.

6 Beuys, "Questions to Joseph Beuys," in *Joseph Beuys: Multiples*, 9.

7 Ibid.

8 Rirkrit Tiravanija, conversation with the author, New York, July 19, 2011.

9 Instructions on the lid of the box containing the bottles, quoted by Schellmann and Klüser, in *Joseph Beuys: Multiples*, 12.

10 Tiravanija, conversation with the author, New York, July 19, 2011.

11 Ibid.

12 "Thomas Schütte: A rather serious game," in Ulrich Loock, *Thomas Schütte* (Cologne: DuMont Literatur und Kunst Verlag, 2004), 60.

13 Thomas Schütte, conversation with the author, Düsseldorf, July 16, 2011.

14 Ibid.

15 Philippe Parreno, quoted on the website for Air de Paris, http://www.airdeparis.com/parreno/fade/fade.htm.

16 Ibid.

17 Ibid.

18 Martin Kippenberger, *Modell Interconti* (1987), in the collection of Gaby and Wilhelm Schürmann, Germany.

19 As recalled by Ann Goldstein in "The Problem Perspective," in Ann Goldstein, *Martin Kippenberger: The Problem Perspective* (Los Angeles: The Museum of Contemporary Art, 2008), 93.

20 Kippenberger, quoted in Jessica Morgan, "The Exhibitionist," in Doris Krystof and Jessica Morgan, eds., *Martin Kippenberger* (London: Tate Publishing, 2006), 20.

21 Jeremy Lewison, "Contemporary British Art in Print?," in Patrick Elliott, ed., *Contemporary Art in Print: The Publications of Charles Booth-Clibborn and His Imprint the Paragon Press, 1995–2000* (London: Booth-Clibborn Editions, 2001), 13–21.

22 The concepts of citationality and performativity are borrowed from Judith Butler's *Bodies That Matter: On the Discursive Qualities of Sex* (New York: Routledge, 1992). As cited in Ruth Pelzer-Montada, "The Discursivity of Print: Damien Hirst's Series *The Last Supper* (1999)," *Visual Culture in Britain* 9, no. 1 (2008): 84.

23 This project followed a similar project for the Gesellschaft für Aktuelle Kunst, Bremen, Germany, in 2005, for which Mir produced eight postcards of Bremen in an edition of three hundred thousand copies total.

24 Aleksandra Mir, conversation with the author, New York, June 20, 2011.

25 Joanna Fiduccia, "Original Copies: Images in the Zero Dimension," *Art on Paper* 13, no. 5 (May–June 2009): 48.

26 Julia Friedrich, "The Harder You Look . . . ," in Julia Friedrich and Ulrich Loock, eds., *Christopher Wool: Porto-Köln* (Porto: Museu Serralves; Cologne: Museum Ludwig, 2009), 44–46.

27 Josh Smith, "I, Robot: On Christopher Wool at Luhring Augustine New York," *Texte zur Kunst* 18, no. 71 (September 2008): 196.

28 Kelley Walker's artist file, Department of Prints and Illustrated Books, The Museum of Modern Art, New York.

29 The note asks for any work produced from the CD-ROM to be exhibited with the following mention: "The work on view was created by XXX [owner] from an image supplied by Kelley Walker."

30 These panels can be arranged on the wall at the discretion of the owner, and may be shown in part or in full.

31 The campaign ran at least from 1972 to 1976 in mainstream magazines, such as *Newsweek* and *Playboy*. Initiated by Ken Kai, Pioneer's founder in the United States, and geared toward a younger market, it included athletes, musicians, and artists, including Walt Frazier, Elton John, and Andy Warhol.

32 The artist has suggested a number of possible associations with this circular shape: a recycling symbol, the tip of a finger, or a period. Kelley Walker, conversation with the author, New York, November 5, 2010.

33 Robert Rauschenberg, as quoted in Edward A. Foster, "Introduction," in *Robert Rauschenberg: Prints, 1948/1970* (Minneapolis: The Minneapolis Institute of Arts, 1970), [6].

34 Philip Tinari, "Some Simple Reflections on an Artist in a City, 2001–2007," *Parkett*, no. 81 (2007): 112.

35 Victor Brand, "Permanent Food," in Philip E. Aarons and Andrew Roth, eds., *In Numbers: Serial Publications by Artists Since 1955* (Zurich: PPP Editions in association with Andrew Roth Inc., 2009), 307.

36 Edward Ruscha, "Information Man," republished in Siri Engberg, ed., *Edward Ruscha: Editions, 1959–1999*, vol. 2 (Minneapolis: Walker Art Center, 1999), 55.

37 "'eXelento' & 'DeLuxe,'" interview with Ellen Gallagher, Art21, accessed September 22, 2011, http://www.pbs.org/art21/artists/gallagher/clip1.html.

38 A full set of state proofs is in the collection of the Ludwig Museum, Cologne.

39 Trisha Donnelly, Conversations with Contemporary Artists, lecture series at The Museum of Modern Art, New York, November 3, 2006.

40 Jacob Samuel, interview with Cynthia Burlingham, Leslie Jones, and Britt Salvesen, February 26, 2010. Published in exhibition brochure for *Outside the Box: Edition Jacob Samuel, 1988–2010* (Los Angeles: Hammer Museum, 2010), 11.

41 When the book is still available, the specific number of copies is simply acquired and inserted in a new dust jacket designed by the artist.

# MARTIN KIPPENBERGER CONTENT ON TOUR

From the late 1980s to his untimely death, Martin Kippenberger (German, 1953–1997) realized an impressive body of multiples in collaboration with various publishers and galleries. Drawing on elements as diverse as drums, pills, packing boxes, bathmats, and tic-tac-toe games, most of the artist's multiples involved the alteration or playful misappropriation of popular objects from everyday life. Drums, for instance, became pedestals for cast-bronze elements, while pills, made of wood and enlarged to an absurd scale, were engraved with the invented brand name "Kippen Seltzer." Much of Kippenberger's work across mediums involves pastiche, imitation, and reproduction, exemplified in projects from mass-produced paintings to an unrealized global network of subway stations. Detached from notions of originality and uniqueness, his multiples represent yet another dimension in Kippenberger's complex and provocative oeuvre.

In the introductory text for the catalogue raisonné of Kippenberger's multiples, Martin Prinzhorn addressed the artist's particular relationship to the notion of reproduction, explaining that it has always had a double meaning for him. In his work, Kippenberger questions not only the concept of uniqueness, but also the potential to truly create something out of nothing. According to Prinzhorn, "The idea that mechanical reproduction and its technical possibilities could signify the end of the work of art is hereby reversed. It is often the copy or the edition that first makes something into art which, so to speak, makes the trait visible that identifies it as such."[1] As they have done for other major figures of the twentieth century, from Marcel Duchamp to Joseph Beuys, prints, multiples, and artists' books— all based on notions of reproduction and duplication—played a key role in Kippenberger's practice.

In 1991 Kippenberger embarked on what would become a multifaceted project involving painting, photography, sculpture, and printmaking. The first step toward his realization of this project was in fact his decision to discard a series of fifty-one paintings. Based on reproductions of his own work,

these paintings had been executed according to his instructions between 1989 and 1990 by his assistant, the artist Melvin Carpenter.[2] Unsatisfied with the copies, Kippenberger chose to destroy them, but first asked his friend and photography collector Wilhelm Schürmann to photograph them. The photographs were enlarged to the sizes of the original paintings, framed, and exhibited in place of the paintings under the title *Heavy Burschi* (*Heavy Guy*). The series was first shown by itself in Santa Monica in 1991, and, later that year, in three exhibitions (in San Francisco, Vienna, and Cologne). In these subsequent presentations, the photographs were displayed together with the destroyed paintings, now stuffed into three replicas of an industrial container.[3]

Adding another layer to this project, Kippenberger photographed the interior of one such container filled with the tangled and mashed up paintings. Instead of just documenting the fate of a previous work, the resulting photograph served as the basis for a screenprint, *Inhalt auf Reisen* (*Content on Tour*), which he realized in 1992 with Austrian publisher Edition Artelier.[4] This screenprint exists in four variants: one reproduces the photograph in full and the other three are cut-down versions of the same image in smaller sizes. Each print was then mounted on plywood, and the artist or his assistant used a circular saw to make random linear marks on most of the surfaces, partially destroying the images and also distinguishing each as a unique object.[5] These prints become the material result of the artist's previous endeavors in painting, photography, and sculpture.

With unmistakable irony, *Content on Tour* can be perceived as the final development in a series of failed attempts, ultimately producing a work that transcends its origin through a long sequence of reproduction and alteration. It's perhaps no coincidence that the final print bears the crumpled words "INPUT-OUTPUT," as if symbolizing an inescapable breakdown of communication. Yet throughout this process there is no real loss of information, but instead the establishment of a system of production based

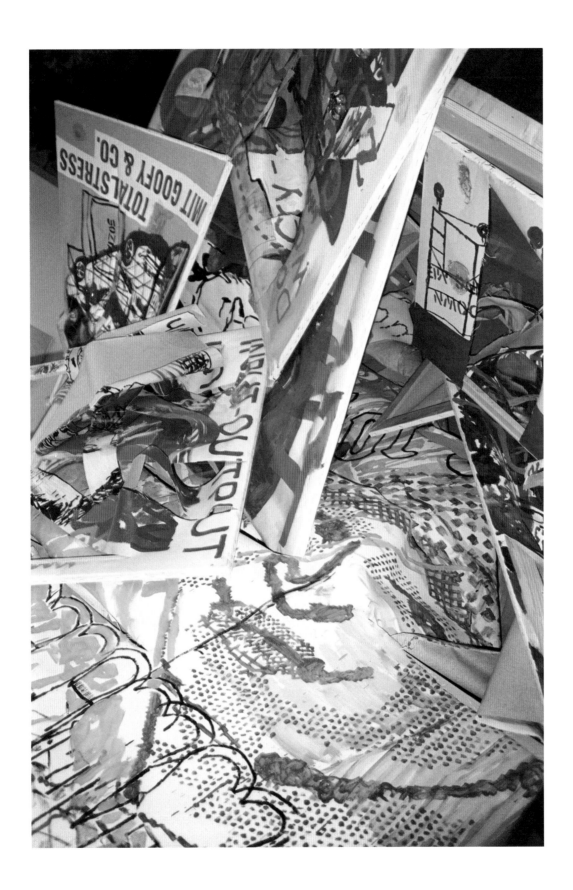

**Source photograph for *Content on Tour*. 1992**

**Martin Kippenberger**

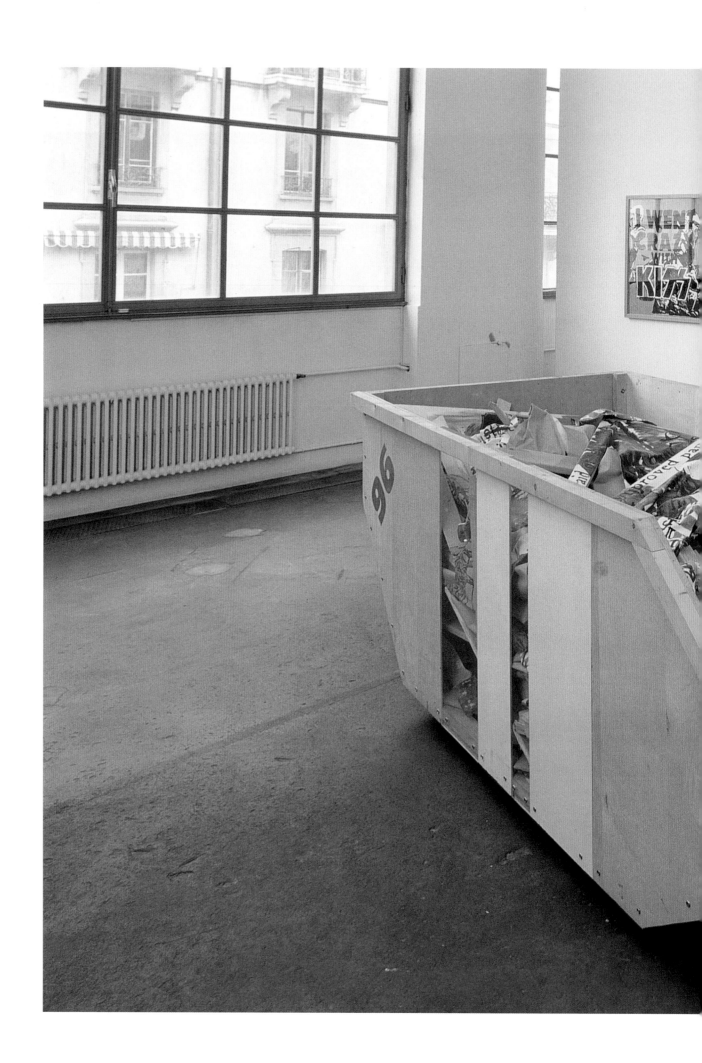

Installation view of *Respektive 1997–1976*. Musée d'Art Moderne
et Contemporain (MAMCO), Geneva, 1997

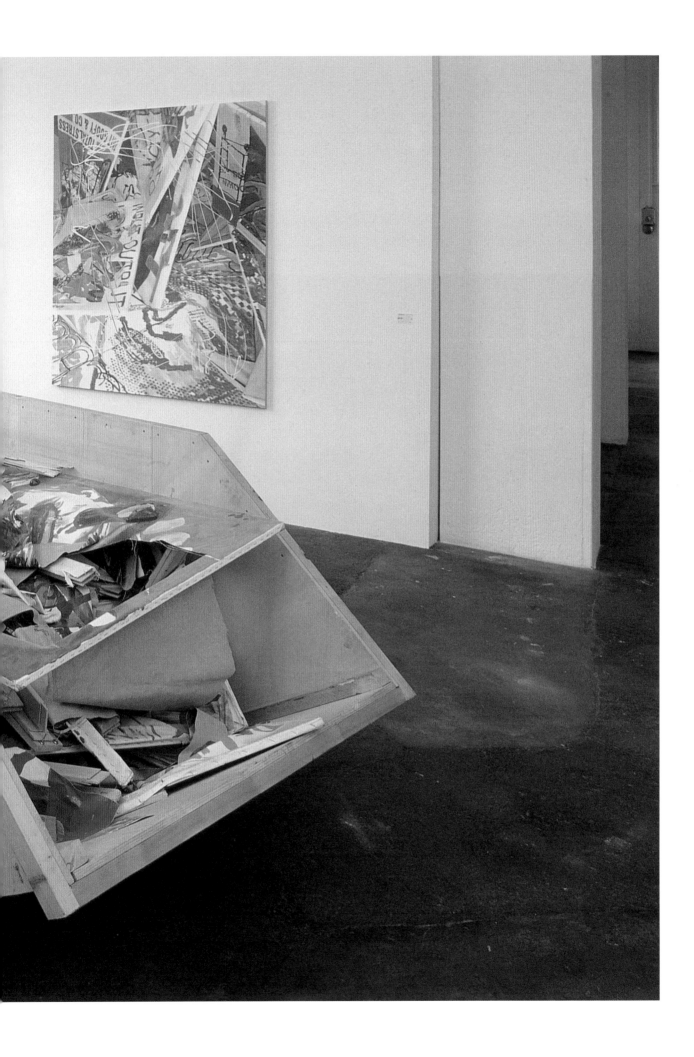

**Martin Kippenberger**

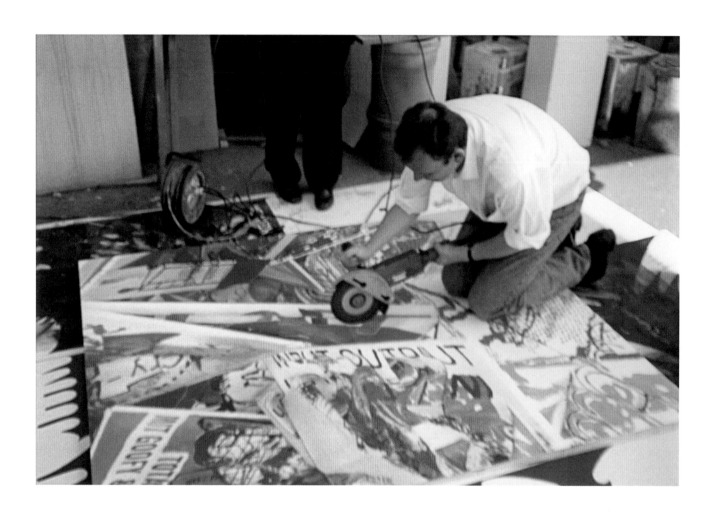

**Martin Kippenberger working on** *Content on Tour* **at Edition Artelier,**
**Graz, Austria, 1992**

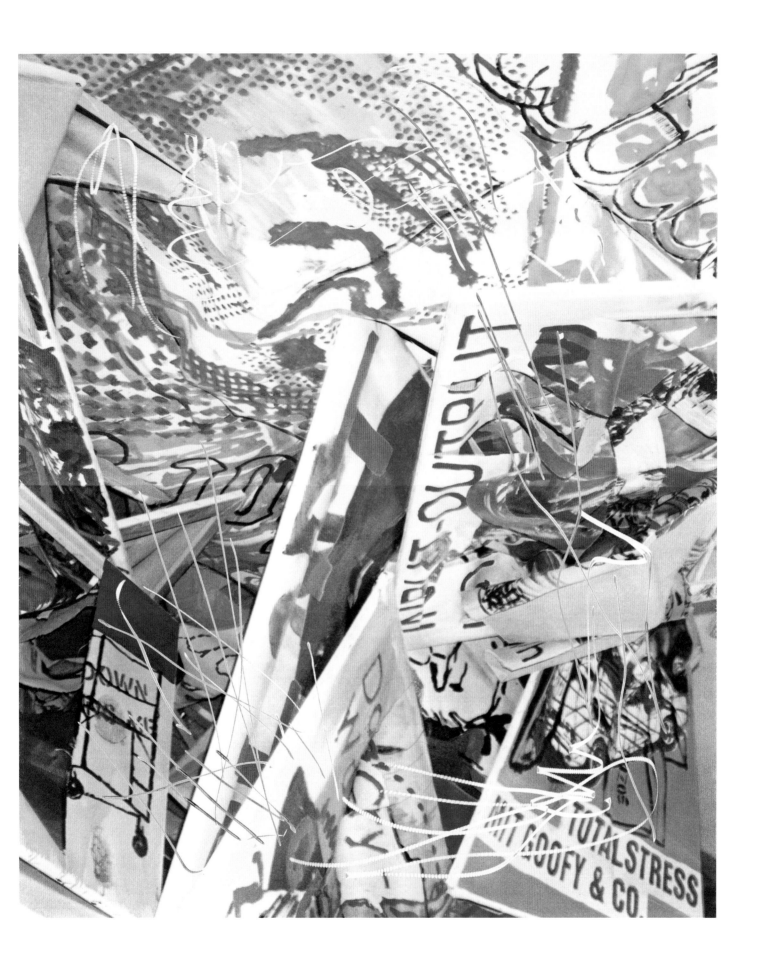

*Content on Tour.* 1992

**Martin Kippenberger**

*Content on Tour.* 1992

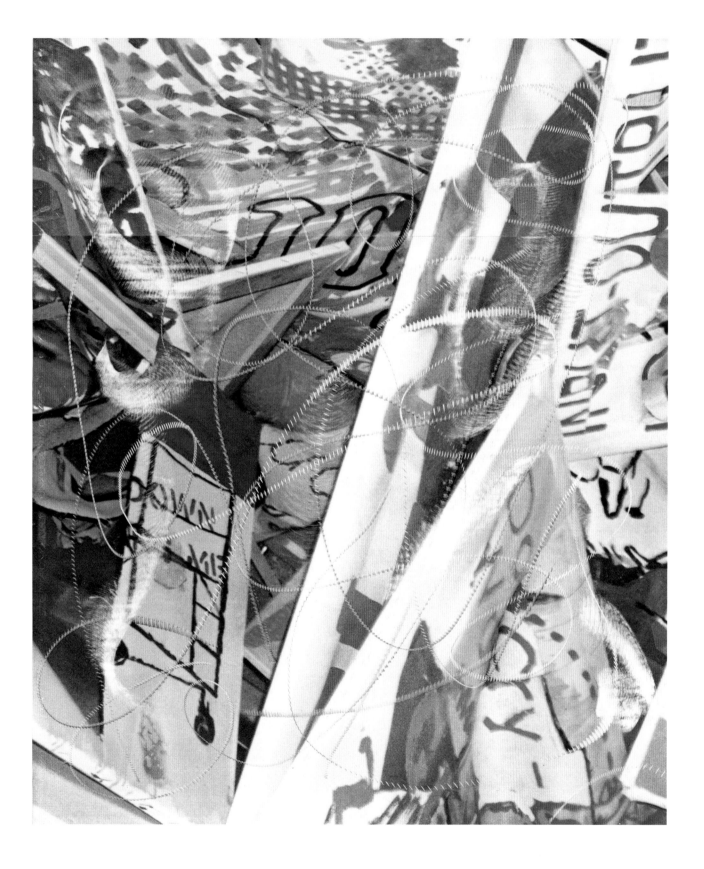

**Martin Kippenberger**

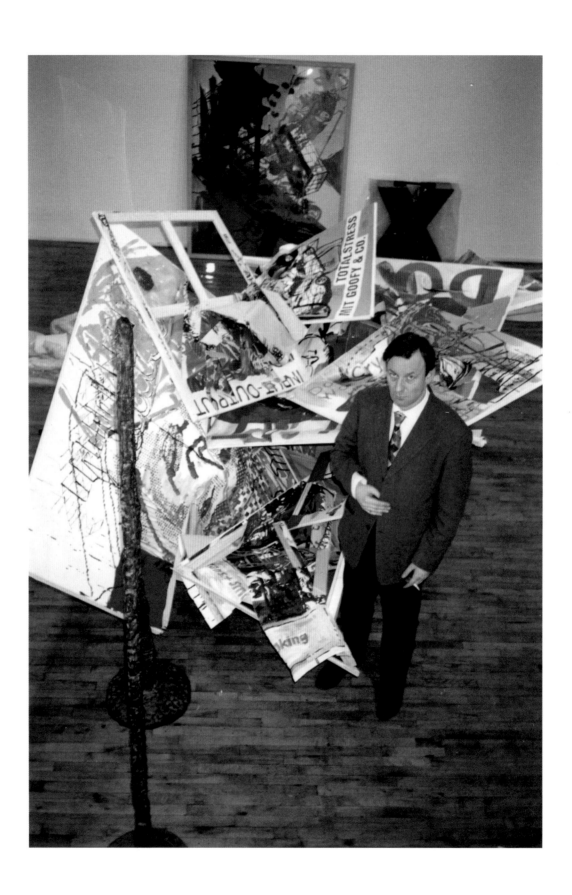

**Martin Kippenberger in front of the container photographed for *Content on Tour*, Metro Pictures, New York, 1992**

entirely on the transfer of content from one medium to another—a process in which the printed medium has the final word.

—Christophe Cherix

### Notes

1   Martin Prinzhorn, "Edition Unlimited," in Karola Grässlin, ed., *Kippenberger: Multiples* (Cologne: Verlag der Buchhandlung Walther König, 2003), 11.
2   For more information on the many stages of this project, see Jessica Morgan, "The Exhibitionist," in Doris Krystof and Jessica Morgan, eds., *Martin Kippenberger* (London: Tate Publishing, 2006), 20.
3   The exhibitions took place at Luhring Augustine Max Hetzler Gallery, Santa Monica; San Francisco Museum of Modern Art; Wiener Festwochen, Vienna; and Kölnischer Kunstverein, Cologne. Only in Cologne was the full set of photographs presented with a container.
4   The title of this edition relates to the fact that these containers were sent "on tour" for the previous year's exhibitions.
5   Some of the copies kept by the artist were left untouched by the saw.

# Chicken®

Concentrated Oral Solution
Morphine Sulphate

## 20mg/ml

Each 1ml contains Morphine
Sulphate BP 20mg

## 120ml

Damien
Hirst

Damien Hirst. *Chicken* from *The Last Supper*. 1999

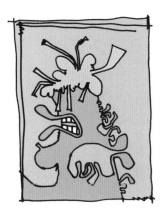

Carroll Dunham. Three from *Female Portraits*. 2000

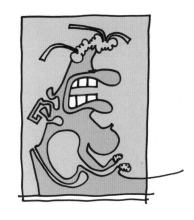

# DUMPLING 10mg

Lisinopril dihydrate equivalent
to 10 mg anhydrous lisinopril

28 tablets

Damien Hirst. *Dumpling* from *The Last Supper*. 1999

Thomas Schütte. Six from *Low Tide Wandering*. 2001

**Thomas Schütte. Four from *Low Tide Wandering*. 2001**

**Kara Walker. *Foote's Gun-Boats Ascending to Attack Fort Henry* from *Harper's Pictorial History of the Civil War (Annotated)*. 2005**

Liam Gillick. *Thursday from Guide*. 2004

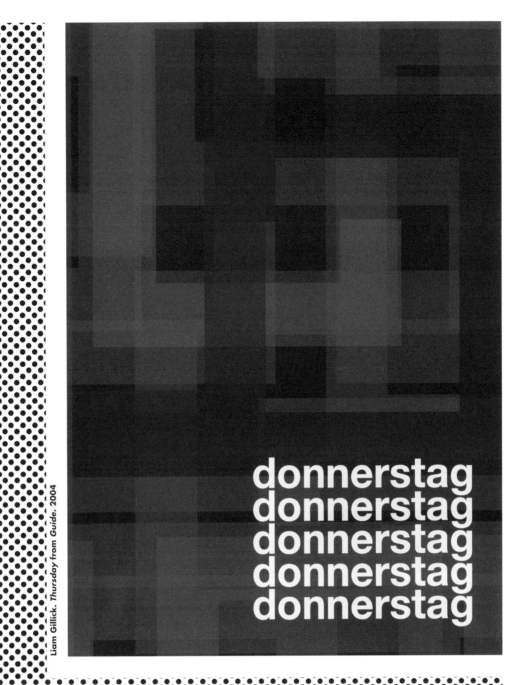

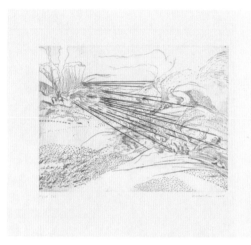
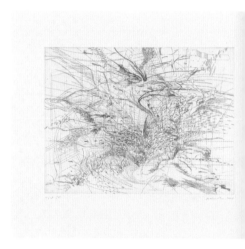

**Thomas Schütte. Five from *Low Tide Wandering*. 2001**

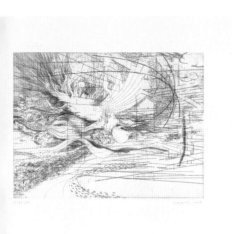

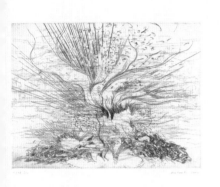

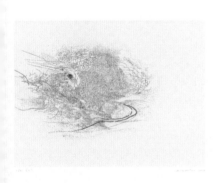

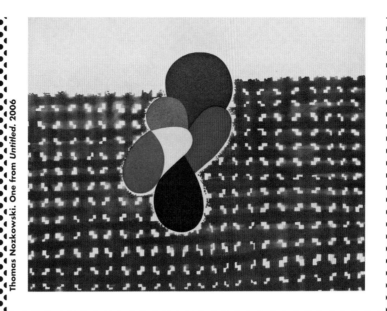

Thomas Nozkowski. One from *Untitled*. 2006

Julie Mehretu. *Landscape Allegories*. 2004

Slavs and Tatars. One from *Nations*. 2007

das
kapital
hill

*Thomas Schütte. Three from Low Tide Wandering. 2001*

™
# *Omelette*
ondansetron
## tablets 8mg

Each tablet contains
**8mg ondansetron**
as ondansetron hydrochloride dihydrate
Also contains lactose and maize starch

## 10 tablets

## *HirstDamien*

*Damien Hirst. Omelette from The Last Supper. 1999*

*Kelley Walker. Nine from Andy Warhol Doesn't Play
Second Base for the Chicago Cubs. 2010*

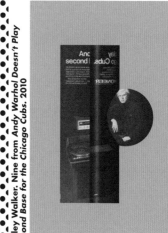

Pae White. *My Melody* from *Untitled*. 1999

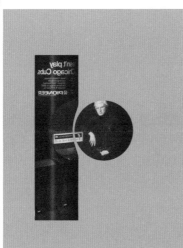

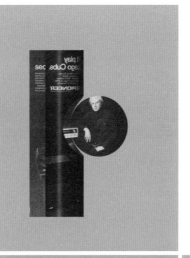

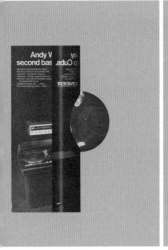

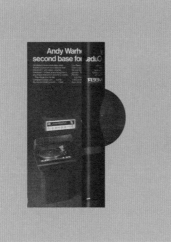

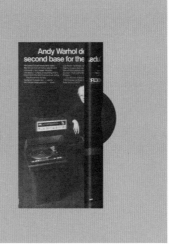

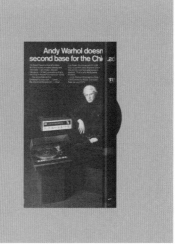

OPEN

LUER-LOCK
NO NEEDLE PROVIDED

DSH

# LIVER BACON
# ONIONS, S.P.

1 mg
per
10 mL

STOCK NO. 1039

FOR INTRACARDIAC OR INTRAVENOUS USE
ANTIMUSCARINIC

## POT-8-O®

Damien Hirst. *Liver Bacon Onions* from *The Last Supper.* 1999

Lisa Yuskavage. *The Bad Habits.* 1996–98

While recognized as an artist, a political activist, a widely followed member of the blogosphere, a provocateur, and an iconoclast, Ai Weiwei (Chinese, born 1957) is often overlooked in his role as a pioneering publisher. In fact, the three volumes he produced in the 1990s, known as *The Black Cover Book* (1994), *The White Cover Book* (1995), and *The Grey Cover Book* (1997), could well be among his most impactful and enduring legacies. Sparsely and elegantly designed, the paperbacks comprise artists' submissions, essays, and translations of existing art historical and critical texts accompanied by black-and-white reproductions of artworks, photographs of installations and performances, sketches for project proposals, and portraits of artists. In a moment marked by a near total lack of access to foreign monographs, exhibition catalogues, and art magazines, these volumes represented a new vehicle for circulating and disseminating information among China's contemporary artists. Produced in collaboration with like-minded curator Feng Boyi,[1] the books represent a seminal moment in Chinese contemporary art.

**Sarah Suzuki: When you returned to China in 1993, you had been in the United States for more than a decade. What was your take on the contemporary art network in Beijing at the time?**

Ai Weiwei: For me, there was almost no contemporary activity after 1989. The liberal thinking and our student movement had been crushed, and it was very depressing actually, because there was not much mental or intellectual engagement. So we tried to establish a base to encourage more experimental and performance-based work through *The Black Cover Book*. I think that, through it, we succeeded in creating a kind of platform through which artists saw really experimental work, and it gave them great encouragement in the face of dominant practices: "political pop," social realism, export art made for foreign travelers, depictions of the Cultural Revolution. Many of the works that were included were made specifically for the books and grew out of conversations that I had with my fellow artists, so it marks a real starting point.

**SS: During that time, both authors and artists alike had difficulties getting work printed. With printing and production so controlled by the government, printers would sometimes decline jobs to avoid running afoul of the censors. How did you manage to get the books published and into circulation?**

AW: We printed them in Hong Kong, and then snuck them back into China through Shenzhen, which was a freer economic center. The first book I laid out by hand, by cutting and pasting. I remember it was so hot and so humid in Shenzhen, and we were laying the pages out and just sweating.

**SS: Each book was printed in an edition of three thousand. Did you have a sense at that time of what the geographic reach of *The Black Cover Book* would be, or any sense of how dispersed it would become?**

AW: Well, we thought only a few hundred people were involved in these types of activities and would be interested. But when it comes to books, it's the same price if you print one thousand or three thousand, so we printed three thousand. Since we couldn't openly distribute the book, it came as a big surprise that through just a few artists we knew, the book quickly disappeared. Everybody wanted to have a copy.

**SS: Yes, I've heard from numerous artists that they considered themselves really lucky if they could get their hands on a copy. Would you describe it as a relatively closed circuit of artists operating at that time?**

AW: Yes. Until the year 2000, very few people in China accepted contemporary art. It was a very small circle.

**SS: Was there any support for the books from art institutions or academies like China Art Academy in Hangzhou or the Central Academy of Fine Arts in Beijing?**

AW: No. Totally not. In China, if you could get into those universities you already thought you were a member of the elite. The academies were the enemies of those of us who wanted to do something new.

中國·北京
一九九四年第一輯

## 目　錄
### CONTENTS

**Cover and table of contents for *The Black Cover Book*. 1994**
**Ai Weiwei**

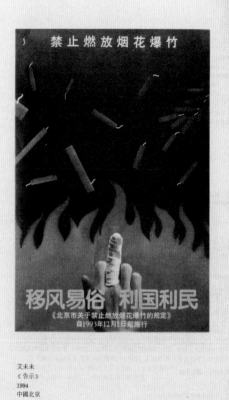

禁止燃放烟花爆竹

移风易俗 利国利民

《北京市关于禁止燃放烟花爆竹的规定》
自1993年12月1日起施行

艾未未
《告示》
1994
中國北京

北京市关于禁止燃放烟花爆竹的规定

(1993 年 10 月 12 日北京市第十届人民代表大会
常务委员会第六次会议通过)

第一条  为了保障国家、集体财产和公民人身财产安全,防止环境污染,维护社会秩序,根据国家有关法律、法规,结合本市情况,制定本规定。
第二条  本规定由各级人民政府组织实施。
公安机关是禁止燃放烟花爆竹工作的主管机关。
第三条  各级人民政府、街道办事处和居民委员会、村民委员会,以及机关、团体、企业事业单位,应当在居民、村民、干部、职工和学生中广泛深入开展禁止燃放烟花爆竹的宣传教育。
第四条  本市东城区、西城区、崇文区、宣武区、朝阳区、海淀区、丰台区、石景山区为禁止燃放烟花爆竹地区。
朝阳区、海淀区、丰台区、石景山区远离市区的农村地区,经区人民政府报请市人民政府批准,可以暂不列为禁止燃放烟花爆竹地区。
其他远郊区、县的禁止燃放烟花爆竹地区,由区、县人民政府划定。
市人民政府应当采取措施,逐步在本市行政区域内全面禁止燃放烟花爆竹。
第五条  在禁止燃放烟花爆竹地区,任何单位或者个人,不准生产、运输、携带、储存、销售烟花爆竹。
在本市禁止燃放烟花爆竹地区以外的地区,生产、运输、储存、销售烟花爆竹,须经公安机关批准。
第六条  在禁止燃放烟花爆竹地区,违反本规定有下列行为之一的,由公安机关给予处罚:
(一)单位燃放烟花爆竹的,处 500 元以上 2000 元以下罚款;
(二)个人燃放烟花爆竹的,处 100 元以上 500 元以下罚款;
(三)携带烟花爆竹的,没收全部烟花爆竹,可以并处 100 元以上 500 元以下罚款。
第七条  违反本规定生产、运输、储存、销售烟花爆竹的,由公安机关没收全部烟花爆竹和非法所得,可以并处 5000 元以上 20000 元以下罚款。
第八条  个人或者单位直接负责人,违反本规定情节严重的,依照《中华人民共和国治安管理处罚条例》处以 15 日以下拘留;造成国家、集体、他人财产损失或者人身伤害的,依法承担经济赔偿责任;构成犯罪的,依法追究刑事责任。
第九条  违反本规定的行为人未满 18 岁没有经济收入的,对他的罚款或者由他负责赔偿的损失,由其监护人依法承担。
第十条  国家及本市庆典活动燃放礼花,由市人民政府决定并发布公告。
第十一条  本规定具体应用中的问题,由市人民政府负责解释。
第十二条  本规定自 1993 年 12 月 1 日起施行。

告 示

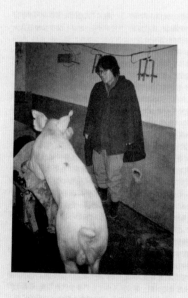

徐 冰
《文化動物》
訓猪
1994
北京永豐第一良種猪場

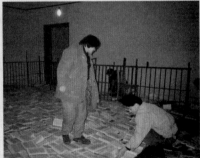

徐 冰
《文化動物》

印字              攝影:馮博一

一噘書和安裝猪欄

攝影:馮博一

馬塞爾・杜香
《噴泉》設計圖
1964(第4版)

馬塞爾・杜香
《噴泉》
1917
美國紐約

## 創作的行爲

馬塞爾・杜香

　　我們來考慮一下兩個重要的因素,即藝術創造的兩個角色:一方面是藝術家,另一方面就是以後要成爲後人的觀衆。

　　很顯然,藝術家的行爲猶如巫士,他從超越時空的迷宮中尋找通往光明的途徑。

　　如果我們將媒介的屬性賦予藝術家,那麼我們就會在美學層面上否認他對自己在做什麼和爲什麼這樣做等問題擁有清醒的狀態。他在作品的藝術創造中所作出的一切決定都出於純粹的本能,並且不可能被譯解爲自我分析,無論是口頭的,文字的甚或是思考中的。

　　T.S.愛略特在《傳統與個人天賦》一文中寫道:"藝術家越是完美,那麼在他身上肉體的人與創造的大腦之間就越是徹底分離;大腦也就越是完全地吸收和改變爲其素材的情感。"

　　億萬個藝術家都在創造,只有數萬個藝術家被觀衆討論和接受,而受後人所敬仰的就更少。

　　在上述分析中,藝術家也許會大聲疾呼自己是天才;他會耐心等待觀衆的裁決以使自己的名聲產生社會價值,並最終使後人將他收入藝術史的入門書籍中。

　　我知道我的這段話不會得到很多藝術家的同意,他們不願承認巫士的角色,而是一味堅持認爲他們的創造活動中確實很清醒——然而藝術史決定一件藝術作品的價值所依據的想法與藝術家本人理性化的解釋全然無關。

　　如果藝術家作爲一個對自己和整個世界充滿了最美好的意圖,但對

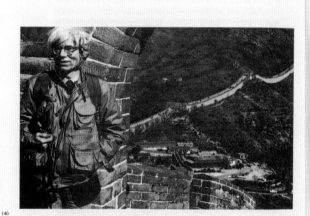

安迪・沃霍爾在長城
1982

杰夫・庫恩斯
《自塑像》
大理石
1991

Ai Weiwei

★

中國北京‧一九九五

莊：80年代之後美國藝術有什麼重要旳事情發生嗎？

艾：我個人認為，八十年代是一個糟糕的時期，是藝術商人揀了錢的時期，是多數藝術家在精神上感到壓抑的一個時代。

莊：進入八十年代末期，由於全球冷戰結束，蘇共陣營解體、歐盟各國加大了共同合作的步伐。在這種前景下，流行於學術界中的後現代主義多元理論也迅然奮起，從某種意義上講，歷史為今天的人們賦予了新的責任。我們已經逐漸消除了對那些所謂的民族主義、國家利益等等話題關懷的熱情。

艾：九十年代的藝術發生了一些變化，人們從八十年代轟轟烈烈的潮流中走向了藝術的個人化、多元化，這實際上是人們對個人狀態和個人方式的重新審視，由於近幾十年來電視、電腦、信息網絡的發展，使代表著個人意志、個人特征的藝術形式在逐漸消弱，（包括受安迪‧沃霍爾思潮的影響。），這種處境一旦被人們省悟，就會發現我們作為個人存在的方式已經不存在了，這是一種人類前所未有的狀態。

莊：那麼，我們最終要尋找什麼樣的結果呢？

艾：最終，是否要達到一種群體性的思維方式，還是像人們今天鼓吹的走向個人自由化的狀態，還需要人們去探討。當然，從某些意義來說，現在存在的方式還是比較古老的，只有幾個共同的價值觀，在精神上實際沒有太大的不同。

莊：你認為藝術中存在所謂的創造性嗎？

艾：我不喜歡創造這個詞，它是一個比較宗教的概念，是我們談上帝的時候從無到有的一種奇跡般東西，談創造性是誇張了自己的功能。

莊：最後你是否能談一下目前藝術家所普遍面對的一些問題。

艾：我認為，現在的藝術家無論中國還是西方的，都普遍對藝術的原始功能、今天的藝術到底是什麼？這方面問題的發問比較少，而對功利及短期效益的考慮比較多。所以，多數人還是屬於機會主義的方式，我們的時代缺少有獨立人格的、有自己獨特價值觀的一批藝術家。

（根據錄音整理）

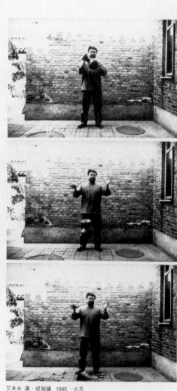

艾未未 漢‧綠釉罐 1995‧北京

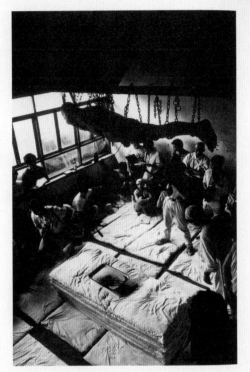

張洹

《隱秘伍公斤》
1994.7.10 · 北京

　　用鐵鏈將自己裸露的身體平行吊在鐵樑上，使懸在空中的身體正面朝向地面。從身體中抽出250毫升血液滴在一個醫用大盤子裡，盤子下面設置了一個接電源的電爐。

　　我的工作室總面積約32平方米，長6.5米，寬5.5米，高5米，鐵樑距地面為3米高。20條梅子平整的擺在一起像一張單人床，放置在平行與我身體的正下方處，電爐及盤子安放在"單人床"的中央部位。捆綁身體用了十條鐵鏈，頭部用一根皮帶，一塊175cm × 50cm的木板。氣溫32度。這是做這件作品時的基本環境及用具。

　　作品實施一個小時。

張　洹《六十五公斤》1994 · 北京 攝影：艾未未

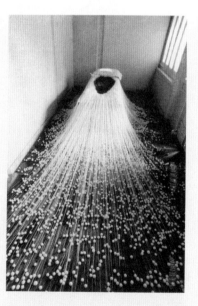

林天苗
《纏的擴散》 1995 · 北京

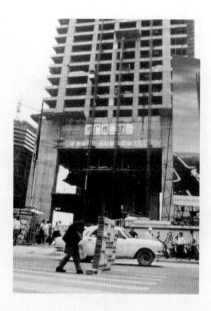

林一林
《安全渡過林和路》 1995 · 廣州

★

中国北京·一九九七

颜 磊·洪 浩
《I·O道库门特》1997·北京

17

关于《I·O道库门特》的对话

Aleagon · Hionhy　颜 磊·洪 浩
1997.9

本谈话是在北京王府饭店的咖啡厅里进行的。Aleagon · Hionhy先生是"时事90分钟杂志"节目的主持人，他带来了一位穿着像在MTV中做DJ的耶鲁大学的上海籍硕士留学生做翻译。在镁光灯和摄像前，Aleagon · Hionhy先生整理了一下领带，开始提问。

（以下Aleagon先生简A、洪浩简称H。颜磊简称Y）

A：被叫做《I·O道库门特》的作品，我想问一下你们做这个作品的一些情况和想法。首先，你们的动机是什么？

H：从事艺术创作工作，经常有一些虚幻的东西在起作用，但当某种虚幻变得和现实很近的时候，便想更清楚地表达这种虚幻。就像"文件展"这样的问题。因为"小文件展"曾光顾过我们的现实里。

A：你是说参加西方人策划的展览是虚幻吗？你的作品好象在证实参加西方展览是虚幻的，结果是不好的。

Y：关于参加西方的展览，并不是对每个中国艺术家来说都是虚幻的。有的艺术家在这个问题上处理和把握的非常好，我们是不容许怀疑中国艺术家的人格和品质的。这也是我们能坐在这里谈话的前提。

H：可能有人坚持把它拉到道德规范和游戏规则中去评判，或许我们自己没有弄清自身的知识和层次的处境的缘故。凭直觉这种说法是对这个作品的赞扬，

**Cover and interior spreads from *The Grey Cover Book*. 1997**

宋 冬

《哈气》
1996

将北京天安门广场的一块方砖用哈气哈成冰，用时约40分钟，气温（－9℃）。
在北京后海的冰面上哈气40分钟，气温（－8℃）。

宋 冬
《哈气》 1996·北京

---

────但但但　我仍要突然来一个一百八十度
大转弯
────我们必须拒绝演奏！！
阿多诺不是在天天告诫我们吗────
"自奥斯威辛之后　还有诗歌吗？"
我们也深深地知道人的尊严只有靠自己才能维护
但黑手党的尊严哪？国家机器的尊严哪？
还有我────大同大张胡说八道　屁话连篇
可怜巴巴的一点点酸叽叽的尊严哪？
────我们是谁？
诅咒说────我们是抽水马桶里的一条蛇
我说────我们是太阳星座上的一只蝎子

俄罗斯人卡巴柯夫我们想得透彻呵　当天空
都变成一大块铅板的时候　活着本身就是尊严！
爵士────爵士就是挺立在虚无中　用比首
闭着眼　伸缩性地向前刺探！　并假设
我们的周围都是一些彬彬有礼的家伙　正统
古典音乐的捍卫者！

爵士────是一种自伤　当革命的大调红色突然
遭遇到小资产阶级戴金丝眼镜的蓝色小调后　浑身的
鸡皮疙瘩以光的速度迅速癌变　并把仅有的
一点点真理的依赖也赛送在现在进行时态的────
自恋癖里！　刀生锈的刀　在切断股动脉后
我们才感觉到历史血脉的涌动

爵士────爵士在大雪封山的时候　它同样是
一段人类高海拔的恋情！　想象一下
美国白人天堂的黑人灵歌和沙皇时代俄罗斯土地的
悲歌被用中国制造的警棍胡搅一气后────仍残留在嘴
边还没来得及────被粗粗红色餐巾纸擦掉之前的
那种东西────是什么！？
────是腹泻吗？

爵士────我是你老爹！

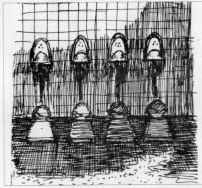

大同大张
《红旗一口气能抬多久》
《深毒症》
　　────作品草图

不合作方式
FUCK OFF

中国 · 2000 · CHINA

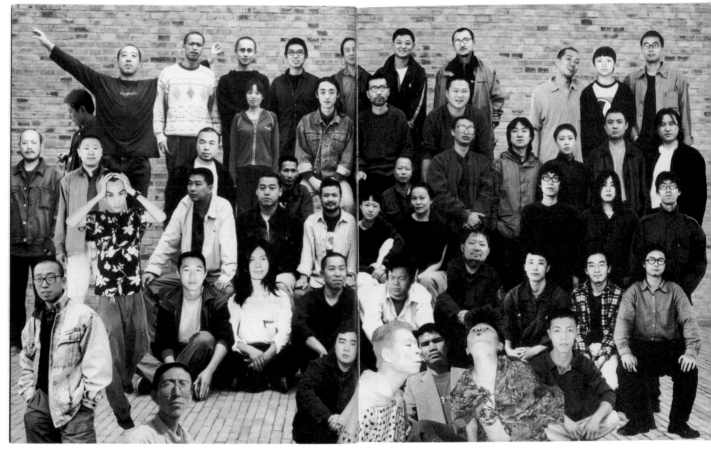

**Cover and interior spread from** *Fuck Off.* **2000**

SS: The books included sections for essays, news, projects submitted by artists, as well as translations of well-known texts.

AW: I thought that we should have a section for materials that were already iconic in the West and would have some value in China, but had never been published there.

SS: You started with the big guys, Duchamp and Warhol.

AW: Well, I started with what seemed important to me at the time.

SS: Later, *The White Cover Book* and *The Grey Cover Book* included Barbara Kruger and Jenny Holzer, right?

AW: Yeah, I like political art, with a strong statement. I think for China this work is fitting, easier to grasp. But we also have a [Joseph] Kosuth text, which helped to further introduce ideas of art that were conceptually driven, rather than just object-based. The book was intended to show readers what we cared about. I guess it's an old way, but it works, especially in a society that had very limited information. It's propaganda, anyhow.

SS: Is there something in particular about the book format that appeals to you?

AW: I've always been interested in books. My father [Ai Qing] was a poet, so as I was growing up, we always had beautiful books on the shelf. Books are easy to handle, there's an intimacy of scale to them. But in making them, you have total control and can decide everything so precisely —the structure, the balance, the information. In the end, if something is wrong, it's just because you didn't make it better.

SS: One of the significant legacies of your books was a shift in contemporary art practice in China—a noticeable emergence of work driven by the conceptual, experimental, and performative impulses advanced in them. In 2000 you organized with Feng Boyi the exhibition *Fuck Off*, which documented this trend and examined these new activities. The catalogue, which today serves as a kind of primer for Beijing's experimental underground art movement, took on a particular weight at the time as well.

AW: We knew the show was going to be closed [by the government], so that's why we printed the book before the show and announced an opening date that was a few days after the actual opening, so people could see it and the book could circulate before it was closed.

SS: So how long was the show open? Less than two weeks?

AW: Something like that. But once the catalogue was printed it was already successful.

SS: And the artists invited to participate?

AW: They were selected by me and Feng Boyi. We had discussions with each individual about what they were going to present, and, as you can see, what we included wasn't the art that was popular in the market at the time.

SS: How consciously was it a response to the selection of the official 2000 Shanghai Biennial?

AW: The organizers of the Biennial had no idea what we were up to. I heard later that [President] Jiang Zemin was very angry when he saw our catalogue and the challenging work that we were showing. It wasn't the version of contemporary art that the Shanghai Biennial wanted to show to the world. For me, this reaction really made the show and the book worth it.

Beijing, July 27, 2011

Note

1   The three books were coedited by Zeng Xiaojun, and Xu Bing also served as a coeditor on *The Black Cover Book*.

Christopher Wool. *Untitled.* 2008

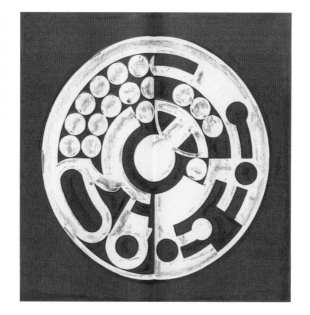

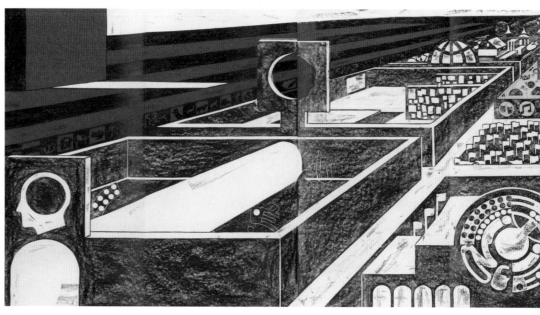

DEADBROOK AFTER THE BATTLE OF EZRA'S CHURCH.

Kara Walker. *Deadbrook After the Battle of Ezra's Church* from
*Harper's Pictorial History of the Civil War (Annotated)*, 2005

Matt Mullican. Selection from *88 Maps*. 2010

Jorge Pardo. *Eucalyptus.* 1997

Become to Thinker. 2002

Spockie. 2002

Yoshitomo Nara. *Night Walker.* 2002

Green Eyes. 2002

N.Y. (Self-Portrait). 2002

Damien Hirst. Mushroom from *The Last Supper*. 1999

# Mushroom™

## 30 tablets
## Pyrimethamine
## Tablets BP

## 25mg

PIE

# HirstDamien

Thomas Schütte. Four from *Low Tide Wandering*. 2001

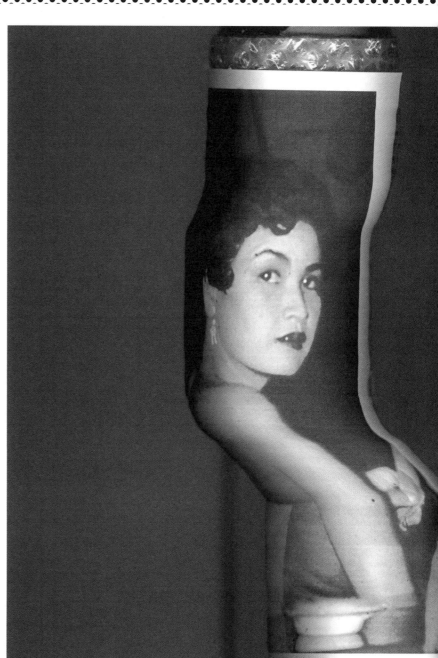

**Thomas Schütte. Three from *Low Tide Wandering*. 2001**

**Trisha Donnelly. *Satin Operator (11)* from *Satin Operator*. 2007**

Carroll Dunham. Three from *Female Portraits.* 2000

beneath
THE
ASPHALT

the
b e a c h

Daniel Joseph Martinez. One from *If Only God Had Invented Coca Cola,
Sooner! Or, The Death of My Pet Monkey.* 2004

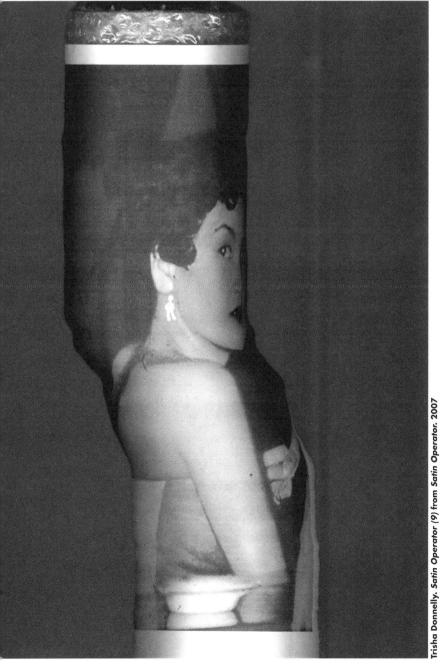

Trisha Donnelly. *Satin Operator (9)* from *Satin Operator.* 2007

Franz West. Double-sided poster from *Conventional Dichotomy*. 1990

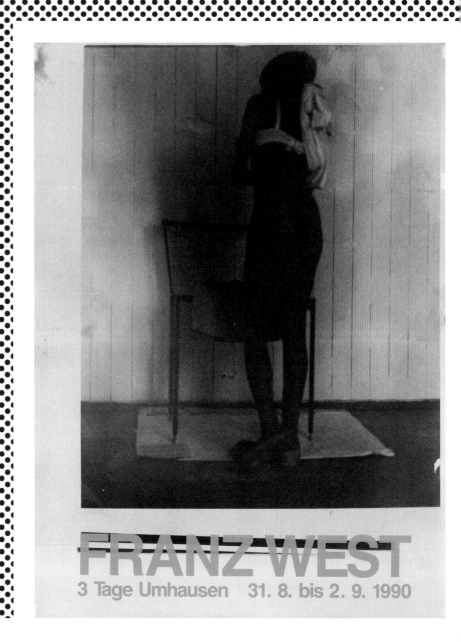

Museum in progress (1990– ), an art association based in Vienna, aims to establish a model for the twenty-first-century museum. Founded by professor and bookshop owner Kathrin Messner and the late artist Josef Ortner, this museum is not tied to any physical structure or location but rather provides a flexible platform for the presentation of work that is "media-specific, context-dependent, and temporary."[1] Established in the wake of the breakdown of so many geopolitical borders and institutional structures throughout Central and Eastern Europe, museum in progress chose to deconstruct the traditional role of the museum. Its exhibitions and projects are realized in the form of interventions within existing mass media forms, from magazines and newspapers to billboards, television, and the Internet. By infiltrating these mediums—all of which have a broad reach and established distribution channels—museum in progress creates opportunities for artists' voices to reach far beyond their typical social, cultural, and geographic communities.

The unique relationship that museum in progress has cultivated between the fine arts and the media has emerged from a series of important shifts in artistic practice throughout the twentieth century, particularly the advent of Conceptual art in the late 1960s and early '70s. During that time, artists such as Dan Graham, Joseph Kosuth, Adrian Piper, and others began making work for the pages of magazines and newspapers, motivated by a potential to distribute widely and cheaply and also to circumvent traditional museum and gallery systems.

By the 1980s artists like Felix Gonzalez-Torres and Jenny Holzer had expanded on this idea, creating projects for large-scale public advertising spaces like billboards and electronic signboards. Museum in progress takes up this legacy and pushes it further, developing formal partnerships with government, business, and the media, which agree to dedicate some portion of their space (spreads in a magazine, advertising spaces in a newspaper, or a billboard rental, for example) to artists' projects. Financing for the media buys and special projects comes from a group of private companies, which, like the editorial staff of the magazines or newspapers, do not enjoy any influence over the content of these interventions.

Museum in progress sees itself as functioning "more like a power station, a producer of new energy"—a quote drawn from German art historian Alexander Dorner's (1893–1957) own prescient description of the future of museums.[2] Indeed, over the past two decades, museum in progress has served as a generative hub, working with more than four hundred international artists, including Graham and Gonzalez-Torres, in the production of numerous individual projects and nearly sixty exhibitions. Organized by a rotating team of curators (which has included Hans-Ulrich Obrist, Robert Fleck, and Stella Rollig, among many others), these nontraditional exhibitions are based around loose themes upon which artists are invited to develop relevant projects for newspapers, magazines, and other media, sometimes over multiple years. These presentations, with evocative titles like *Global Positions* (1999–2002) and *Travelling Eye* (1995–96), reveal themselves over space and time rather than as unified wholes within designated physical sites.

The first of these, *The Message as Medium* (1990–91), introduced one of the central tenets of museum in progress—demonstrating the viability of print media as a site for art. Organized by Helmut Draxler and supported in part by Austrian Airlines, the exhibition took form in the pages of Vienna newspaper *Der Standard* and Austrian financial magazine *Cash Flow*, two publications that have remained among museum in progress's foremost venues. For his contribution, Heimo Zobernig laid bare the organizational structure of the project itself by keeping his pages completely empty except for a text along the edge with a dedication to museum in progress and the Austrian Airlines insignia. Werner Büttner, in *Cash Flow*, chose to respond to current events and to the context of the financial magazine. Over a double-page spread, he presented enlarged images of two Austrian schillings, one a standard coin and then its "flip side" (with a cutout

**Heimo Zobernig.** Page project for the exhibition *The Message as Medium* in the newspaper *Der Standard*. 1990

**Werner Büttner.** Page project for the exhibition *The Message as Medium* in the magazine *Cash Flow*. 1991

**museum in progress**

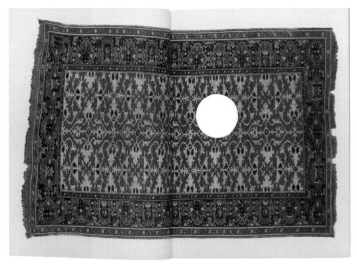

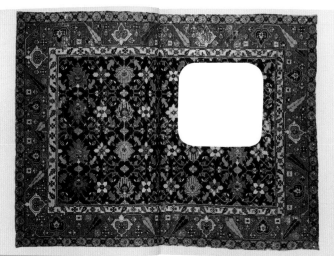

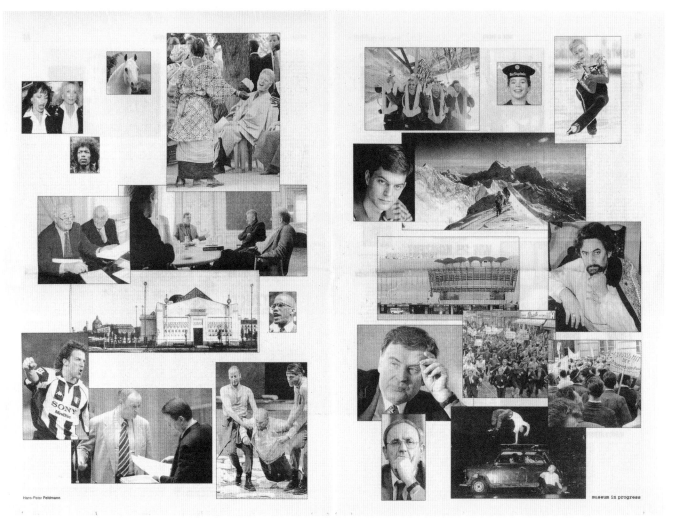

**Andreas Slominski.** *Flying Carpets,* selection from page project
for the exhibition *museum in progress on Board* in the magazine
*Skylines.* 1994

**Hans-Peter Feldmann.** Page project for the exhibition *Interventions in
progress* in the newspaper *Der Standard.* 1998

**Felix Gonzalez-Torres. Selection from page project for the exhibition** *Travelling Eye* **in the magazine** *Profil*. **1996**

**Aleksandar Battista Ilić (in collaboration with Tomislav Gotovac and Ivana Keser).** *Weekend Art*, **selection from page project for the exhibition** *Interventions in progress* **in the newspaper** *Der Standard*. **1999**

museum in progress

**Claude Closky.** *Beautiful Face,* **page project for the exhibition** *Global Positions* **in the newspaper** *Der Standard.* **2000**

**Roberto Cuoghi. Page project for the exhibition** *Global Positions* **in the newspaper** *Der Standard.* **1999**

IRWIN. *NSK Guard Prague / NSK Guard Rome / NSK Guard Graz,*
page project for the exhibition *Global Positions* in the newspaper
*Der Standard.* 2001

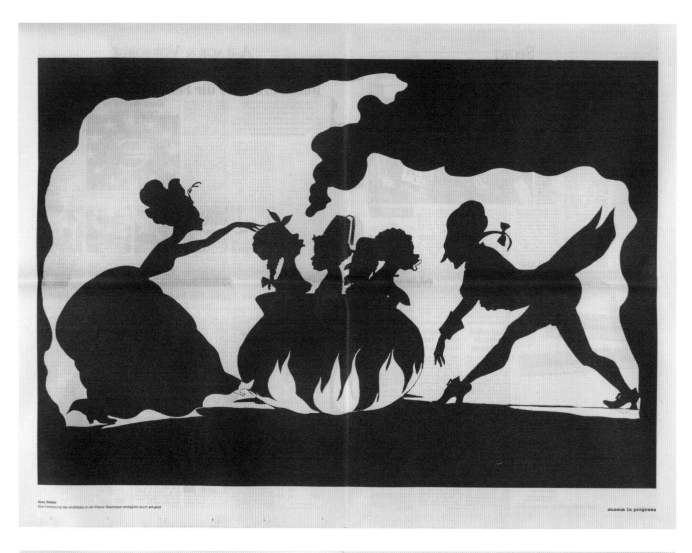

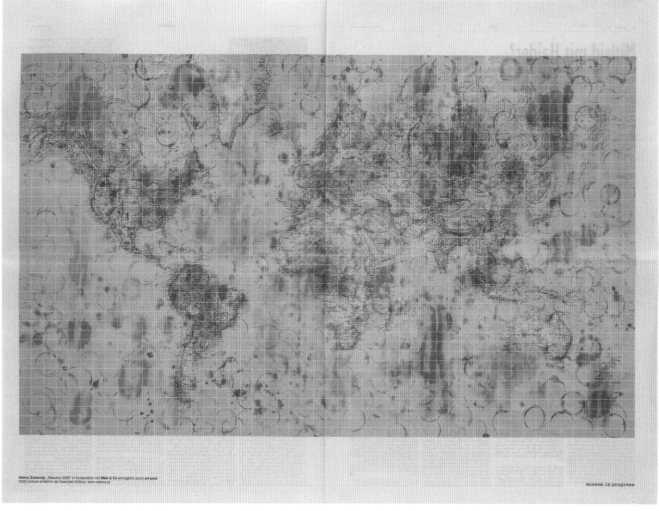

**Kara Walker. Page project for the exhibition *Safety Curtain* in the newspaper *Der Standard*. 2000–01**

**Heimo Zobernig. Page project for the exhibition *Selection 2000* in the newspaper *Der Standard*. 1999**

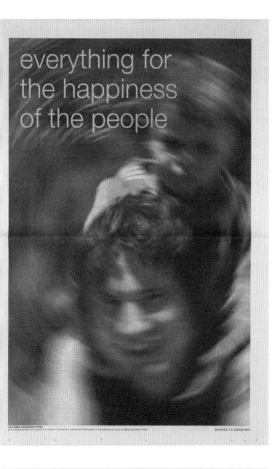

everything for
the happiness
of the people

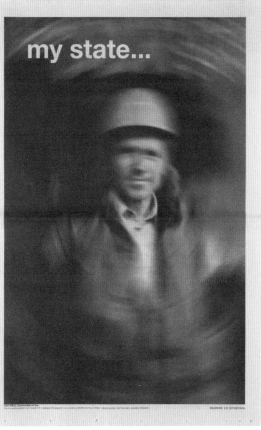

my state...

**Rirkrit Tiravanija.** Top to bottom: *Demonstration n°1* (2003); *Untitled (a moment of life concretely and deliberately constructed by the collective organization of a unitary ambience and a game of events)* (2004); *Demonstration n°2 (freedom cannot be simulated)* (2003–04). Page projects for the exhibition *Speed and Slowness* in the newspaper *Il Giornale di San Gimignano*

**Liam Gillick.** *Construction of One,* page project in the newspaper *Der Standard.* 2004–05

**Hans-Peter Feldmann.** *Without Words*, page project in the magazine
*Profil.* 2000

at the bottom suggesting buttocks). This reimagined currency referred to a recent scandal, in which the Austrian arms manufacturer Noricum was privatized for a single schilling after being charged with profiting from illegal arms sales during the Iran–Iraq War.[3]

In subsequent projects with artists ranging from Liam Gillick and Rirkrit Tiravanija to Kara Walker and Aleksandar Battista Ilić, museum in progress has offered spaces in a variety of publications, including German newspaper *Süddeutsche Zeitung*, Tuscan bimonthly *Il Giornale di San Gimignano*, and Austrian Airlines magazine *Skylines*. While some projects have utilized double-page spreads to create an exhibition space separate from the rest of the publication's content, others have worked within the standard page content. For the exhibition *Speed and Slowness* (2003–04), for example, Tiravanija had bold imagery printed directly over articles, partially obscuring the text below.[4]

One of museum in progress's most intricate interventions was a major project with Hans-Peter Feldmann in 2000. Feldmann—whose work from the late 1960s and the 1970s often involved small, handmade books with found reproductions of a chosen motif presented together without captions—proposed a related project for Austrian news magazine *Profil*: an entire issue published with all of the text omitted. The resulting work, *Without Words*, represents a rare (and generous) collaboration between an artist and the media, who worked together over several months, ultimately releasing one thousand copies of Feldmann's altered issue concurrently with the magazine's standard circulation.[5]

—Kim Conaty

Notes

1 "Die Praxis von museum in progress ist medienspezifisch, kontextabhängug und temporär," in Kathrin Messner and Josef Ortner, eds., foreword to *museum in progress*, vol. 1.1 (Vienna: museum in progress, 2000), n.p.
2 Alexander Dorner, *The Way Beyond "Art"*, 2nd ed. (New York: New York University Press, 1958), 147. Originally published in German, as *Überwindung der "Kunst"* (Hannover: Fackelträger Verlag, 1947). Cited by *museum in progress*, in the original German, in Messner and Ortner, eds., dedication page to *museum in progress*, vol. 1.1.
3 Helmut Draxler, "Artikulatorische Praxis," in Messner and Ortner, eds., *museum in progress*, vol. 1.1, n.p.
4 These pages were then published as inserts in the paper, so that readers had the option to remove them to read the full articles.
5 *Profil*, which had served as the sole venue for an earlier exhibition, *Travelling Eye*, was the major supporter of Feldmann's project, having suggested after the success of *Travelling Eye* that museum in progress propose an even more substantial project for its pages. Sarah Valdez, "No Museum at All: The Willfully Parasitic Museum in Progress," *Art on Paper* 13, no. 3 (January–February 2009): 62.

Thomas Schütte. Five from *Low Tide Wandering.* 2001

Liam Gillick. *Friday from Guide.* 2004

freitag
freitag
freitag
freitag
freitag

Daniel Joseph Martinez. One from *If Only God Had Invented Coca Cola,
Sooner! Or, The Death of My Pet Monkey.* 2004

VERY ETHEREALLY
an
INSTANT SURGES
of
WithinOneSelfNess
something
LIKE A PROPENSION
to
fashion one's self
ONE'S OWN BODY

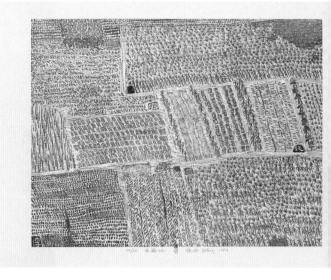

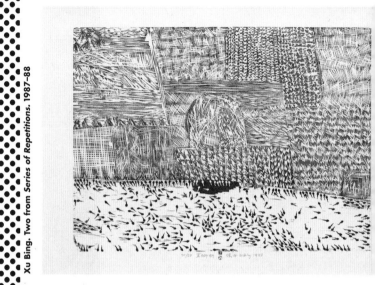

Xu Bing. *Two from Series of Repetitions.* 1987–88

Thomas Schütte. *Seven from Low Tide Wandering.* 2001

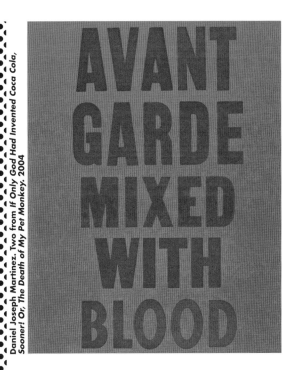

AVANT GARDE MIXED WITH BLOOD

this funeral is for the WRONG CORPSE

Daniel Joseph Martinez. Two from *If Only God Had Invented Coca Cola, Sooner! Or, The Death of My Pet Monkey*. 2004

Untitled 2. 1997

Untitled 1. 1997

Guillermo Kuitca. Double Theater. 1997

Fourth Wall. 1997

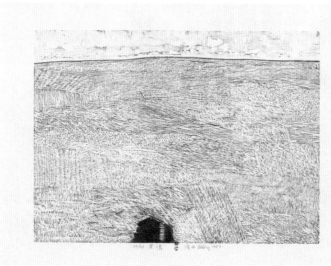

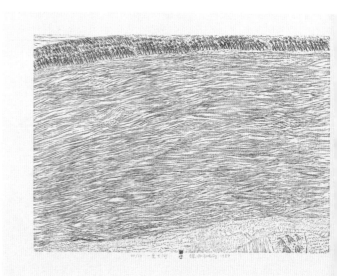

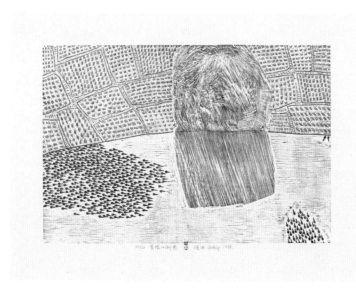

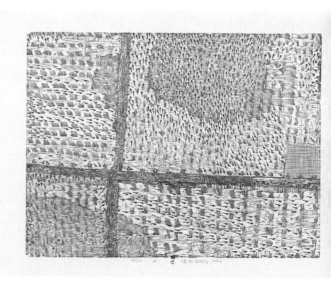

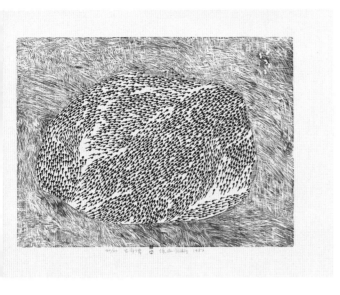

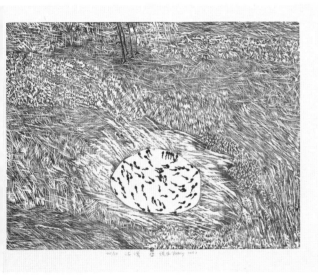

Xu Bing. Eight from *Series of Repetitions*. 1987–88

Daniel Joseph Martinez. One from *If Only God Had Invented Coca Cola, Sooner! Or, The Death of My Pet Monkey.* 2004

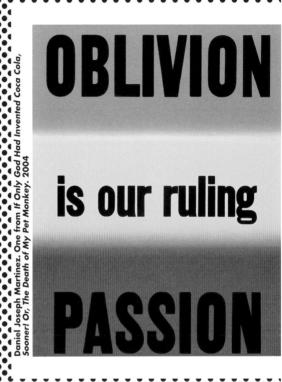

OBLIVION

is our ruling

PASSION

Thomas Schütte. Five from *Low Tide Wandering.* 2001

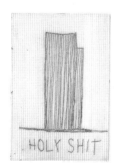

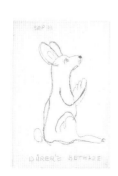

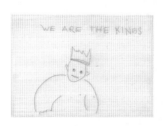

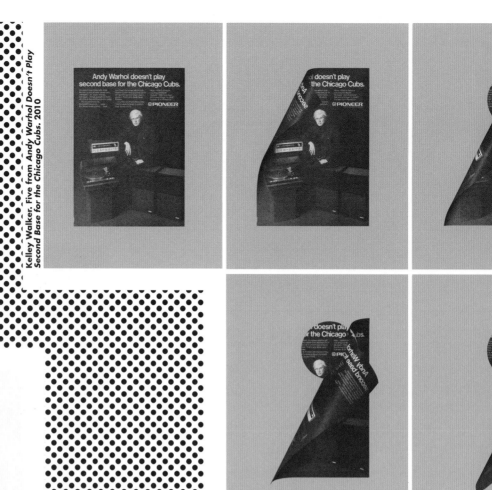

Kelley Walker, *Five from Andy Warhol Doesn't Play Second Base for the Chicago Cubs*, 2010

Thomas Schütte, *Three from Low Tide Wandering*, 2001

Kara Walker, *Confederate Prisoners Being Conducted from Jonesborough to Atlanta from Harper's Pictorial History of the Civil War (Annotated)*, 2005

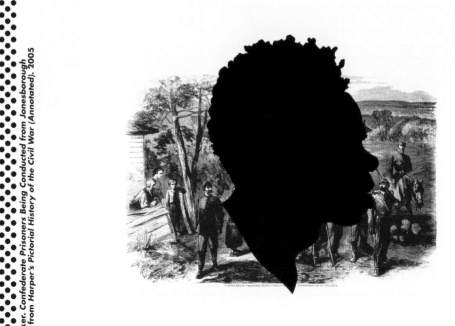

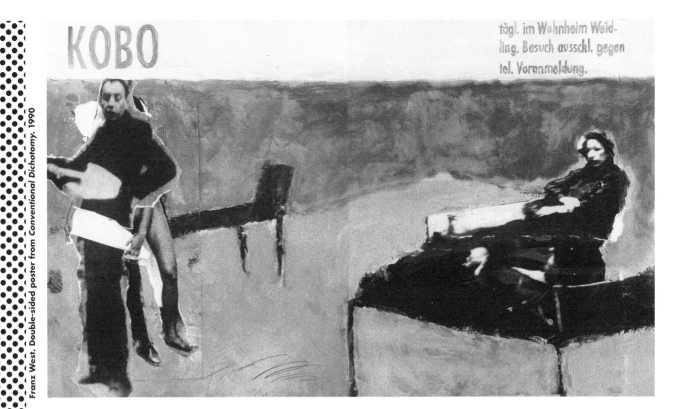

KOBO

tägl. im Wohnheim Weidling. Besuch ausschl. gegen tel. Voranmeldung.

Franz West. Double-sided poster from *Conventional Dichotomy*. 1990

# PROBES
## your head like a

## prolonged
## accusation

Daniel Joseph Martinez. One from *If Only God Had Invented Coca Cola, Sooner! Or, The Death of My Pet Monkey*. 2004

# FRANZ WEST
## BILDHAUERFOTOGRAFIE

### 13. 7.–29. 8. WIENER SECESSION
### FOTOGRAFIEN VON GÜNTHER
### FÖRG FOTOGRAFIERT VON
### OCTAVIAN TRAUTTMANSDORFF

Pae White. *Green Sheep from Untitled.* 1999

Thomas Schütte. Three from *Low Tide Wandering.* 2001

Pae White. *Unknown Rocks from Untitled.* 1999

# RIRKRIT TIRAVANIJA

## UNTITLED

## 2008–2011

## (THE MAP OF

## THE LAND OF

## FEELING)

Since the early 1990s, Rirkrit Tiravanija (Thai, born Argentina 1961) has been challenging traditional models of art-making, developing a practice based in participation, interaction, and collaboration. In *Untitled (Free)*, a paradigmatic work from 1992, the artist turned a gallery setting into a social space, serving Thai vegetable curry rather than exhibiting objects. Around the same time, he began to produce editions, publishing the first of many multiples in relation to his ephemeral or experience-based work (tins of curry paste or a backpack equipped for an expedition, for example). Tiravanija's hybrid practice, which extends to a sustainable-farm-as-artist-project in Thailand (The Land, founded 1998), has been tremendously influential in redefining approaches to art-making.

In 2011 Tiravanija completed what he considers to be his first traditional print project, *Untitled 2008–2011 (the map of the land of feeling)*, three scrolls stretching more than eighty feet altogether. The relentlessly peripatetic artist's expansive passport —reproduced page by page, end to end—provides both a central organizing structure and an autobiographical narrative, the story of the artist's life through the places he has visited. For Tiravanija, the laborious production process required for prints of this scale and complexity, involving the collaboration of forty assistants over a span of four years, was an integral part of the final work.

**Christophe Cherix:** You've published a large number of multiples over the years. What made you start?

**Rirkrit Tiravanija:** I was always quite influenced by Fluxus, but, in a way, a key point in a lot of things that I do is to try not to fall into the Fluxus trap. You make objects to play with, interact with, or have a relationship with, and then they end up in a glass case. Editions or multiples function for me as a kind of drawing or map to the ideas.

**CC:** How do your various editions relate to one another?

**RT:** The earlier works had a lot to do with movement. They're also about the idea of being kind of unstable in

that moving. It's a combination of being in places, but being there temporarily. After school, when I was in the U.S., it was very difficult for me to travel. I was always nervous about being sent back.

**CC:** Could you talk about your ongoing *Atlas* editions, which you started in 1995? They seem to capture not only a process but actual moments in your work.

**RT:** The *Atlases* are meant to map out different ideas in each work I have done, but they are not linear maps; they are filled with things that I thought of at that time, but with afterthoughts as well. I always try to keep my work very open-ended in terms of process because I want it to resist finality. But of course, this can be perceived as a failure.

**CC:** Is that a bad thing?

**RT:** It's about perspective. From a Buddhist perspective, it doesn't mean anything. When I talk about ephemerality, it's more about a process. It's not about being more or less, but about being more open than closed. When I did *Untitled 2008–2011 (the map of the land of feeling)*, it all seemed so final. The whole project took a lot longer because I was trying to find a way not to be so defined by a process or the actual work itself. Everyone who was involved with its fabrication was always aware that I could show up and turn it around another way.

**CC:** How do you feel about the fact that the work—a set of three scrolls— is very much an object in the end?

**RT:** I have never seen the scrolls all opened up and hung on the wall. I feel like it's still unfolding, in a way. For me it wasn't about the total thing, but parts, even if in the end it will be a total thing.

**CC:** The work is very autobiographical.

**RT:** Yeah, more personalized in a way. Everything for me is about the process, the experience, and the memory. And the memory is actually where everything changes again.

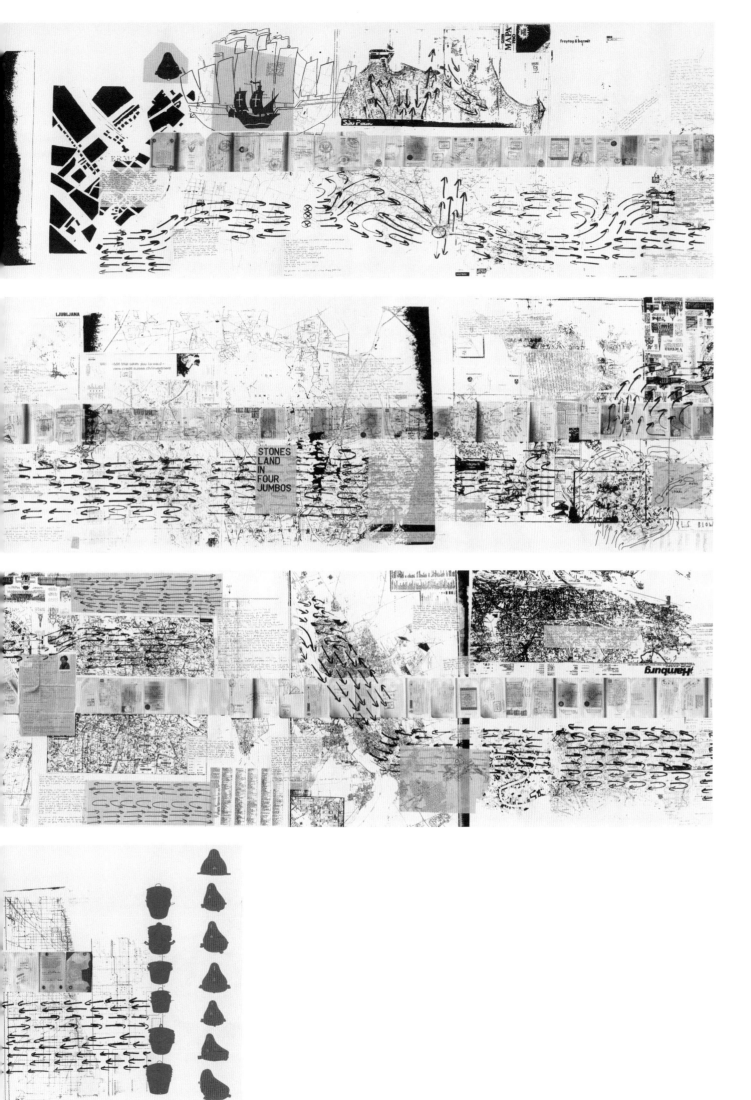

*Untitled 2008–2011 (the map of the land of feeling) I.* 2008–11
**Rirkrit Tiravanija**

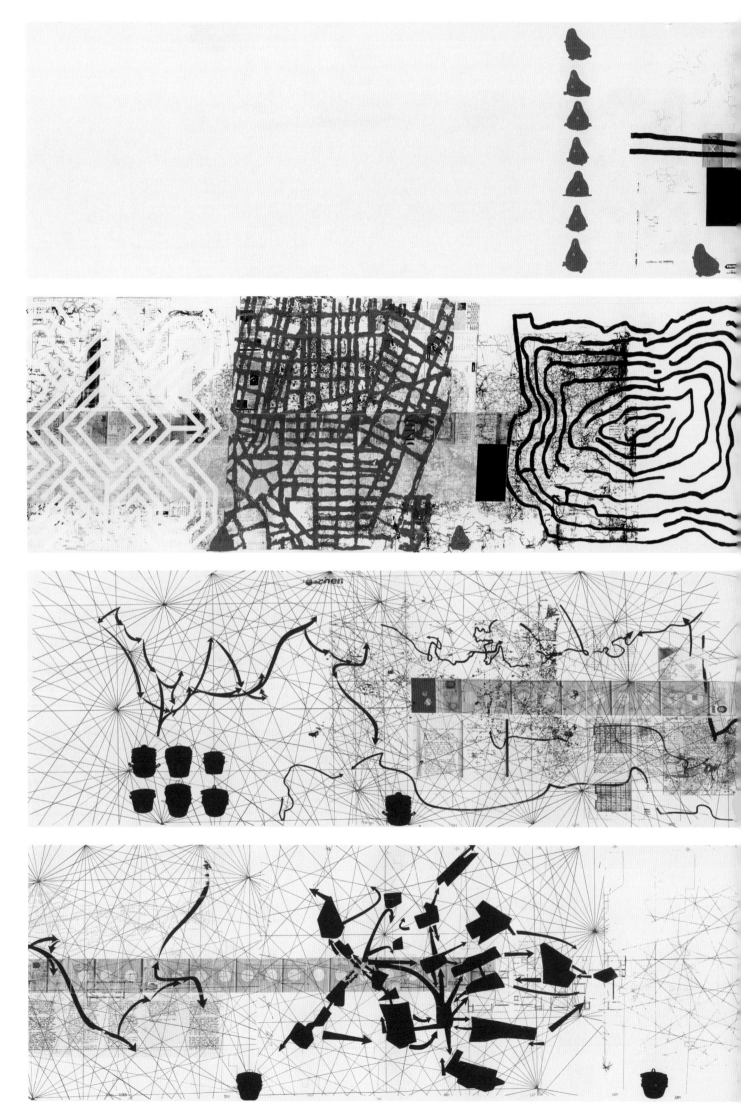

*Untitled 2008–2011 (the map of the land of feeling) II–III.* 2008–11

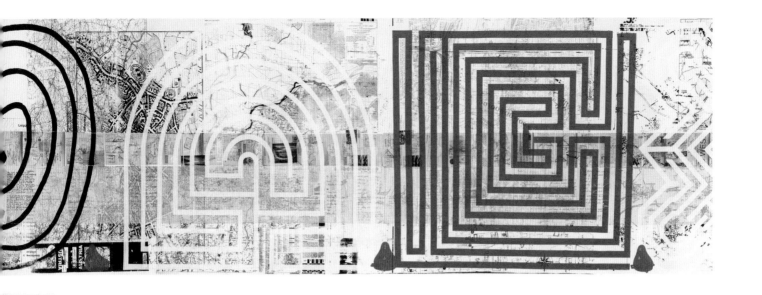

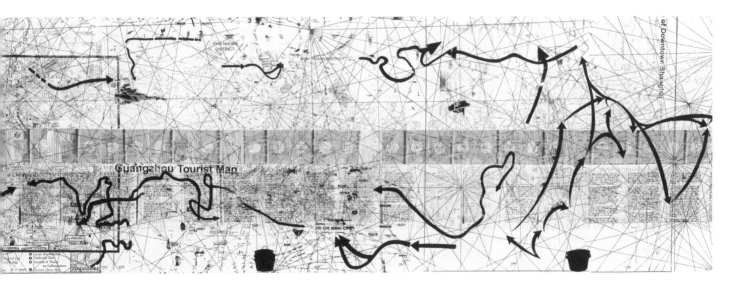

**Rirkrit Tiravanija**

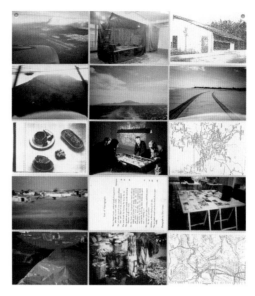
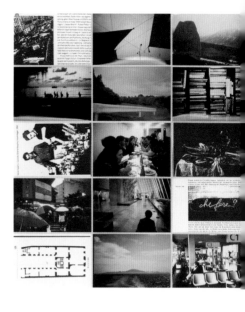
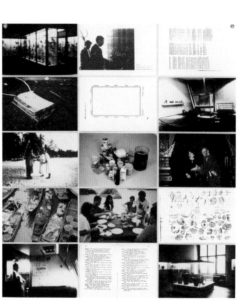
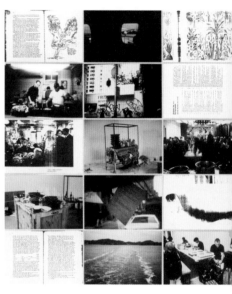
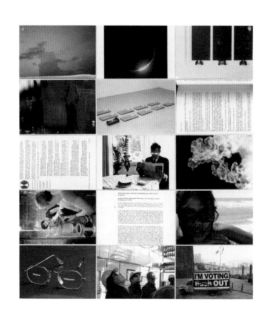
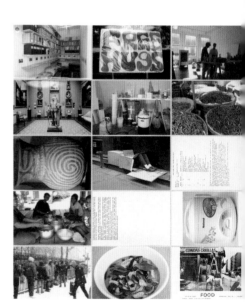

*Atlas I* (folded) and *Atlas I–VI* (unfolded). 1995–2007

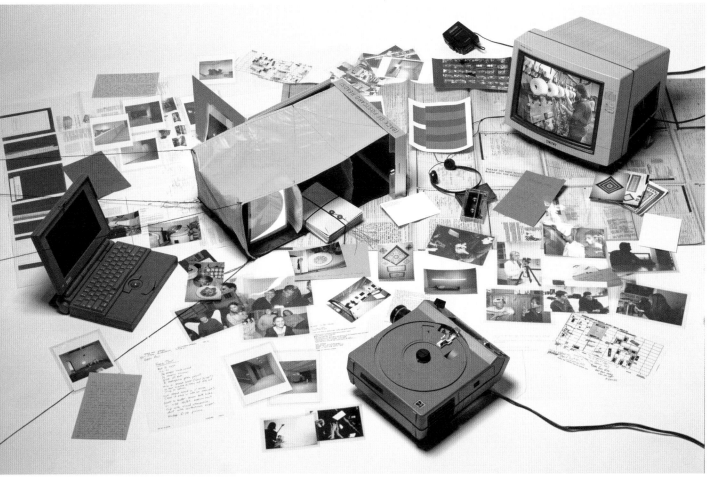

**CATALOGUE (BACK OF POSTCARD READS) MEMORIES. 1997**
**Rirkrit Tiravanija**

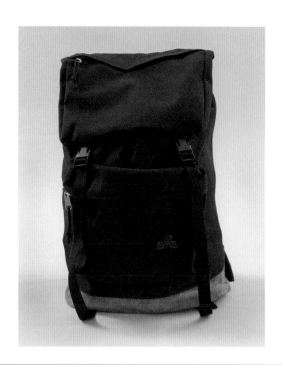

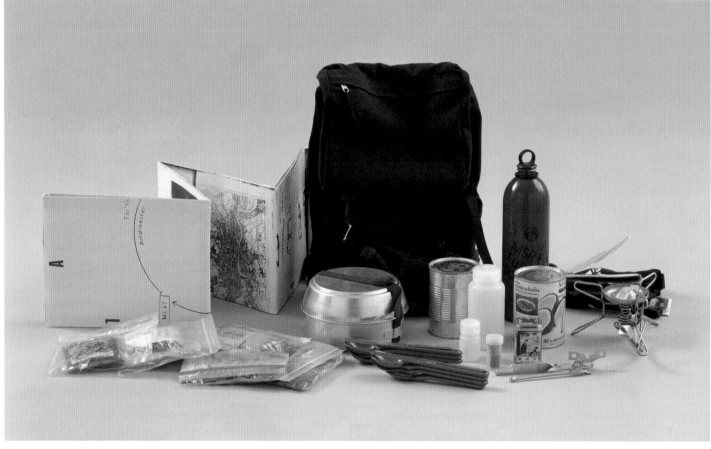

*Untitled (rucksack installation).* 1993

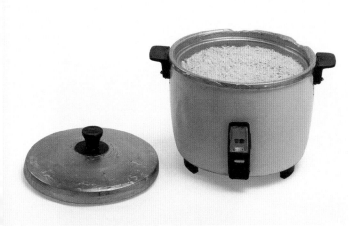

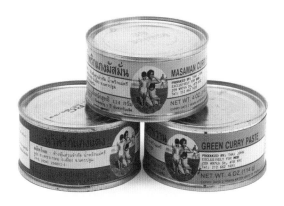

*Untitled (lunch box).* 1996
*Untitled, 1999 (the power of cheese).* 1999
*Young man, if my wife makes it . . . .* 2000

**Rirkrit Tiravanija**

*Untitled, 1992 (Red, Yellow, Green Curry).* 1992

*Untitled, 1999 (flags from the 1. royal thai pavilion, 48. Esposizione
Internazionale d'Arte, La Biennale di Venezia). 1999*

**CC:** The scrolls allude to a number of historical figures, such as Marcel Duchamp and Marcel Broodthaers.

**RT:** When I teach and talk to younger people, I always find that there's a need to look a bit deeper back. For me, those figures are like registers on a map, like kilometer markers.

**CC:** Even if your maps are full of mazes.

**RT:** It's a way for me to introduce the idea of a trap on one side and a kind of disorder on the other. The maze shifts from a very systematic structure to a kind of opened, more organic one. It is about the idea of passage, to move toward something less structured.

**CC:** You have also mentioned Robert Rauschenberg as an influence.

**RT:** For the layering of the print and the map, I was very much thinking about Rauschenberg. The other reference to his work is the fact that he went to China, and came back with a project for a massive print.

**CC:** *Chinese Summerhall* [1982–83], the one-hundred-foot-long photograph!

**RT:** In a way, it can be seen as a Chinese landscape painting, a scroll, which just keeps going. In a funny way, I think that his idea of putting too much on it was also a way to avoid putting a focus on anything. There is a randomness and an awareness of letting things go, both of which go back to John Cage and are very important to me.

**CC:** Indeed, some of the strategies that you have used had already been explored in various ways by artists in the past.

**RT:** I've always said that an artist has to deal with the readymade. My way out was to take the readymade and reuse it. And in this use, you find meaning. There's got to be some kind of spiritual structure within this idea. It's actually a kind of belief in change. In many ways, it's also about language, because when I first started to make art, I really didn't know the language and what it could do.

**CC:** It's like an acquired grammar.

**RT:** Yeah, it becomes that. A grammar you acquire through experience, through living. And through living and using it, things change again. I'm always interested in that change, which might be related to the Cagean idea of letting things go, which is very Buddhist too. It means that you let other people have input into, let's say, the structure, the place, the thing that you set out. In a way, for me, my experience is always about learning.

New York, July 19, 2011

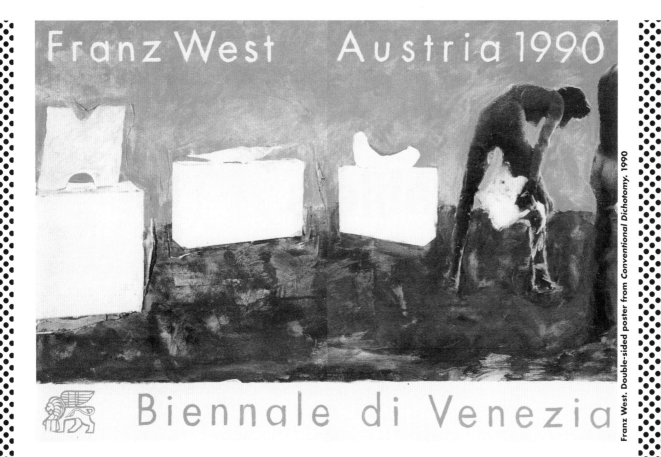

Franz West · Galeria Pieroni
Roma, Via Panisperna 203
28. 10. – 8. 12. 1990

# Salad™ tablets
## Lamivudine

Each coated tablet contains
**lamivudine 150mg**

## 60 tablets

*HirstDamien*

Damien Hirst. *Salad* from *The Last Supper.* 1999

Thomas Nozkowski. One from *Untitled*. 2006

Thomas Schütte. Six from *Low Tide Wandering*. 2001

Kara Walker. *Cotton Hoards in Southern Swamp from Harper's
Pictorial History of the Civil War (Annotated)*. 2005

*Banks's Army Leaving Simmsport from Harper's Pictorial
History of the Civil War (Annotated)*. 2005

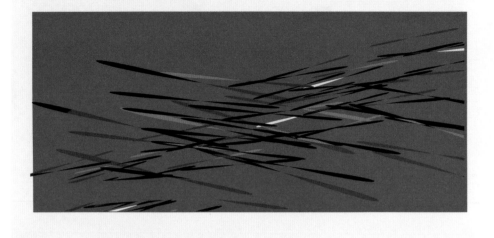

Pae White. *Night Fish from Untitled.* 1999

What's the Plan, Uzbekistan?

I'm your man, Azerbaijan!

Slavs and Tatars. One from *Nations.* 2007

Daniel Joseph Martinez. One from *If Only God Had Invented Coca Cola, Sooner! Or, The Death of My Pet Monkey.* 2004

the world is hollow

and i have touched the sky

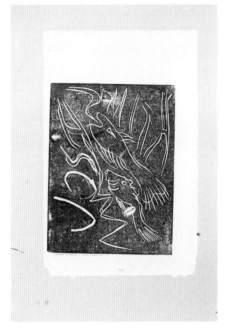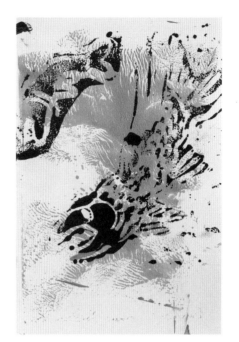
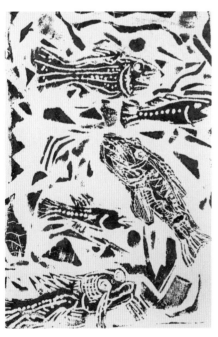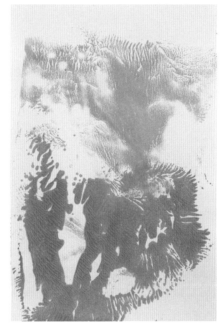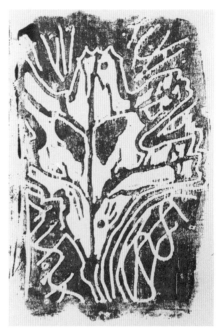
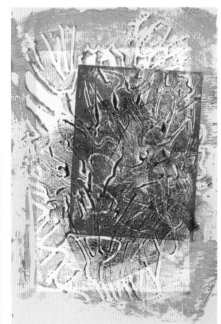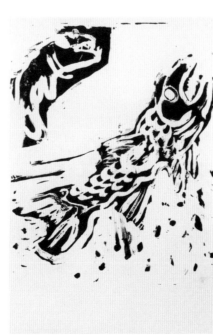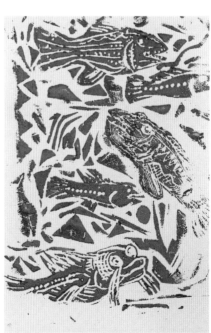

## Damien & Hirst

# Beans™

## Chips™

### 400 micrograms

### 112 Chips

SEQUESTERED BOWER - NUMEROUS COMPARTMENTS. LOOK OUTS:

*bird's-eye view of old chateau inhabited by storks*

COZY NOOKS
(FEATHER-LINED)

REASONABLE RATES

aquarium in base of tree with rare deep forest specimens

garden relic of Karl Maria Von Weber

CHALET VIEW
OF VALLEY

*chalet-bis-and approaches*

PINE* SCENTED LOUNGE

MUSICAL WATERFALLS
within stone's throw.

Easy walking distance to enchanted lake.

salamander crannies

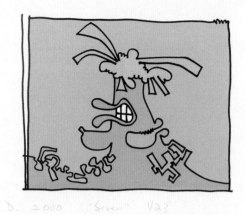

C.D. 2000 "Seven" 1/23

C.D. 2000 "Thirteen" 1/23

### Damien     5036-23

# Steak and Kidney*
Ethambutol Hydrochloride

## Tablets
## 400mg

## 100 Tablets     PIE

# ELLEN GALLAGHER

# DELUXE

Ellen Gallagher (American, born 1965), whose diverse body of work has mined topics from cultural identity and Afro-Futurism to American literature and history, challenged the traditional notion of what a print could be with her tour de force, *DeLuxe* (2004–05). Consisting of sixty prints, shown in a grid five images high and twelve wide, the project combines a veritable riot of mediums that span printmaking's history. Gallagher experimented with everything from the favored Victorian technique of photogravure to recent developments in digital printing and laser-cutting. She also employed unorthodox tools, including tattoo machines and scalpels, and incorporated elements such as cut velvet, gold leaf, slicks of greasy pomade, plastic ice cubes, googly eyeballs, and crystals.

On the heels of her 2002 exhibition *Preserve* at The Drawing Center in New York, David Lasry invited Gallagher to collaborate with his workshop, Two Palms Press. In its first decade, Two Palms had developed a reputation for innovation and experimentation, producing unusually sculptural, multi-dimensional prints on its massive hydraulic press and introducing digital laser-cutters for woodblocks and polymer plates. At the same time, they maintained close ties to printmaking's traditions, through specialists like photogravure master Craig Zammiello, who worked closely with Gallagher to help her achieve her vision. Given its scope and ambition, *DeLuxe* demanded new strategies from artist and print workshop alike, which Two Palms provided through its whole-hearted embrace of technologies and approaches both old and new.

The appeal of printmaking to Gallagher is multifold. She has spoken about the unique rhythm of working on *DeLuxe*, describing the call-and-response that is inherently built into the work-shop process. Ideas of distribution also underlie her interest: "I get really excited by this idea that printed material can be so widely distributed. The history of the black press is radically connected to ideas of distribution and there is a great American history of manifestos. I was always jealous of writers because their story could be in so many different hands . . . There is a possibility for distribution and freedom."[1]

In fact, it was Gallagher's personal collection of vintage lifestyle magazines, particularly photo journals targeted toward African-American audiences like *Our World* and *Ebony*, that became the base layer for *DeLuxe*. Gallagher cut these magazines apart and then collaged them back together, reinventing their pages as her own layouts. These collages were then translated into photogravure, collapsing the three-dimensional maquettes back into two-dimensional surfaces. At this point, Gallagher realized the final images "could not remain flat if I was going to construct them into a larger grid. I was going to need another layer of intervention. I was going to have to elongate that process between the plate and the printed image, elongate my building."[2] So she built on top of the photogravures, further scratching into plates, painting in her signature eyeballs or adding Plasticine cut-outs that resemble superhero masks, helmets, and wigs. This process of compressing and expanding both form and content is a central leitmotif in the project.

Beyond its technical complexity, *DeLuxe* offers a dense, multivalent constellation of the ideas that permeate Gallagher's work. Functioning as a kind of exploded book, it offers a cast of characters, strands of narratives that are both tangential and inter-secting, and a weaving together of historical and contemporary concerns. For the individual plates, Gallagher often focuses on the commerce of the "new Negro" period, using advertisements that offered consumers the chance to project a new or altered identity: a better career through nursing school, a slimmer figure through girdles, an improved complexion through acne products and skin-lightening cream, and, most frequently, a recast appearance through a vast array of wigs. Gallagher modified the advertisements—editing them and changing their scale—before she began, so that even her starting point was alienated from the original. "Just like the disembodied eyes and lips refer to performance, to bodies you cannot see, floating hostage in the electric black of the minstrel stage, the wigs are fugitives, conscripts from another time and place, liberated from the 'race' magazines of the past. I have

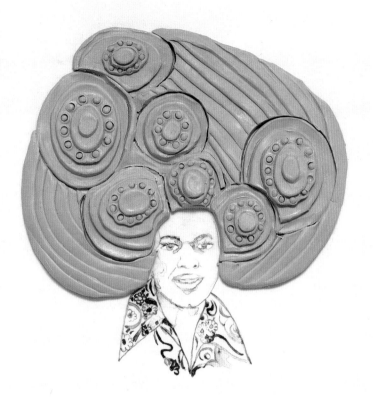

*The riots in Harlem last August left scenes like this after many violent nights. Police personnel, such as Captain Lloyd Sealy, were found to be heroes in helping maintain law and order in the strife-torn Harlem 28th Precinct.*

# THE MAN WHO KEPT HARLEM COOL

*The Man Who Kept Harlem Cool* from *DeLuxe*. 2004–05
Ellen Gallagher

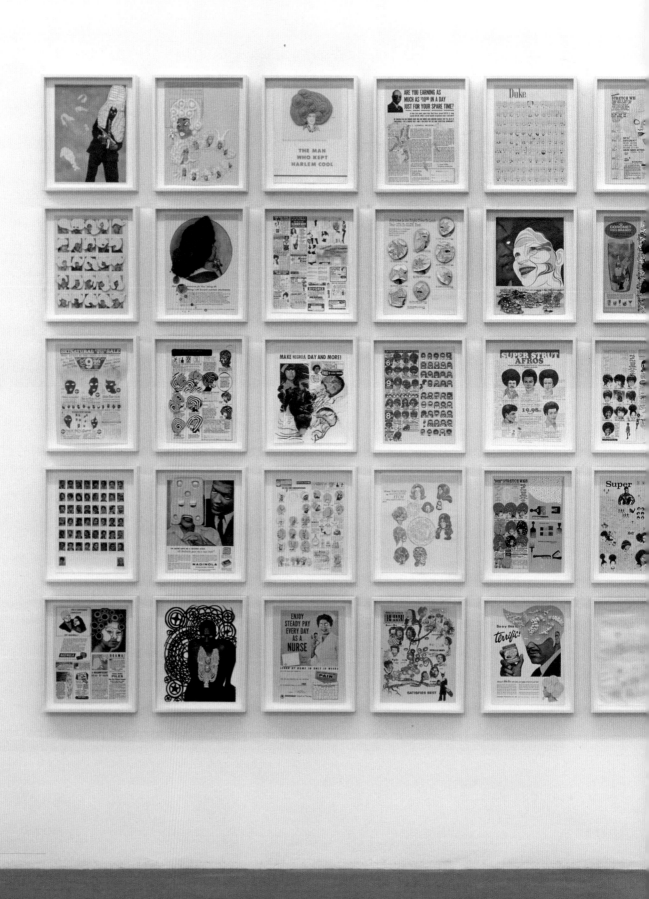

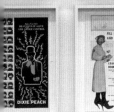
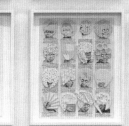

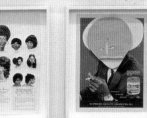
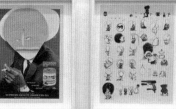

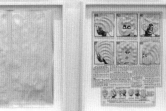
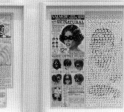
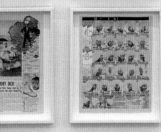

**Ellen Gallagher**

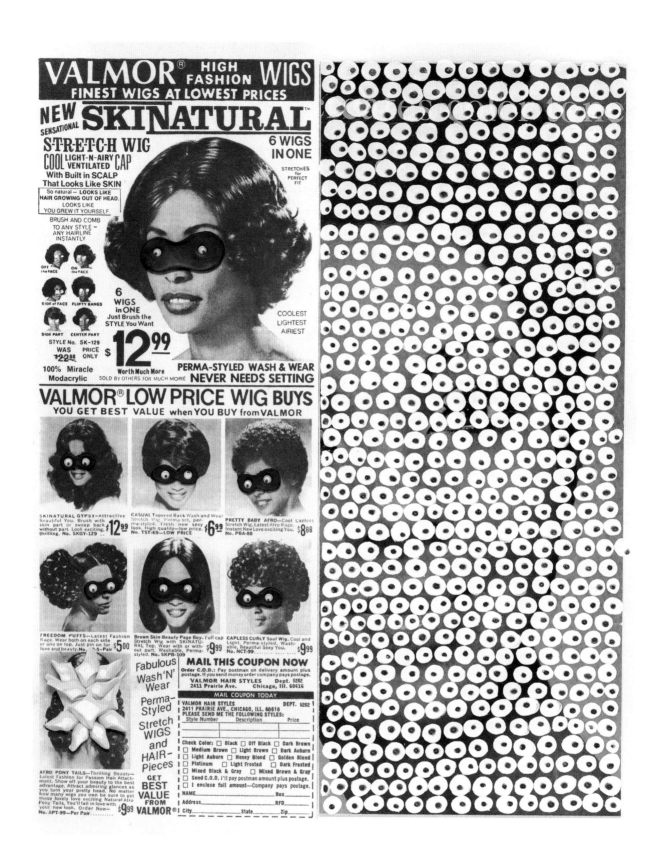

# PRINTIN'

**An exhibition organized by Ellen Gallagher and Sarah Suzuki**

**Ellen Gallagher's chart for *Printin'*, 2011**

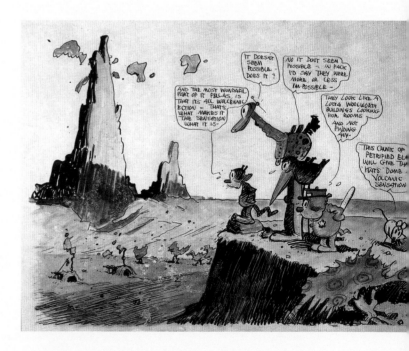

Experiens Sillemans (Dutch, 1613–1653). *Ships with Salt Collectors on the Shore.* c. 1650. Oil on panel, 11 3/8 x 15 3/4" (29 x 40 cm). Het Scheepvaartmuseum, The National Maritime Museum, Amsterdam

James Van Der Zee (American, 1886–1983). *Baptism Celebration to Maria Warma Mercado.* 1927. Gelatin silver print, 7 5/8 x 9 1/2" (19.4 x 24.1 cm). The Museum of Modern Art, New York. Acquired through the generosity of Harriette and Noel Levine

George Herriman (American, 1880–1944). *Krazy Kat and friends discussing Agathelan in Monument Valley.* c. 1925. Ink and watercolor on paper, 9 x 12" (22.9 x 30.5 cm). Collection of Arthur Wood, Jr.

Sarah Lucas (British, born 1962). *Smoking.* 1998. Black-and-white photograph, 6' 5 3/16" x 49 5/8" (196 x 126 cm). Edition: 6. Courtesy Sadie Coles HQ, London

David Hammons (American, born 1943). *Untitled (Kool-Aid drawing).* 2003. Mixed mediums on paper, terry cloth, and silk, 40 1/2 x 25 3/4" (102.9 x 65.4 cm). Collection of Alice Kosmin, New York

Vija Celmins (American, born Latvia 1938). *Ocean Surface Woodcut 1992.* 1992. Woodcut, 19 5/16 x 15 7/16" (49 x 39.2 cm). Publisher and printer: The Grenfell Press, New York. Edition: 50. The Museum of Modern Art, New York. Johanna and Leslie J. Garfield Fund

Edgar Cleijne (Dutch, born 1963). *Crater.* 2010. Photogravure, 29 x 36 1/4" (73.7 x 92.1 cm). Publisher and printer: Two Palms Press, New York. Edition: 25. Collection the artist

```
loopy    groggy    boozy

tight    steamed up    bent

folded    flooey
```

```
stewed
boiled
potted
corned
pickled
preserved
canned
fried to the hat
```

**Martha Rosler (American, born 1943). Details from *The Bowery in two inadequate descriptive systems*. 1974–75. Series of forty-five gelatin silver prints on twenty-four backing boards, each 10 x 22" (25.4 x 55.9 cm). Collection the artist**

transformed them, here on the pages that once held them captive."[3]

Specific historical figures are also conscripted into Gallagher's pages, from well-known personalities like vaudeville performer Bert Williams to Lloyd Sealy, the first African-American New York City police precinct commander, portrayed in *The Man Who Kept Harlem Cool*. The inspiration for this work came from a story on the 1964 Harlem riots, accompanied by an image of a burnt-out street corner. Excising that image, leaving only the descriptive caption, Gallagher turned the headline into her title and replaced devastated urban landscape with an aquatint portrait, crowned with a gray Plasticine Afro of swirls and rivulets that offers an "Afro-aerial view" of the city streets, fantastically rendered as fire hydrants and hoses.[4] Gallagher has described this spatial recontextualization as "collapsing the Nu-Negro geographies of urban centers like Harlem and Detroit into blank relocated space. Not so much a portrait of body but of space negotiated. The way characters move from being inside and outside their bodies."[5]

This kind of disruption, translation, and recasting of space hovers over the exhibition *Printin'*, organized by Gallagher and this author as a focused section within *Print/Out*. Offering a kind of technical dissection and conceptual unpacking of *DeLuxe*, *Printin'* brings together work by more than fifty artists from multiple disciplines. The works presented, some of which can be seen on the preceding pages, offer a free-flowing yet incisive web of associations that are reflected in *DeLuxe*, touching on themes of portraiture, identity, history, advertising, and commodity, among others. Like Gallagher, many of artists in *Printin'* operate as translators or documentarians of the transposed geographies they create. Experiens Sillemans's (c. 1611–1653) landscapes and seascapes offer variations on *penschildering* (pen paintings) that, like *DeLuxe*, defy traditional medium-based categorization. Hybrids of print, drawing, and painting, they employ a self-invented process that uses an offset technique to deposit engraved and abraded forms onto a prepared oil ground. In *Ships with*

*Salt Collectors on the Shore* (c. 1650), Sillemans depicts Dutch traders collecting salt for import from Cape Verde—seen here as a rocky moonscape incongruously dotted with European architecture—offering an invented vision of an African geography, while also charting the beginning of a complex transnational trade network. Likewise, George Herriman conflates geographies in his comic strip *Krazy Kat*. Merging the foreboding and arid landscape of Monument Valley, Utah, with Arizona's verdant Coconino County, Herriman animates this imagined habitat with a cast of cartoon characters and their jazz age, Creole dialect. Through the work of these and other artists, *Printin'* offers a rich, sliding timeline that collapses past and present, forming a dense weave of formal, technical, and conceptual connections and intersections.

—Sarah Suzuki

### Notes

1   "'eXelento' & 'DeLuxe,'" interview with Ellen Gallagher, Art21, accessed September 22, 2011, http://www.pbs .org/art21/artists/gallagher/clip1.html.
2   Ellen Gallagher, conversation with the author, May 7, 2007.
3   Ellen Gallagher, quoted in Suzanne P. Hudson, "Ellen Gallagher Talks about Pomp-Bang, 2003," *Artforum* 42, no. 8 (April 2004): 131.
4   Ellen Gallagher, conversation with the author, October 15, 2011.
5   Ibid.

# Sausages

intraconazole 100 mg per capsule

## 4 capsules

**DAMIEN-HIRST** Ltd
Saunderton, High Wycombe,
Buckinghamshire HP24 9QY

Carroll Dunham. One from *Female Portraits*. 2000

Damien Hirst. *Sausages* from *The Last Supper*. 1999

Kara Walker. *Crest of Pine Mountain, Where General Polk Fell* from
*Harper's Pictorial History of the Civil War (Annotated)*. 2005

Franz West : Konventionelle Dichotomie
Fotografie: Octavian Trauttmansdorff    Grafik: Ralph Schilcher

Edition Artelier u. Jänner Galerie

FRANZ WEST·KONVENTIONELLE DICHOTOMIE·GALERIE &
EDITION ARTELIER·GRAZ·EISENGASSE 3·20.11. bis 14.12.90

**30 Tablets**

**Meatballs**

**Hirst**

**150mg**

Each film-coated tablet contains
**150mg moclobemide**

Use only as directed by a physician

KEEP OUT OF REACH
OF CHILDREN

Store in a dry place

GRAVY

PL0031/0275          PA 50/81/2

Hirst Products Limited
Welwyn Garden City  England

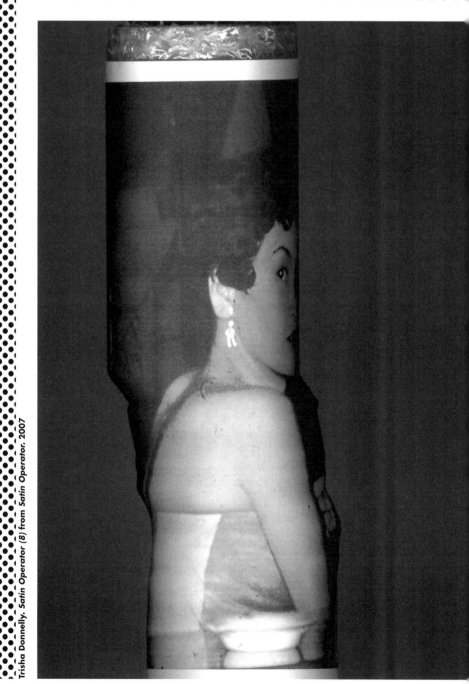

*Trisha Donnelly. Satin Operator (8) from Satin Operator. 2007*

Thomas Schütte. *Seven from Low Tide Wandering.* 2001

Daniel Joseph Martinez. One from *If Only God Had Invented Coca Cola, Sooner! Or, The Death of My Pet Monkey.* 2004

# I AM NOTHING ANDYOUARE EVERYTHING

Trisha Donnelly. *Satin Operator (6)* from *Satin Operator.* 2007

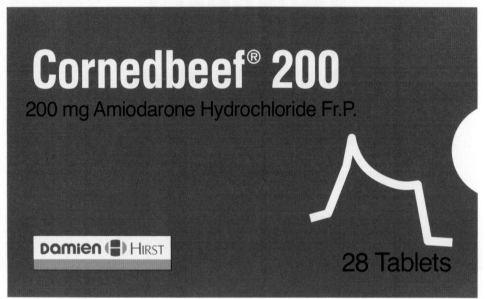

Damien Hirst. *Corned Beef from The Last Supper.* 1999

Thomas Schütte. *Three from Low Tide Wandering.* 2001

Carroll Dunham. *Two from Female Portraits.* 2000

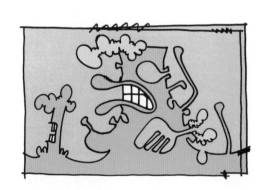

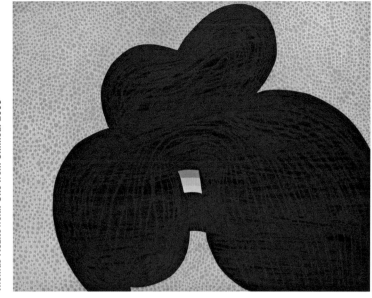

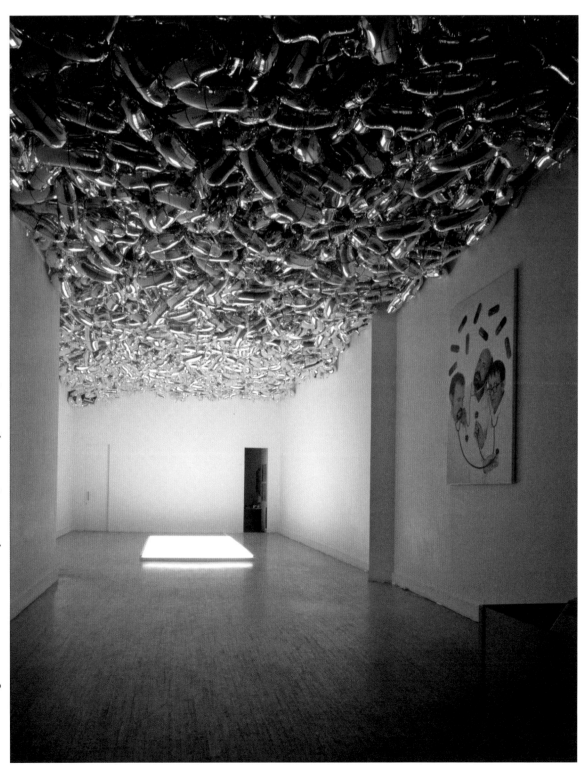

# Cornish 100mg/5ml Pasty

Rifampicin B.P.

To be taken by mouth

## Peas

CHIPS

100ml Syrup

EDITION
JACOB SAMUEL

Jacob Samuel, a California-based printer and publisher, established himself in the 1970s and '80s as one of the few intaglio printers in Los Angeles, a city heavily rooted in lithography and screenprinting. In 1988 he founded his own studio, Edition Jacob Samuel, in Santa Monica, and began working with artists on projects in serial formats (primarily portfolios but also some bound and unbound books). Since that time, he has emerged as a vital figure in his field, deftly adapting the traditional printmaking process of etching to the diverse practices of contemporary artists. In 2010 Samuel was the subject of a major exhibition at the Hammer Museum, Los Angeles, titled *Outside the Box: Edition Jacob Samuel, 1988–2010*, organized in conjunction with the joint acquisition of his archive of prints by UCLA's Grunwald Center for the Graphic Arts and Hammer Museum, and the Los Angeles County Museum of Art. This exhibition, which presented Samuel's complete published work, including the forty-three portfolios he had realized up until that time, offered viewers for the first time an opportunity to see the full breadth and depth of Samuel's important contribution to printmaking over the previous two decades.

When asked about his working relationship with the wide range of international artists with whom he has collaborated, Samuel offers a matter-of-fact response: "I do not think like an artist. I do not have creative thoughts. I have technical thoughts."[1] Samuel explains that his job is "to be as well versed in all the aspects of the medium of etching as I can be so that I have a variety of techniques to offer the artists I work with."[2] Indeed, Samuel has consistently chosen to work with artists because of his personal interest in their work, regardless of their experience with etching or printmaking in general. An important early influence on his development was the artist Sam Francis, whom he met in 1976 when working at a community etching workshop in Venice, California. He began working independently with Francis, finding new ways to translate the artist's abstractions into the etching medium, and, in the process, becoming involved in other major print studios (such as the Litho Shop and

Lapis Press, both run by Francis, and Gemini G.E.L.) before eventually starting his own workshop.

As part of the extensive interviews with Samuel conducted by the organizers of *Outside the Box*, Cynthia Burlingham, Leslie Jones, and Britt Salvesen, Samuel discussed the significant innovation he developed directly in response to artists' needs— the portable print shop:

> I learned from Sam [Francis] that artists are more comfortable in their own studio. I thought it could be possible to do a portable studio, but how could I create perfect aquatints on the road? So in 1994 I designed a portable aquatint box, of which the primary components are the bellows from eight-by-ten view cameras. Jack Brogan built it for me. The first project I used it for was with Marina Abramović in Amsterdam. My portable studio fit in two carry-ons. I had all the plates, acid, and copper cleaner, and I was able to get these really cool European hot plates, for rolling out grounds and melting rosin.
>
> With soft-ground Marina didn't have to use an implement to draw but could use her fingernails instead. When she saw that the spit bite could be done with her saliva, and with her being so performance oriented and body oriented, it all started to gel.
>
> A very big part of this was realizing that I really had no control, and the whole thing about a print shop is that you are in control. But on the road I'm etching plates on bathroom floors and using whatever is around. It's about working without a net, on the road, on the fly, and realizing, too, that by putting myself in the artist's studio I am deferring to them aesthetically.[3]

Since his project with Abramović, in 1996, Samuel has continued to push his practice in new directions, first traveling frequently with his portable studio to work with several European artists in their studios (such as Rebecca Horn, Jannis Kounellis, and Giuseppe Penone). In recent years, he has turned his focus back to his

ABRAMOVIĆ

SPIRIT COOKING

with

essential aphrodisiac recipes

EDITION JACOB SAMUEL

SANTA MONICA

1996

**Marina Abramović. Title page for *Spirit Cooking*. 1996**

**Edition Jacob Samuel**

breakfast

9 GLASSES of WATER

lunch

9 GLASSES of WATER

dinner

9 GLASSES of WATER

breakfast

1 GLASS of LIQUID SILVER

lunch

1 FRESH FIG

dinner

1 GLASS of LIQUID SILVER

breakfast

ROSE QUARTZ

lunch

OBSIDIAN

dinner

TOURMALINE

breakfast

NIGHT DREAMS

lunch

DAY DREAMS

dinner

EVENING DREAMS

essence drink

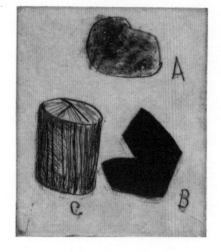

mix fresh breast milk

with

fresh sperm milk

drink on earthquake nights

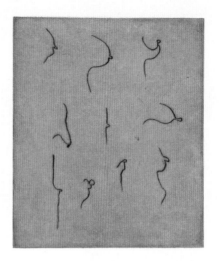

look in the mirror

for as long as it is necessary

for your face to disappear

don't eat the light

with a sharp knife

cut deeply into the middle finger

of your left hand

eat the pain

**Edition Jacob Samuel**

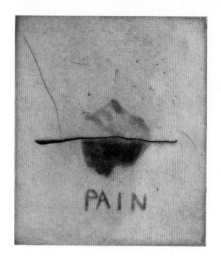

fresh morning urine
sprinkle over nightmare dreams

in time of doubt
keep a small meteorite stone
in your mouth

**Marina Abramović. Selection from *Spirit Cooking*. 1996**

**Jacob Samuel using his portable aquatint box with
Marina Abromović in her Amsterdam studio, 1996**

**Edition Jacob Samuel**

*Coyote Stories*

Chris Burden

Edition Jacob Samuel
Santa Monica
2005

Chris Burden. Title page for *Coyote Stories*. 2005

1. First Encounter

When I first started living on my property in
Topanga, I camped out in my van. One day
I was eating a bag of potato chips and walking
on a trail through the brush near my van. I
caught a glimpse of a coyote ahead of me on
the trail. Out of curiosity, I stopped eating my
potato chips, assuming my noise would alert
the coyote, and quietly tried to follow it. After
walking a bit, I realized it had disappeared.
I gave up on my search and resumed crunching
noisily on my potato chips, retracing my steps
back to the van. About halfway back to the
van, I glanced over my right shoulder and
saw the hindquarters of the coyote slowly
and nonchalantly walking away from the main
path. At that moment, I realized the coyote
had been boldly and deliberately watching me
the entire time.

2. Sharp Knives

A family bought the lot next ours and
moved a house trailer on it. For more privacy,
Nancy and I moved deeper down the canyon
into a hidden eucalyptus grove and commenced
camping out on a wood platform, sleeping under
the stars at night. All our possessions were
outside in cardboard boxes or on little tables. At
the time, I had inherited a set of extremely
sharp, all carbon steel French kitchen knives
my parents had used when we lived in France.
One by one the knives were stolen by the coyotes
off the tables or out of the boxes. Twenty
years later I still miss those knives and
am perplexed as to how the coyotes were
able to discern and steal only my favorite,
finest, and sharpest knives.

**Chris Burden. Selection from *Coyote Stories*. 2005**

**Edition Jacob Samuel**

### 3. Poop

When the weather turned cold, Nancy and I purchased a small 12 x 12 Sears and Roebucks camping tent to live in. Later we moved into a 16 x 30 canvas army tent, which we lived in for many years. Invariably, almost every morning we would awaken to find a strategically placed coyote poop right at the entrance to our tent.

### 4. Blue Wallet

In 1985, Nancy and I were coming home from the beach and decided to stop and pick up supplies at the Topanga Market. I gave Nancy my wallet and waited in the car for her. Several days later I asked her for my wallet. It was nowhere to be found. I assumed it had been dropped in the parking lot and was lost. Nancy wondered aloud if perhaps it had been put down at our campsite and stolen by a coyote. Since this was a blue nylon surfer wallet, this idea seemed to me a lame excuse for her having lost my wallet at the market. Two months later, upon returning from a trip to Washington D.C., I woke early to take a pee in the bushes. My eyes spotted a blue glimmer deeper in the brush. I wanted this to be my wallet, but my rational mind told me it was probably a piece of trash. Foraging deeper into the brush to investigate, I realized that indeed it was my wallet lying on the ground at the confluence of 4 or 5 coyote trails. Every time a coyote passed by my wallet, it peed on it.

5. Telephone Wire

We lived at the end of an unimproved dirt road in a deep secluded canyon and had no utilities or telephone. To maintain contact with the outside world, we bought 8500 feet of heavy gauge copper wire and attached it to last telephone pole, 1½ miles from our campsite. The wire was draped across the ground, through the brush, and was always being gnawed on by rabbits and other vermin who were attracted to the low voltage current. It required constant maintenance. The telephone wire passed through a vineyard in which the owner had let the grapes ripen and ferment on the vine. One evening, deep in our canyon, we could hear the coyotes yelping and carousing louder and more frequently than normal. The ruckus went on late into the night. Inspecting the vineyard area in the morning, I discovered huge 20 and 50 foot sections of the wire had been severed and wildly scattered about. The coyotes had had a drunken telephone wire party.

6. The Sound of Hooves

One quiet afternoon inside the house that we had finally built at the top of our canyon, the stillness was shattered by the sound of thundering hooves. We looked out to see the rare sight of a pair of deer running at breakneck speed down our back hill. Close on their heels were two coyotes.

7. Classical Music

I was leaving one day and listening to classical music on my radio in the car. The window was down, and as I approached the front gates of my ranch property, I saw a coyote standing beside the road. To my surprise, the coyote did not bolt and run, but stood its ground. It stood about five feet away from my stopped car, listening intently to the concerto on the radio. Our eyes met and I stared into the multiple grey and green rings of its eyes and I knew then that coyotes were truly intelligent and sentient.

**Edition Jacob Samuel**

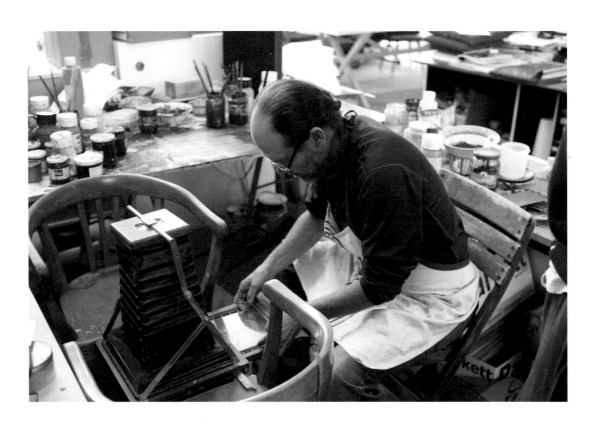

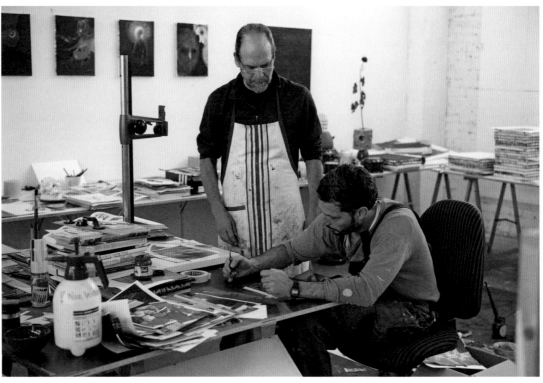

Jacob Samuel with Uwe Tobias in Gert and Uwe Tobias's studio,
Cologne, 2011

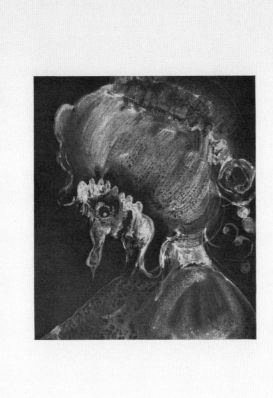

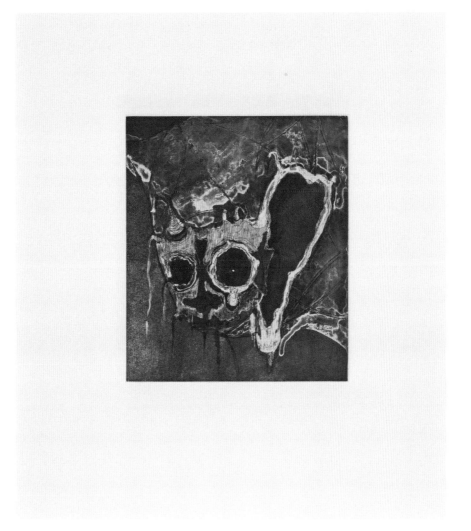

**Gert and Uwe Tobias. Selection from** *Untitled*. **2011**

Edition Jacob Samuel

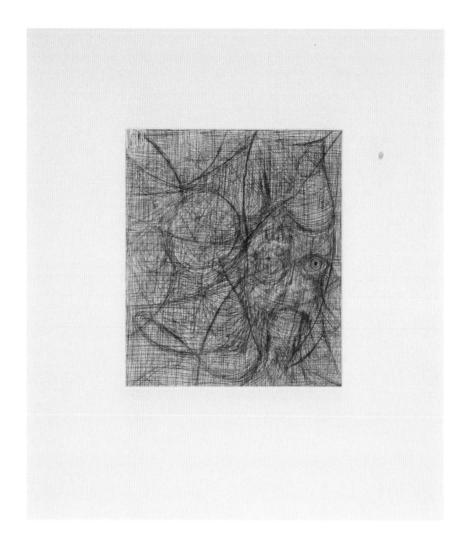

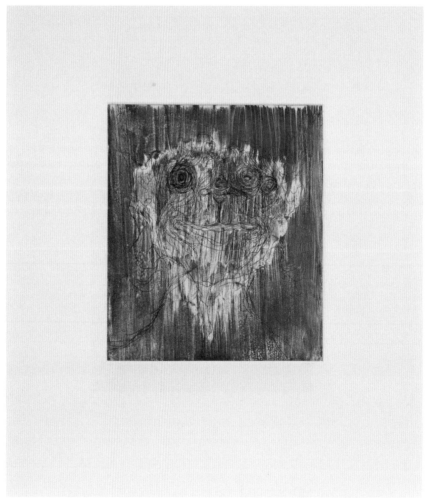

**Gert and Uwe Tobias. Selection from** *Untitled.* **2011**

West Coast contemporaries, exploring a range of practices—including street art (Barry McGee), conceptual photography (James Welling), and performance (Chris Burden)—and how these approaches can be translated to the print medium. In *Coyote Stories* (2005), Samuel's portfolio project with Burden, the artist offers visual and textual descriptions related to his encounters with wild coyotes near his home in Topanga Canyon, California. Samuel captured the personal, documentary mode of this project through experimentation with techniques, choosing a digital printing process to best reproduce the artist's handwritten text on ledger paper. Samuel also encouraged Burden, as he had Abramović, to try out nontraditional implements on the plate surface. In this case Burden used objects described in his account, from potato chips to knives, to create direct imprints—not unlike the animal prints that the artist had been tracking.

As part of *Print/Out*, Samuel is working on a new portfolio with the artists and twin brothers Gert and Uwe Tobias, whose colorful, graphic compositions draw on a range of motifs, from popular culture, Eastern European folk art, and Russian Constructivism. While the two have worked extensively in large-scale woodcut (as well as collage, watercolor, and ceramics), this project presented new challenges, as etching was an unfamiliar medium for them. Over the course of three days, Samuel worked with the artists in their Cologne studio, teaching them the basics of etching and helping them translate and adapt motifs from their visual lexicon into a set of plates, some proofs of which are reproduced here.[4] The exhibition will follow this project through the printing, proofing, and publishing process, presenting a range of working materials and documentation in the galleries and taking the opportunity to study one of Samuel's collaborations from start to finish.

—Kim Conaty

Notes

1   Jacob Samuel, quoted in Melanie Reynard, "Printmaker Jacob Samuel Works 'Outside the Box' to Capture Artists' Visions," Jewishjournal.com, July 6, 2010, http://www.jewishjournal.com/arts/article/printmaker_jacob_samuel_works_outside_the_boxto_capture_artists_visions_201.
2   Jacob Samuel, interview with Cynthia Burlingham, Leslie Jones, and Britt Salvesen, February 26, 2010. Published in exhibition brochure for *Outside the Box: Edition Jacob Samuel, 1988–2010* (Los Angeles: Hammer Museum, 2010), 11.
3   Ibid., 18.
4   This project represents the first time in ten years that Samuel has utilized his portable studio. In June 2011 he shipped his aquatint box, prepared plates, and other materials directly to the artists' studio (airline luggage restrictions following September 11, 2001, he explained, have made it impossible for him to travel with these items as he used to). Jacob Samuel, in conversation with curators from the Department of Prints and Illustrated Books in MoMA's Paper Study Center, February 11, 2011.

Dan Walsh. *Folio B.* 2010

Kelley Walker. *Three from Andy Warhol Doesn't Play*
*Second Base for the Chicago Cubs.* 2010

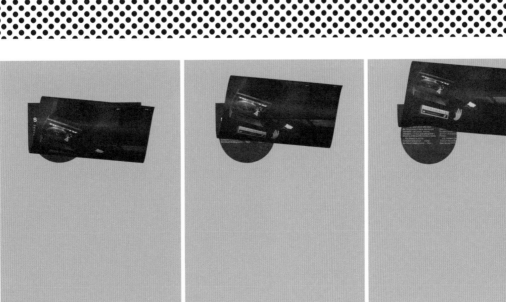

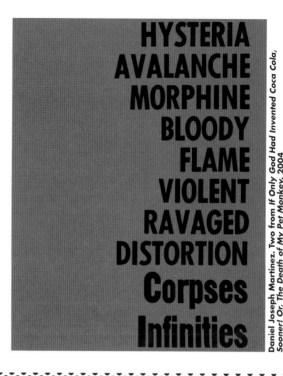

**god is dead**

HYSTERIA
AVALANCHE
MORPHINE
BLOODY
FLAME
VIOLENT
RAVAGED
DISTORTION
Corpses
Infinities

Daniel Joseph Martinez, Two from If Only God Had Invented Coca Cola, Sooner! Or, The Death of My Pet Monkey. 2004

Trisha Donnelly, Satin Operator (2) from Satin Operator. 2007

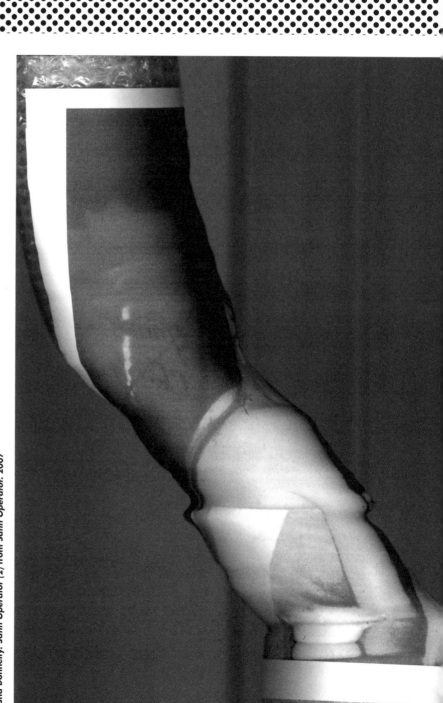

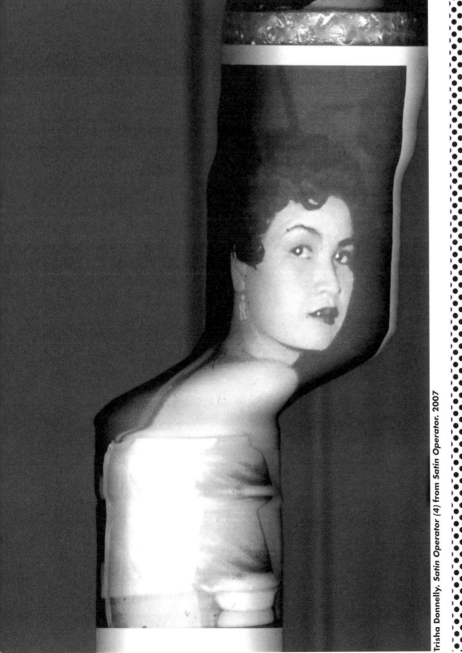

Trisha Donnelly. *Satin Operator (4)* from *Satin Operator*. 2007

Thomas Schütte. *Five* from *Low Tide Wandering*. 2001

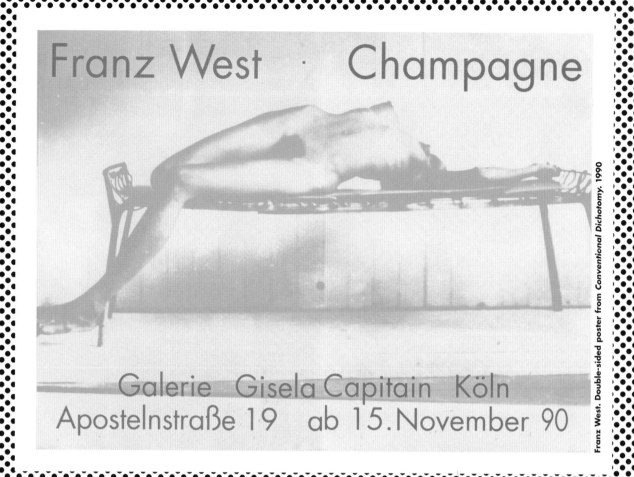

Franz West. Double-sided poster from *Conventional Dichotomy.* 1990

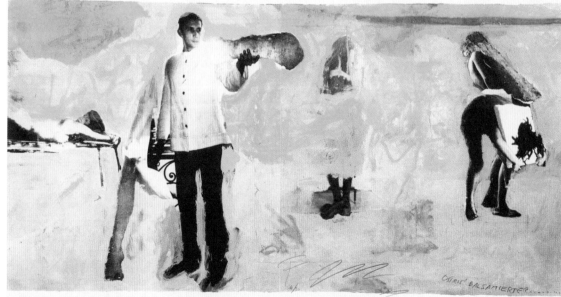

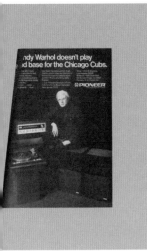
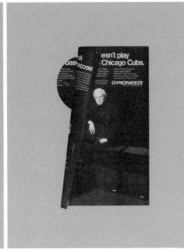
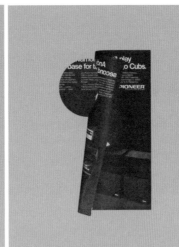
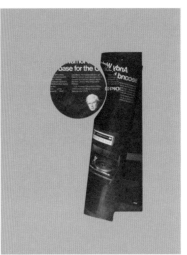

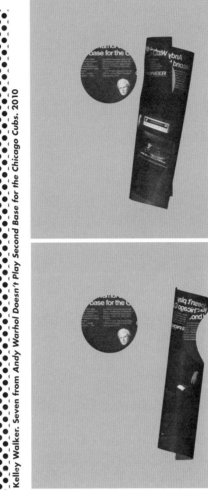

Kelley Walker. Seven from *Andy Warhol Doesn't Play Second Base for the Chicago Cubs*. 2010

Thomas Schütte. Four from *Low Tide Wandering*. 2001

# Sandwich®

Saquinavir

## 200 mg

270 Capsules

Hirst

Andy Warhol doesn't play
second base for the Chicago Cubs.

we are dogs

in love with

our own vom

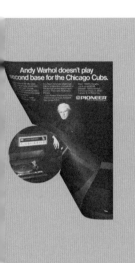
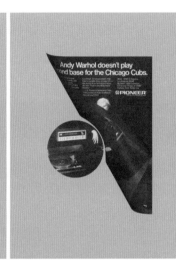
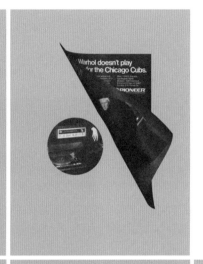

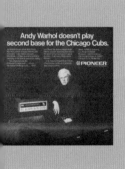
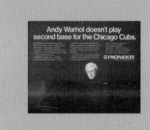

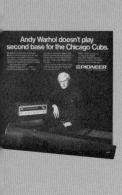
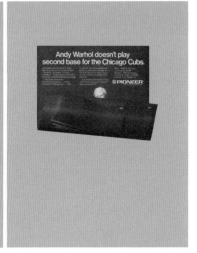

Pae White. *City/Uncity from Untitled.* 1999

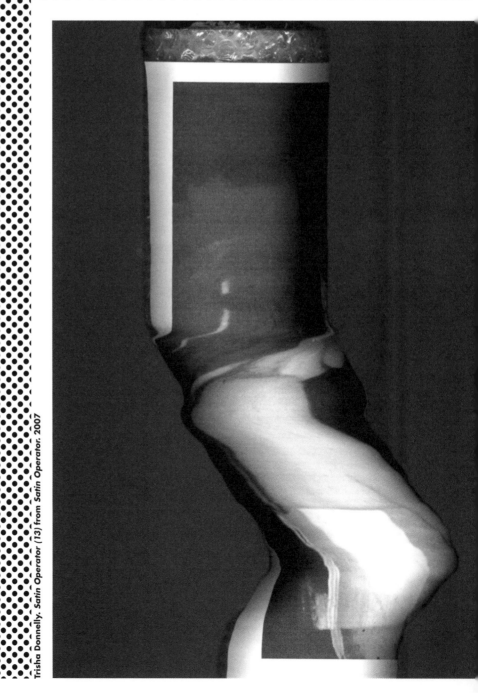

Trisha Donnelly. *Satin Operator* (13) *from Satin Operator.* 2007

SUPERFLEX

COPYLIGHT

FACTORY

SUPERFLEX

COPYLIGHT

SUPERFLEX is a Copenhagen-based artists' group (Bjørnstjerne Christiansen [Danish, born 1969], Jakob Fenger [Danish, born 1968], and Rasmus Nielsen [Danish, born 1969]) that has been organizing projects reflecting on social and economic change since 1993. The group describes its practice in terms of tools (rather than art-works), utilized in the service of concrete cultural interventions that "expose the contemporary consciousness and our evolving relationship to global consumerism, environmenta-lism, and Internet copyright."[1] These tools are not finished products but rather instructions for doing and calls for participation: *Superchannel*, for example, invites individuals to develop Internet broadcast channels that foster community building, while *Supergas* employs a simple technol-ogy for converting organic waste into biogas, developing specially constructed, enclosed units that can be installed outdoors and used to harness the gases emitted from the decomposition of animal or food waste. The Danish group has collab-orated with like-minded artist Rirkrit Tiravanija on several occasions, including an installation of *Supergas* at Tiravanija's sustainable farm The Land in Chiang Mai, Thailand, in 2002. In this project, as in much of its work, SUPERFLEX seeks to create laboratory-like microcosms in which broader questions relating to community resources, sustainability, and social relations can be investigated and played out.

One of SUPERFLEX's more recent projects, *Copy Light/Factory* (2008), addresses the larger implications of copyright through a similar type of experimentation. It consists of a workshop in which a series of iconic (and heavily copyrighted) lamp designs are "refabricated" by affixing photocopies of the designs to a basic cubic lighting structure. The result-ant box lanterns, which fit over a standard bulb, push ad absurdum the logic of copyright laws, as copies of copies become originals again.

Kim Conaty: I believe that your first lamps were developed as part of a *Supergas* project. How did that come about?

SUPERFLEX: Yes, the first lamp we developed was the *Supercopy/Biogas PH5 Lamp.* It is a copy of the PH5 lamp originally designed by Danish architect Poul Henningsen in 1958. We copied the design and changed the function from electrical to gas in order to create a lamp for people living in areas with no access to electricity. We were interested in bringing a focus back to the original idea by Henningsen, which was to create a lamp with high luminosity that was also affordable for the general population, not an expensive, desirable design object for the upper class. In conjunction with our *Supergas* system at [Tiravanija's project] The Land, we wanted to make a lamp that would give the area a light source since there wasn't one. After a first test and presentation of the lamp in an art context, we received a copyright infringement lawsuit by the Danish lamp company Louis Poulsen, which holds the copyright of the PH5 design.

KC: The very notion of the "copy" has historical, cultural, and economic impli-cations, as you have experienced first-hand. How did you conceive of the *Supercopy* tool in general, and how have you dealt with these sorts of copyright issues along the way?

S: We initially developed *Supercopy* after a period spent in Bangkok work-ing on the *Supergas* project. We got inspired by the dynamics of copy and appropriation methods used in busi-ness and in the urban culture of Bangkok. We made some experimen-tal works, for example the *Supercopy/ Biogas PH5 Lamp* and *Supercopy/ Lacoste* [a Lacoste brand shirt with the word "SUPERCOPY" printed several times across the front (2002–07)], and we were confronted with the power behind copyright and trademark systems when we were accused of copyright infringement. This made us think about and then react to these systems. We have since used the language and methods of the copyright empire but turned these upside down, as, in our understanding, intellec-tual property law is based on an ideo-logy and language that is constantly forming, so it needs to be continu-ally challenged. We believe in the idea "if value, then copy," and are more interested in an open culture than in protecting rights. We find that making

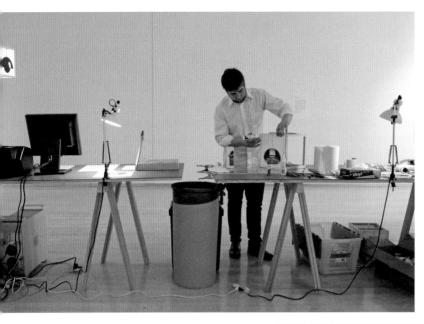

# Copy Light

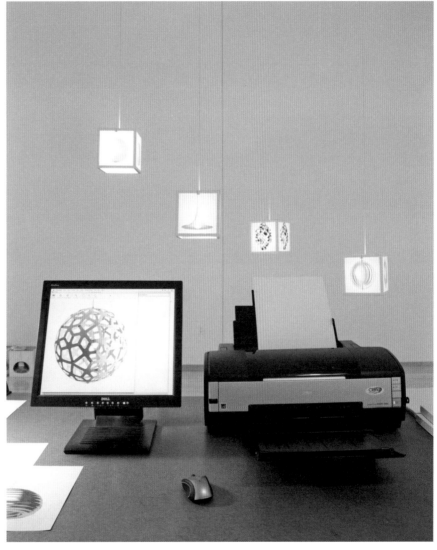

PY LIGHT is seeking the borders between a copy and its original - when is a copy
opy and when does a copy turns into a new original. COPY LIGHT wants to
municate the problems of copyright through its use of famous lamp icons.

motifs on the cube shaped COPY LIGHT are translucent, transparent or paper
tocopies with representations of lamp designs. You can change the lamp image
image of your desired lamp design.

*PY LIGHT factory*
installation is a lamp production setup, cutting wood, photocopying, assembling
ps. As they are produced the lamps are hung in the ceiling slowly filling up the
ce with lamps, illuminating the space - initially the space should be kept dark or
natural light.

up (Variable, depending on production/space possibilities)
etop´s, trestle's, xerox machine/printer or silkscreen setup, electric cords/plugs,
er sheets (transparent/permatrace/normal), electric screwdriver/drill, glue (paper/
od or/and glue stick), tools to cut paper sheets (paper guillotine), tool/machine to
ke the wood pieces for the lamp box ( if this is not possible - they can be pre-
de by 3rd part ).

PY LIGHT was initially developed within the context of COPYSHOP, an ongoing
ject initiated by Copenhagen Brains & SUPERFLEX 2005.

wood cube for Copy Light has been designed in collaboration with Blendwerk.dk

*Copy Light/Factory.* 2008. Instruction manual and installation views,
Philagrafika, Tyler School of Art, Temple University, Philadelphia,
January 29–April 11, 2010

**SUPERFLEX**

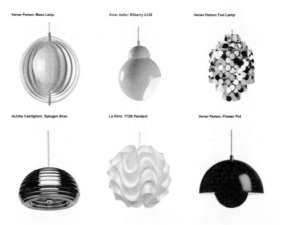

Verner Panton: Moon Lamp    Alvar Aalto: Bilberry A338    Verner Panton: Fun Lamp

Achille Castiglioni: Splugen Brau    Le Klint: 172B Pendant    Verner Panton: Flower Pot

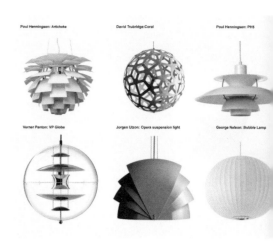

Poul Henningsen: Artichoke    David Trubridge:Coral    Poul Henningsen: PH5

Verner Panton: VP Globe    Jorgen Utzon: Opera suspension light    George Nelson: Bubble Lamp

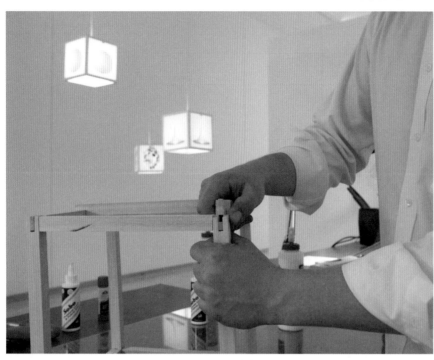

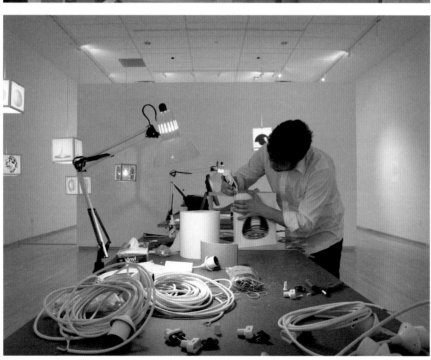

Verner Panton: VP Globe

Jorgen Utzon: Opera suspension light

*Copy Light/Factory.* 2008. Instruction manual and installation views,
Philagrafika, 2010

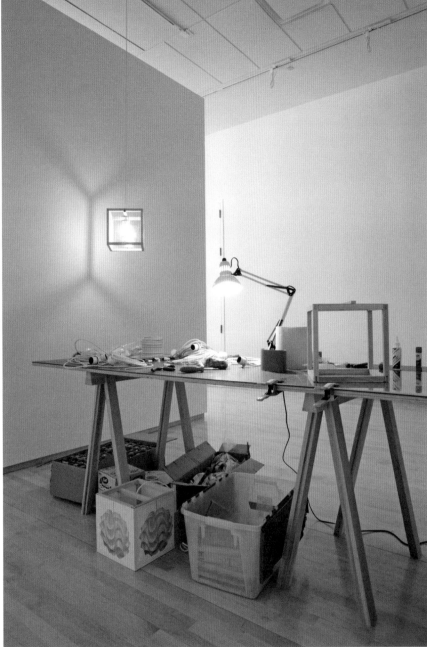

## COPY LIGHT

**Concept:
Copenhagen
Brains &
SUPERFLEX**

**Design of cube
in collboration
with:
Blendwerk.dk**

COPY LIGHT is seeking the
borders between a copy and its
original - when is a copy a copy
and when does a copy turns into a
new original. COPY LIGHT wants
to communicate the problems of
copyright through its use of famous
lamp icons.

The motifs on the cube shaped
COPY LIGHT are translucent,
transparent or paper photocopies
with representations of lamp
designs.

You can change this lamp image
to a image of your desired lamp
design.

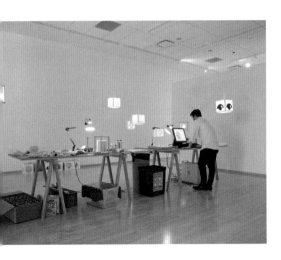

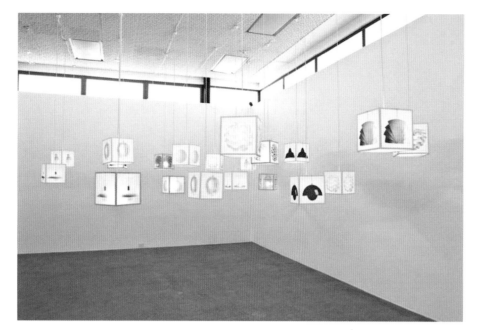

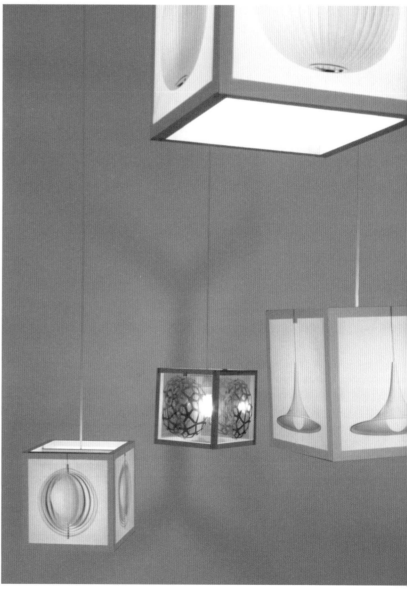

**6.**
Wait 15 minutes for glue to dry.

**7.**
Add glue and attach C-piece.

**10.**
Tighten screw in the fastner.

**11.**
Glue pages one by one to the box

*Copy Light/Factory.* 2008. Instruction manual and installation views,
top: *SUPERFLEX: If Value, Then Copy,* ARTSPACE, Auckland,
New Zealand, October 25–November 22, 2008; right: Philagrafika,
2010

proposals and models are the most effective ways for us (in the particular context that we have chosen to work) to make a difference. *Copy Light/ Factory* is a model that enables you to question the fundamental nature of rights and plays at the same time with your desire for good design and objects.

KC: Many of your projects involve time. *Copy Light/Factory*, for example, is constantly in flux, as more and more lamps are created and hung in an exhibition space, gradually illuminating it over weeks and months. The visitor or participant never quite gets a complete picture of the project. Could you talk about the durational aspects in your work?

S: We have now made quite a few factory or workshop settings, for example *Guaraná Power* [begun 2004], *Free Beer* [begun 2005], *Black Out* [2009] (in collaboration with Simon Starling), *Social Pudding* [2003–04] (in collaboration with Rirkrit Tiravanija), and recently *Free Sol LeWitt* [2010], at the Van Abbemuseum in Eindhoven, The Netherlands. These settings can be understood right away, since all elements are present, but they also invite you to stay or revisit. The work uses a structure or machinery in which production, display, and often distribution are elements. Time is therefore important, both in terms of labor, the visual appearance of the space, and interaction with the persons present in the factory. On some level, the factories work as active manuals or tools, and, with *Copy Light/Factory* in particular, the dismantling and distribution of the lamps at the close of an exhibition becomes an active engagement with the public, who, by taking the objects with them, become partners in questioning and confronting the copyright empire.

KC: Over the last couple decades, many artists have embraced the notion of failure as a productive mode for art-making. Something striking about your practice is that you seem to do the opposite, focusing instead on beginnings.

S: Yes, we understand and appreciate the romantic idea of failure as a productive mode for art-making, but as the kind of professional artists we are, we prefer to engage in a situation because of a belief that we can make a relevant and valuable proposal to challenge the here and now.

Via e-mail, August 30, 2011

Note

1  SUPERFLEX, quoted in Sheryl Conkelton, "Superflex," in José Roca et al., *The Graphic Unconscious* (Philadelphia: Philagrafika, 2011), 216.

SUPERFLEX

mittwoch
mittwoch
mittwoch
mittwoch
mittwoch

Liam Gillick. Wednesday from Guide. 2004

Kara Walker. Signal Station, Summit of Maryland Heights from Harper's Pictorial History of the Civil War (Annotated). 2005

Scene of McPherson's Death from Harper's Pictorial History of the Civil War (Annotated). 2005

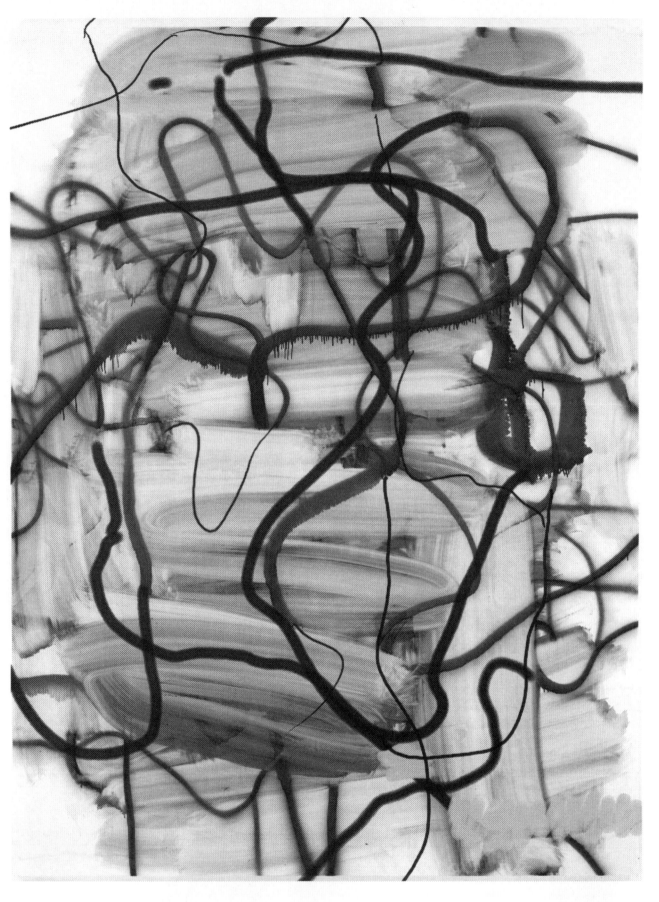

Christopher Wool. *Untitled.* 2006

*Le fric, c'est pas si chic, dit le Tajik.*

Slavs and Tatars. One from Nations. 2007

Daniel Joseph Martinez. Two from If Only God Had Invented Coca Cola, Sooner! Or, The Death of My Pet Monkey. 2004

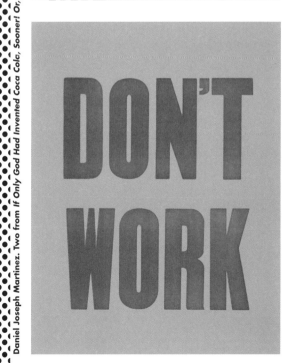

A BLACK CROW SITS IN A PINK MAGNOLIA TREE CAWING AS ORGONE ACCUMULATES & DISCHARGES in a SPLIT SECOND OVER THE CITY I MAY BE YOUR LOVER BUT I SPIT ON YOUR MILLENNIUM

DON'T WORK

**FREEDOM WITHOUT LOVE**

**PICTURES TAKEN HOSTAGE**
**an attempt**
**to**
**hi-jack-history**

Daniel Joseph Martinez. Two from *If Only God Had Invented Coca Cola,
Sooner! Or, The Death of My Pet Monkey.* 2004

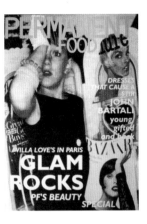
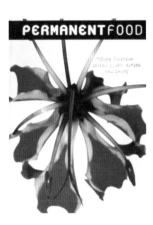
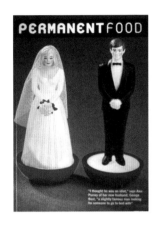
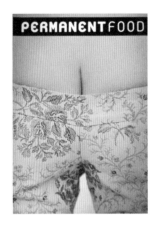
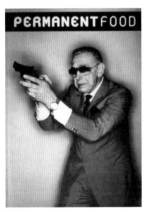
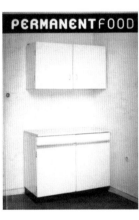
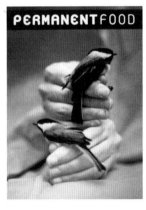
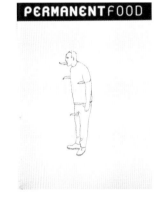
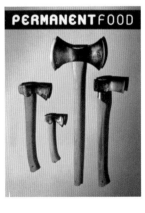
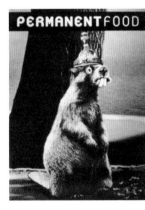
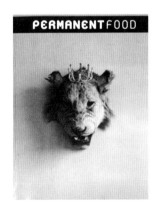
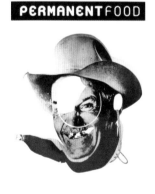
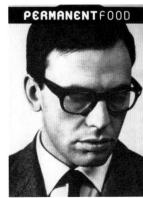
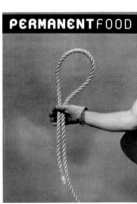
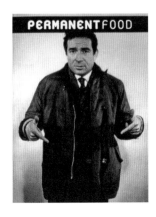

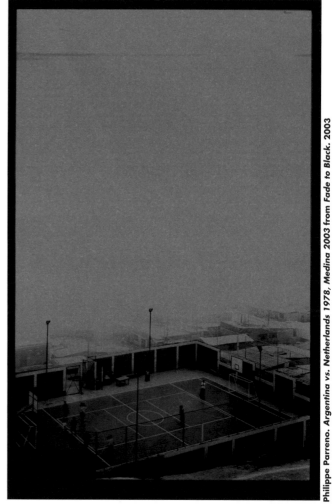

Philippe Parreno. *Argentina vs. Netherlands 1978, Medina 2003* from *Fade to Black*. 2003

the 23/12/03 0:53, pierre huyghe at pierrehuyghe@hotmail.com wrote :
>
>
> philippe,
>
> You first remark this circle of blur on the bay window and if you start
>
> Bloodleak on the playstation, at the place of the high score names is
>
> written DES-TROY-ALL-MONS-TERS. You realise now that others signs have
>
>been
>
> left behind in the house. Someone have been here for a while and just >
>
>left.
>
> That kind of things happen but rarely when this person is a fictional
>
> character.
>
>
>
> This took place in the Assenheim,s castle where we created Anna Sanders
>
> during the winter 1996.
>
>
>
>pierre
>
>
>
>
>
>
> _____
> MSN Messenger  http://g.msn.fr/FR1001/866 : dialoguez en direct et
> gratuitement avec vos amis !

Philippe Parreno. *The winter of 1996 as it has been reported by Pierre Huyghe* from *Fade to Black*. 2003

Trisha Donnelly. *Satin Operator* (10) from *Satin Operator*. 2007

Thomas Schütte. *Five from Low Tide Wandering*. 2001

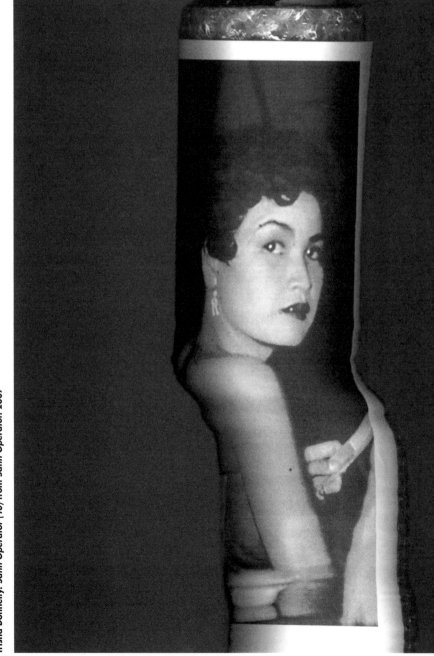

# LUCY McKENZIE
# FLOURISH
# NIGHT POSTERS
# NOVA
# POPULARNA

Lucy McKenzie (Scottish, born 1977) often refers to her prints and editions as posters. This description, however, has less to do with their making—most are self-published in small quantities and using techniques associated with the fine arts—than with their original function. Some were published to celebrate album releases by her record label, Decemberism, while others relate to evenings of poetry and music that she organized in Glasgow (Flourish Nights) or cabaret-like events presented in a temporarily converted Warsaw art space (Nova Popularna; with Paulina Olowska).

Lucy McKenzie and Paulina Olowska at Bar Nova Popularna, National Artist Club Gallery, Warsaw, 2003

Still, McKenzie's posters provide none of the information (locations, dates, times) usually associated with promotional materials. They instead serve as rebuses, offering the viewer a series of visual clues. In the group of eight *Flourish Night Posters* (2002–03), for instance, one print combines the words "Women Only" with the symbol of a musical note, while another reproduces the logo of the 1970s German record label Brain,[1] to whose profile shape McKenzie added the outline of an arm and breast. For the series *Nova Popularna* (2003; with Olowska), an assortment of motifs, such as musical instruments, architectural details, and dancers, are represented separately throughout the suite. It is only when understood as a group that the prints evoke a turn-of-the-century avant-garde cabaret.

In much of her work, McKenzie intersperses references from multiple sources, creating an ironic tension within a single picture. This purposeful layering is exemplified in *Olympic Dames* (2002), a composition conceived as a centerfold for the now defunct British journal *Make: The Magazine of Women's Art*.[2] The final work brings together family and student photos of the artist, found images from the pornographic magazine *Mayfair*, and pictures of well-known female gymnasts from the Soviet Union, such as Nadia Comăneci and Ludmilla Tourischeva. McKenzie lifted the work's headline, "Olympic Dames / Meet Mayfair's Gold Modellists," directly out of *Mayfair*, and then added her own slogan "Your body is a playing-field," which stems from an iconic feminist work by Barbara Kruger titled *Your Body Is a Battleground* (1989). Since her student years, McKenzie has often used her work to explore the social history of women's roles as well as contemporary expressions of sexuality, particularly the trivialization of pornography. *Olympic Dames* can be regarded as a visual manifesto of sorts, putting forth McKenzie's own view of feminism as "a free and personal sexuality" in which "a sexualized subject is not by default an exploited victim."[3]

In 2007 McKenzie's work took an unexpected turn. Together with illustrator Bernie Reid and fashion designer Beca Lipscombe, she started the interior decorating company Atelier, whose purpose is to design public and private social spaces.[4] Later that year, McKenzie enrolled in the Van Der Kelen Institute for decorative painting in Brussels, to follow "an intensive six-month course in traditional painting techniques including faux wood and marble, advertising lettering, illusion painting, patinas, stenciling and gilding."[5] When she was invited to show a group of prints and paintings at The Museum of Modern Art (*Projects 88: Lucy McKenzie*) the following year, she commissioned her company to create the scenography of the show. The display mixed styles from the nineteenth and early twentieth centuries, including a Gothic Revival–inspired stenciled carpet, draped fabric with Bauhaus elements, and a trompe l'oeil Art Nouveau interior designed by McKenzie herself. Reflecting on the

*Olympic Dames.* 2002
Lucy McKenzie

# Flourish
# Winter
# Solstice

*Flourish '03*

*Women Only*

**Four works from *Flourish Night Posters*. 2002–03**

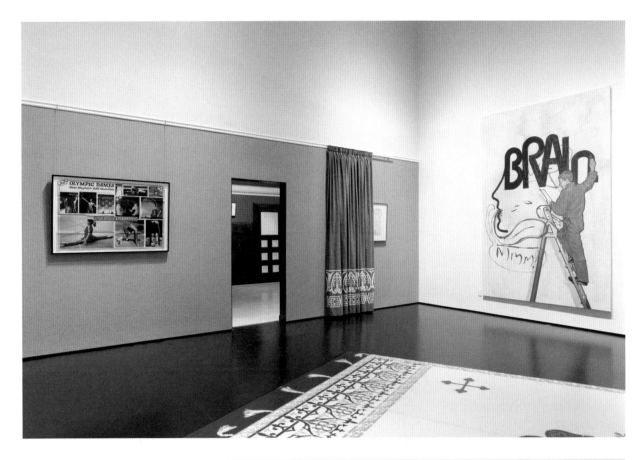

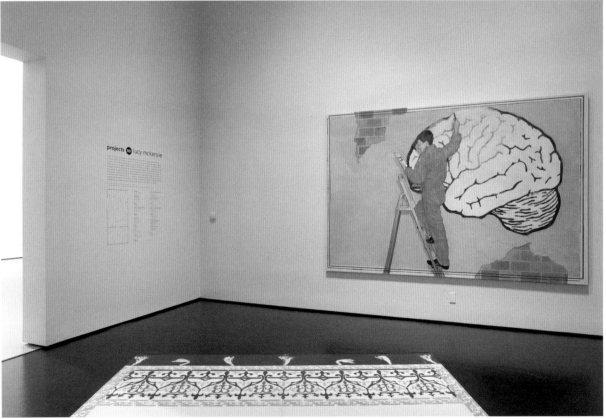

Installation views, *Projects 88: Lucy McKenzie*, The Museum of
Modern Art, New York, September 10–December 1, 2008

Lucy McKenzie

Installation views, *Projects 88: Lucy McKenzie*, 2008

Mmm!
Ahhh!
Ohhh!

**Four works from *Flourish Night Posters*. 2002–03**
**Lucy McKenzie**

**Lucy McKenzie (with Paulina Olowska).** *Nova Popularna.* **2003**

Lucy McKenzie

*Untitled (for Parkett no. 76). 2006*

latter, the artist explained her desire to build "an imaginary Protestant opium den," or "a collapsible and transportable bourgeois room that could be used to show my and others' work should it need those types of display conditions."[6]

The trompe l'oeil mural paintings that created the illusion of the private "den" environment not only provided a physical support and fictional context for the prints hung there, but also revealed the inevitable domestication or institutionalization of work with larger social or political aims. An untitled 2006 screenprint displayed in the room, for example, showed McKenzie's self-portrait as Tintin, the famous young reporter character created by the Belgian comic writer Hergé. However, McKenzie's portrait appears defaced by red graffiti, with a cartoonish pair of breasts, thick glasses, and long teeth added to the famously asexual adventurer. It is through these sorts of clashes—street art versus Art Nouveau, ethereality versus vulgarity—that McKenzie's work conveys both feelings of mordant irony and acute social awareness.

—Christophe Cherix

### Notes

1  Brain was a Hamburg-based sublabel of Metronome Music.
2  *Make: The Magazine of Women's Art* 88 (June–August 2000): 22–23. Galerie Daniel Buchholz, Cologne, commissioned the larger poster edition in 2002. My thanks to the artist for explaining the different sources at play in this image.
3  Lucy McKenzie, e-mail to the author, August 14, 2011.
4  Reid left Atelier in spring 2010. Two new members, Lucy McEachen and Catriona Duffy, have since then joined the company; they are in charge of administering the fashion collection and other projects.
5  Lucy McKenzie, "Canvases Stretched in a Studio Far Less Convenient Than One's Own," in *Chêne de Weekend: Lucy McKenzie, 2006–2009* (Cologne: Verlag der Buchhandlung Walther König, 2009), 11.
6  Ibid., 13.

# COMPOSED
## of
# GESTURES
# CONTAINED
## in a
# RANSITORY
# DECOR

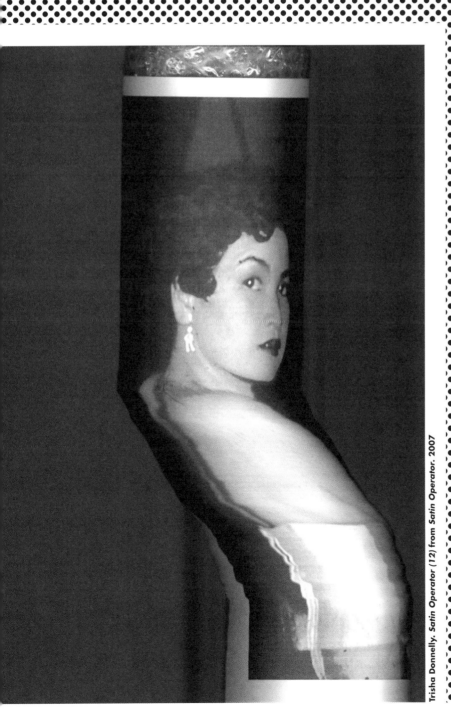

Daniel Joseph Martinez. One from *If Only God Had Invented Coca Cola, Sooner! Or, The Death of My Pet Monkey*. 2004

Trisha Donnelly. *Satin Operator* (12) from *Satin Operator*. 2007

Thomas Schütte. Four from *Low Tide Wandering*. 2001

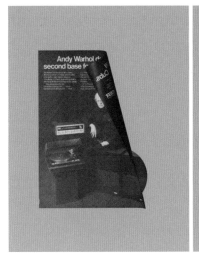
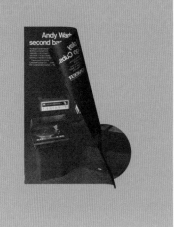
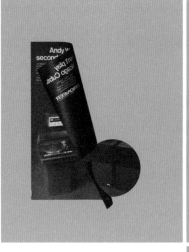
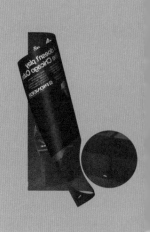

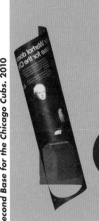

Kelley Walker, *Five from Andy Warhol Doesn't Play Second Base for the Chicago Cubs*, 2010

# Men are from Murmansk

# Women are from Vilnius

Slavs and Tatars. *One from Nations*, 2007

Daniel Joseph Martinez, *One from If Only God Had Invented Coca Cola, Sooner! Or, The Death of My Pet Monkey*, 2004

to WITNESS
the
VICTORY
the ECHO
over the
VOICE

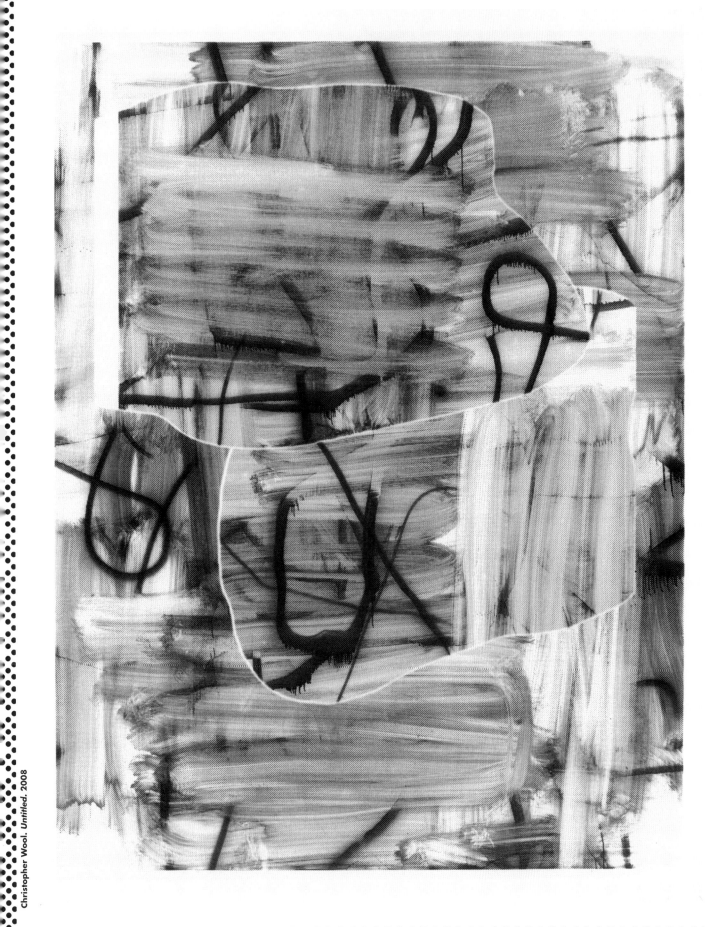

VERY ETHEREALLY
an
INSTANT SURGES
of
WithinOneSelfNess
something
LIKE A PROPENSION
to
fashion one's self
ONE'S OWN BODY

Daniel Joseph Martinez. One from *If Only God Had Invented Coca Cola, Sooner! Or, The Death of My Pet Monkey*. 2004

# Romantics love violence, too.

Slavs and Tatars. *Romantics Love Violence, Too*. 2007

Thomas Schütte. Four from *Low Tide Wandering*. 2001

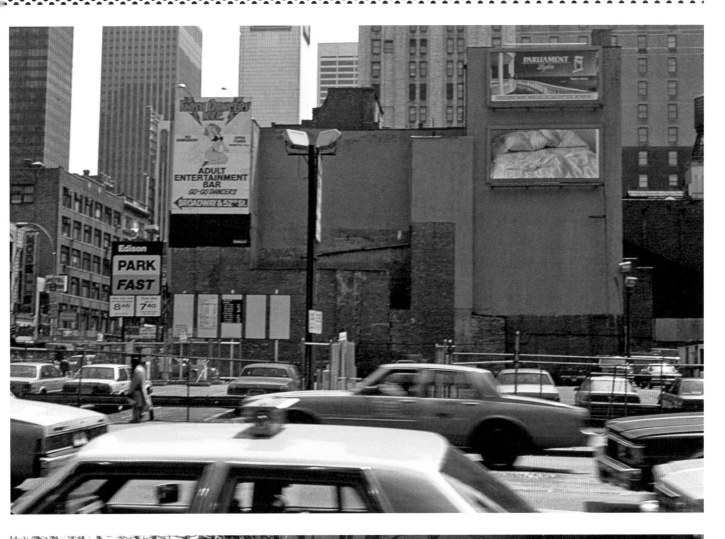

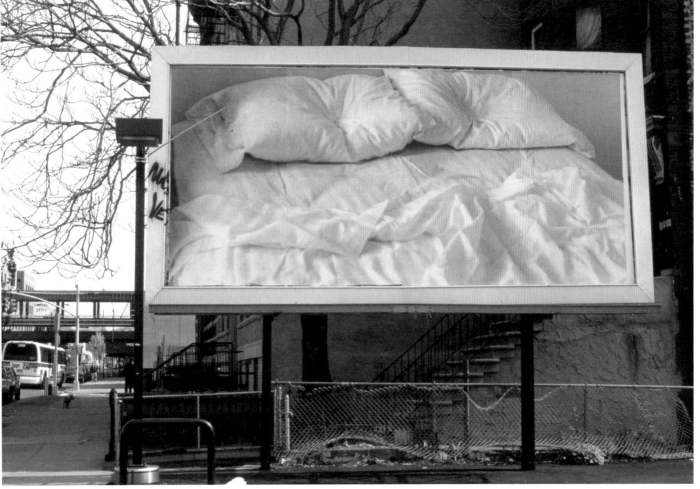

Thomas Nozkowski. One from *Untitled*. 2006

# Sad Sciences Happy Maths

Slavs and Tatars. *Sad Sciences, Happy Maths*. 2007

Thomas Schütte. Six from *Low Tide Wandering*. 2001

Liam Gillick. *Tuesday from Guide.* 2004

Kara Walker. *Occupation of Alexandria from Harper's
Pictorial History of the Civil War (Annotated).* 2005

# Franz West

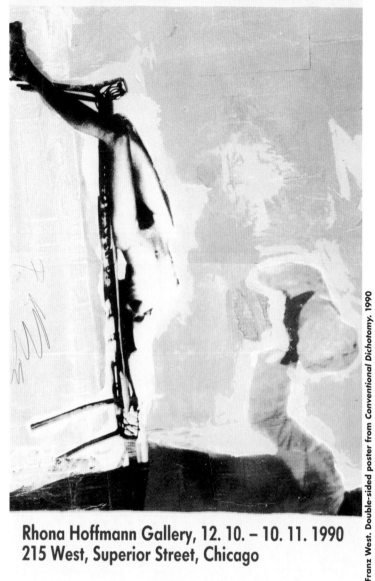

**Rhona Hoffmann Gallery, 12. 10. – 10. 11. 1990**
**215 West, Superior Street, Chicago**

Franz West. Double-sided poster from *Conventional Dichotomy*. 1990

Daniel Joseph Martinez. One from *If Only God Had Invented Coca Cola,*
*Sooner! Or, The Death of My Pet Monkey*. 2004

# CLOTHES
## WITH THE
# PERFUM
### OF THE
# ABSENT
## LIE IN
# RANDOM

FRANZ WEST · KONVENTIONE
DICHOTOMIE · JÄNNER GALER
WIEN · WIESINGER STRASSE 3/
6. 11. bis 7. 12. 90

# ALEKSANDRA MIR
# NAMING TOKYO

Since the mid-1990s, Aleksandra Mir (American and Swedish, born Poland 1967) has developed a practice that merges cultural anthropology and fine art, investigating social structures, globalization, and the contemporary urban experience. Often realized in the form of participatory projects with nontraditional modes of distribution, many of Mir's projects are ongoing, regularly reemerging in slightly modified forms depending on the time and place. Her elaborate mapping project *Naming Tokyo* (2003– ), for example, is organized around her solicitation from friends and colleagues of names for Tokyo's otherwise undesignated streets. In the project's various incarnations, this information takes shape alternately as printed maps given away for free, street signs, and, perhaps one day, guidebooks. The artist's light-handed and witty approach to her material often belies the heavier cultural and political content that it invokes. The colorful maps and playful descriptions of *Naming Tokyo* mask its underlying critique of colonialism, while the soft, sexualized forms in the poster *Please Be Gentle in Fallujah* (2005)[1] overshadow a swarm of bomber planes, referring to the United States' military attacks on the Iraqi city. In a recent project commissioned for the 2009 Venice Biennale, Mir explored cultural geography and displacement. *Venezia (all places contain all others)* (2009) consisted of one million fake postcards— ten thousand each of one hundred designs—combining stock images of generic or well-known scenery (such as a picturesque harbor or the New York City skyline) with the Italian city's name. Functioning as free souvenirs from the Biennale grounds, the postcards could be collected or written and mailed on the spot, using the two Italian postal system mailboxes in the exhibition space. As Mir has explained, "I think the optimal artwork is in constant circulation with the world around itself."[2]

**Christophe Cherix: How did the *Naming Tokyo* project come about?**

Aleksandra Mir: The project started as a commission at the invitation of Nicolas Bourriaud for his exhibition called *Global Navigation System* [2003]. The show was about mapping and related concepts. I have worked on maps my whole life, so the theme was not new to me. I focused in on Tokyo as the exhibition was at the Palais de Tokyo [in Paris], but that was not the real trigger. A lot of my friends had started to go to Japan, and there was this moment when a lot of New York artists were showing their work in Tokyo, and I never got an invitation. I thought, "Well, I'm going to explore Tokyo in my own way." I bought all the guidebooks, and as I was reading, I became really good at the geography. I started to learn the neighborhoods and the significance of all the areas and where people would go and what the tourist attractions were. And then, of course, I learned this little fact—that Tokyo doesn't have street names. For a Westerner, this makes it very, very confusing to get around. I thought that this was such an interesting, subversive gesture toward tourists, like not giving them a key. So the point of the project was to give Tokyo street names from Western culture to help Westerners navigate, so we could move in and make it easier for ourselves to take over the city. The first step was to contact a map manufacturer in Japan. The Palais de Tokyo helped me find one that actually works with GPS systems, and they had this blank map, an exact representation of Tokyo without any signifiers whatsoever.

**CC: Without any street names?**

**AM:** It was a clean, blank map with nothing on it, and they gave me the permission to use this image. Then I contacted my whole network of friends, from Lithuania, Mexico, Iceland . . . north and south, but basically within the Western hemisphere. I picked their brains, and I asked them to send me a list of terms on any subject close to their hearts, a theme that they felt specialized in.

**CC: You reached out to artists such as Jeremy Deller and Lucy McKenzie, and curators like Ina Blom and Raimundas Malašauskas. Did they know how their lists would be used?**

**AM:** Yes. I told them: "You will be honored with a neighborhood in Tokyo, and your list of names will be used for this neighborhood. The list should relate to a particular subject, and it

Please be Gentle

in Fallujah

*Please Be Gentle in Fallujah.* 2005
**Aleksandra Mir**

Top row: *Naming Tokyo (part I)*. 2003
Bottom row: *Naming Tokyo (part II)*. 2003

Aleksandra Mir

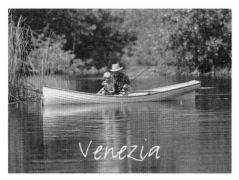
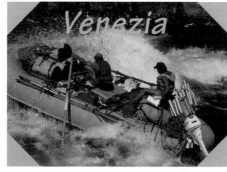
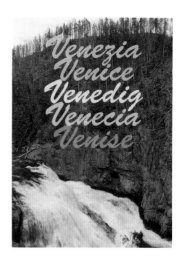
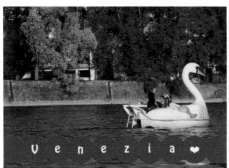
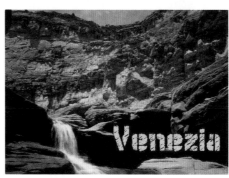
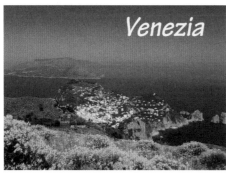
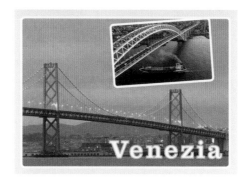
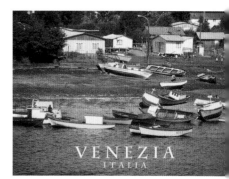
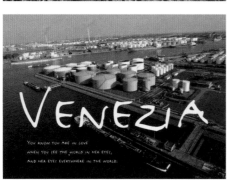
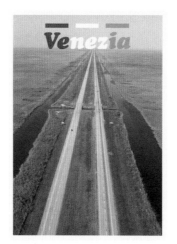
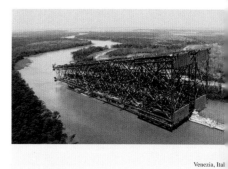
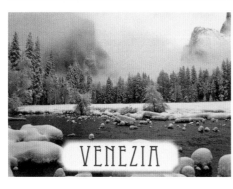
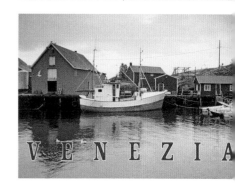

*Venezia (all places contain all others).* 2009

must be a subject that you understand very well." The response was incredible. At that time, I was part of an extensive network of people extremely responsive to these ideas. We were always collaborating and participating in each other's projects. I got a tremendous variety of names and explanations. The list is just beautiful. Everything had some strange, subversive connection to the city or to geography or to power. It wasn't art about art; it was really about a Western understanding of the world. I spent time implementing these neighborhoods and street names on the map according to what I knew about Tokyo, so everything was linked. The text about how I assigned the neighborhoods is published too.

Kim Conaty: These are the designations, printed on the back sides of the maps?

AM: Yes. Basically, I take each person's list and describe my intention behind its designated location, and it becomes a guided tour, a walk through the city. I merge the Western names and subjects with what is physically there in the space and also the history of the space.

CC: We have two versions of the map in the collection. The second one was made for your 2003 show at the Swiss Institute [New York], *Naming Tokyo (part II)*.

AM: Yes, Marc-Olivier Wahler invited me to do the project there, and we contacted the company that makes New York's street signs. They're still made in a workshop in Queens, and they also service the film industry with historical signs, because today they're all green, but originally each neighborhood in New York had a different color (I think the Bronx was brown, yellow was Brooklyn, and so on). The historical signs are incredibly beautiful as physical objects, and we commissioned the workshop to manufacture a series based on the Tokyo street names. I think I had about seven hundred names at the time of the first map, but, by the Swiss Institute, I had updated it to around a thousand names. We produced about fifty or sixty signs to fill the gallery space, and the signs kind of merged the project with New York City. Then we

reprinted the map, with some changes in the designations, so this became the second edition of the map.

CC: In both of these shows, the map was shown in a stack, and people could take copies freely. Did anyone contact you? Were you looking for further interaction, or was the distribution of the project more significant?

AM: I see this work as a lifelong project, and with each exhibition I build on the resources. I actually imagine the final conclusion of the project as having the street names up in Tokyo, for real. But that is such a utopian idea! Eventually, I might like to put out guidebooks and develop a situation where there would be a cross-reference, so that suddenly these maps would be functional.

New York, June 20, 2011

Notes

1   This work was shown as part of a larger series made for the exhibition *NEW DESIGNS: Birth, Death and Abortion*, at Andrew Roth Inc., New York, in 2005.
2   Aleksandra Mir, interview with Christopher Bollen, "Aleksandra Mir," *The Believer* 1, no. 9 (December 2003–January 2004): 82.

Thomas Schütte. Three from *Low Tide Wandering*. 2001

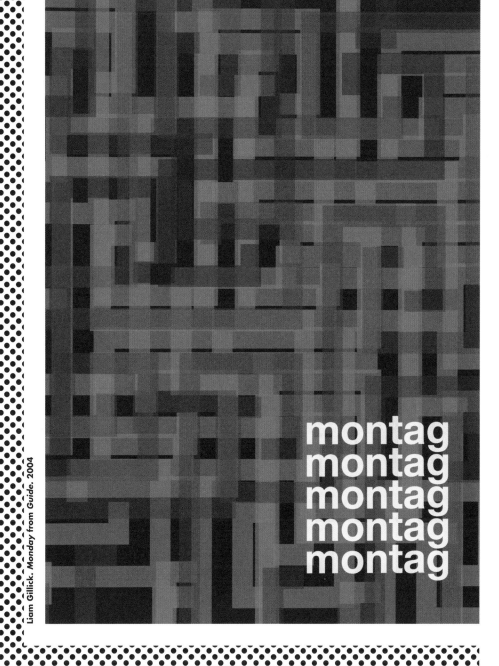

Liam Gillick. *Monday from Guide*. 2004

montag
montag
montag
montag
montag

Kara Walker. *Lost Mountain at Sunrise from Harper's
Pictorial History of the Civil War (Annotated)*. 2005

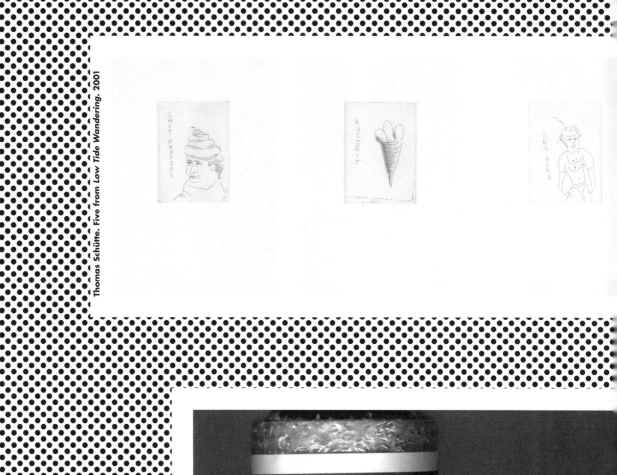

Thomas Schütte. *Five from Low Tide Wandering.* 2001

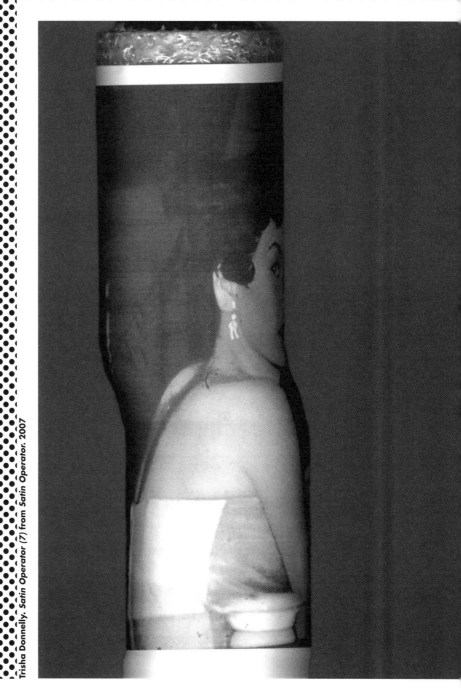

Trisha Donnelly. *Satin Operator (7)* from *Satin Operator.* 2007

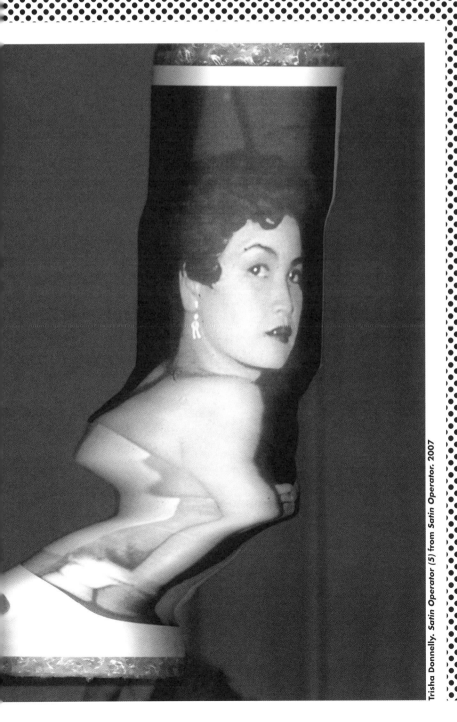

FrenziedidealismContempt for external perceptionPRE-REFLEXIVE COGITOINDIFFERENT OCULAR CARDIAC REFLEXESOrtho-sexuality shamefacedly admittedAbility to go straight to the heart of a doctrine To travel in an instant through various epochsIrritation at the suggestion that being may have preceded existence

Ideational fugacitySURPRISE ATTACKS BY SONOROUS PARACHUTE DROPS AND NOSE-DIVING NEOLOGISMS EXAGGERATED ANGULAR PARANOIAC LOGIC IN WHICH THERE IS MORE RIGOROUS NARROWNESS THAN NARROW RIGOROUSNESS

Daniel Joseph Martinez. One from If Only God Had Invented Coca Cola, Sooner! Or, The Death of My Pet Monkey. 2004

Trisha Donnelly. Satin Operator (5) from Satin Operator. 2007

Thomas Schütte. Two from Low Tide Wandering. 2001

# I PROMISE
## to be good

# sometimes
# I
# CAN'T
# BREATHE

Daniel Joseph Martinez. Two from *If Only God Had Invented Coca Cola, Sooner! Or, The Death of My Pet Monkey.* 2004

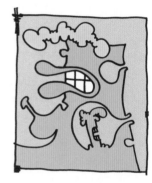

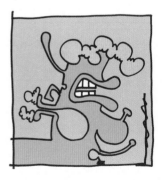

Carroll Dunham. Two from *Female Portraits.* 2000

Slavs and Tatars. One from *Nations.* 2007

# Nice tan,
# Turkmeni-
# stan!

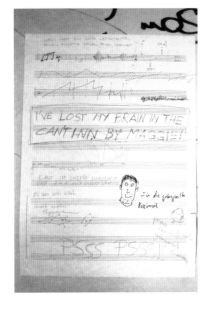
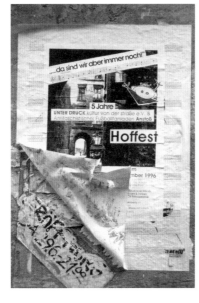
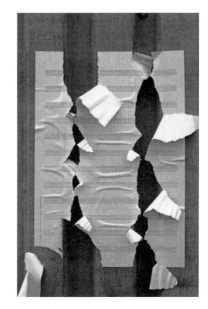

**Christian Marclay.** Selection from
*Graffiti Composition*, 2002

Thomas Schütte. Four from *Low Tide Wandering*. 2001

Daniel Joseph Martinez. One from *If Only God Had Invented Coca Cola,
Sooner! Or, The Death of My Pet Monkey*. 2004

Trisha Donnelly. *Satin Operator (1)* from *Satin Operator*. 2007

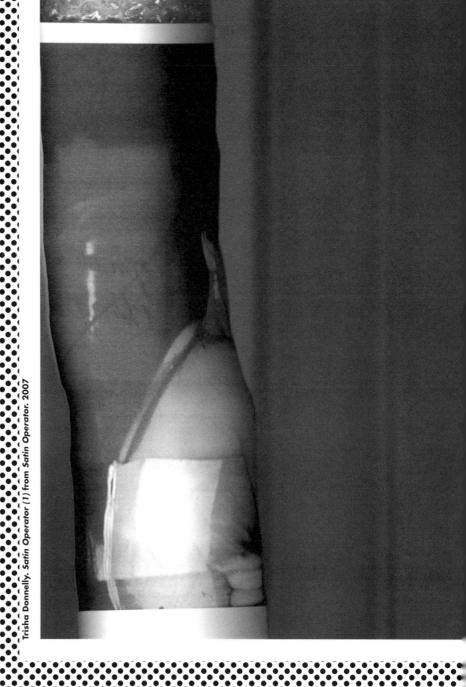

**she
asked him**

**about**
the medallion around his neck

**a dog tag from a war
which was yet to come**

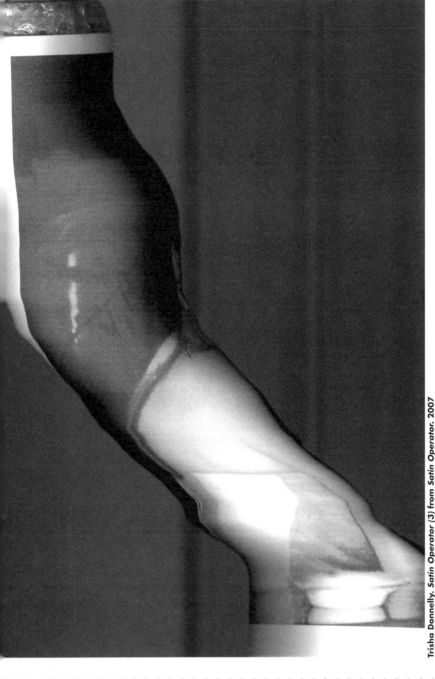

Trisha Donnelly. *Satin Operator (3)* from *Satin Operator*. 2007

Kara Walker. *Alabama Loyalists Greeting the Federal Gun-Boats* from *Harper's Pictorial History of the Civil War (Annotated)*. 2005

Kara Walker, *Pack-Mules in the Mountains from Harper's Pictorial History of the Civil War (Annotated)*, 2005

# ROBERT RAUSCHENBERG
# THE LOTUS
# SERIES

The Lotus Series (2008) is the last printed project completed by Robert Rauschenberg (American, 1925–2008) before his death. Ten of the twelve prints in the set combine intaglio printing—embossed photogravure of images of lotuses—and digital impressions based on the artist's photographs from his trips to China between 1982 and 1985. The two remaining prints, which are the only vertical images, were produced completely through digital processes. Although The Lotus Series is composed of large-scale prints, the source images were small, discolored photographs (the negatives were never found). In order to use the images for these prints, the photographs were digitally restored, enlarged, and printed on films that could be transferred by the artist onto boards. Once Rauschenberg had arranged the images on the boards, twelve of the fourteen resulting panels were scanned and proofed on a high-resolution sixty-inch-wide photographic printer acquired specifically for the project.

From the start of his practice in the late 1940s and early '50s and throughout his career, Rauschenberg aimed to integrate into his work both new technologies—he was closely involved with Experiments in Art and Technology (E.A.T.), founded by physicist Billy Klüver in 1966—and, as he explained, "actual elements from everyday life."[1] In his substantial production of paintings, drawings, and prints, for example, snapshots from travels, newspaper and magazine clippings, postcards, and other ephemera abound, whether in their original forms or as transferred images. His Thirty-Four Illustrations for Dante's Inferno (1958–60; p. 22), in the collection of The Museum of Modern Art, marks one of the artist's first uses of direct image transfer without resorting to collage. For this work, a selection of found printed images were humidified with a solvent and then rubbed from the back in order to transfer them onto sheets of paper. In the years to follow, Rauschenberg continued to experiment with transfer methods in a wide range of printing techniques, such as screenprinting, offset, and inkjet impressions, and, in the last two decades of his life, a variety of digital processes.

Printmaking played a key role in Rauschenberg's practice. At Universal Limited Art Editions (ULAE; Long Island, NY) in 1962, the artist began working with publisher Tatyana Grosman on ways to transfer images from magazines and various sources to printing plates. He was able to pursue these interests further at ULAE in 1969 with the arrival of Bill Goldston, a master printer who had developed new lithographic transfer techniques in the mid-1960s while studying with former ULAE printer Zigmund Priedes at the University of Minnesota and also while working as a commercial printer during his military service at Fort Jackson, South Carolina. Goldston and Rauschenberg worked closely throughout the 1970s, conducting a wide range of technical experiments to find, for example, a better way to photosensitize stones. In the late 1980s, the two became interested in computers and new printing plotters—technologies still considered "developing" at the time and generally held in lower regard than more traditional printing methods. It was the artist and printer's relentless curiosity and openness to new technologies that led to The Lotus Series, initiated in the summer of 2006.

This project stands out in Rauschenberg's printed oeuvre for its method of production and use of new printing tools rather than for its imagery. In fact, several of the source photographs, taken years earlier, had already appeared in photographic projects, such as Chinese Summerhall (1982–83). Published by Graphic Studio, at the University of South Florida, Tampa, this one-hundred-foot-long photograph consists of fifty-two enlarged cut-and-pasted color images from the set of over five hundred photographs taken by the artist in China. Rather than using a transfer process, as he did for The Lotus Series, Rauschenberg produced this work using a giant roll of photosensitive paper, exposing it section by section to produce the work.

While the imagery in The Lotus Series is hardly new, Rauschenberg's reuse of these motifs—more than two decades after he took the photographs—is itself a fascinating aspect of the project. There is a tension between the nostalgic, faded photos of China and the

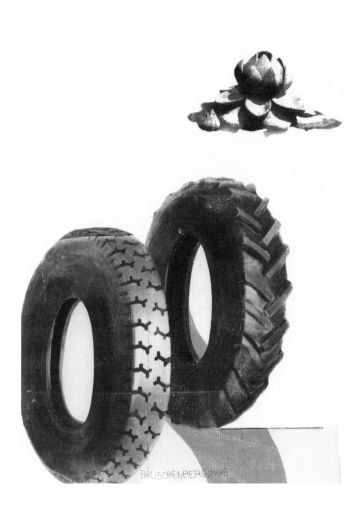

*Lotus II* from *The Lotus Series*. 2008
Robert Rauschenberg

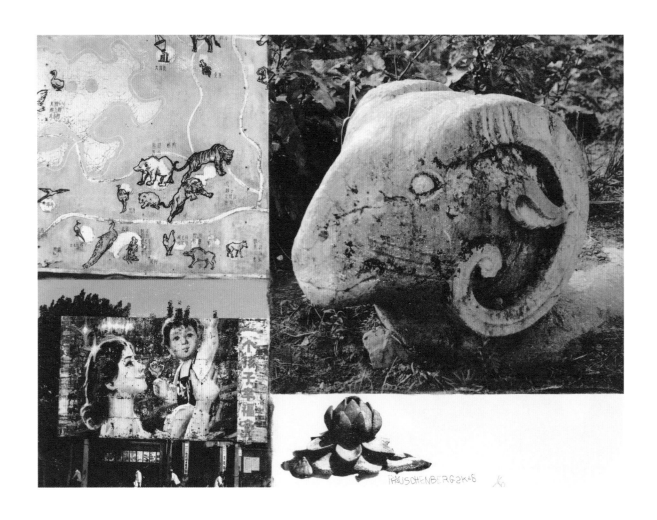

*Lotus X* from *The Lotus Series*. 2008

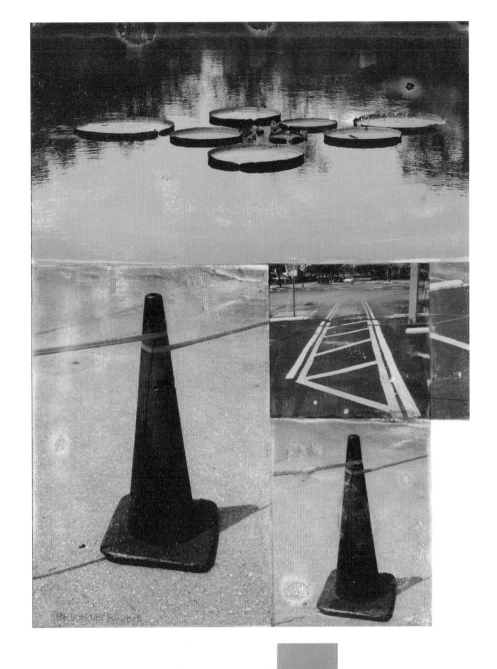

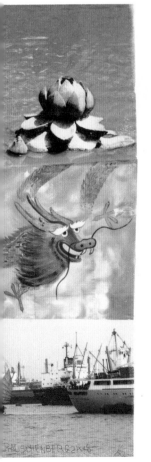

*Lotus Bed I* and *Lotus IV* from *The Lotus Series*. 2008
**Robert Rauschenberg**

*Lotus IX* and *Lotus VII* from *The Lotus Series*. 2008

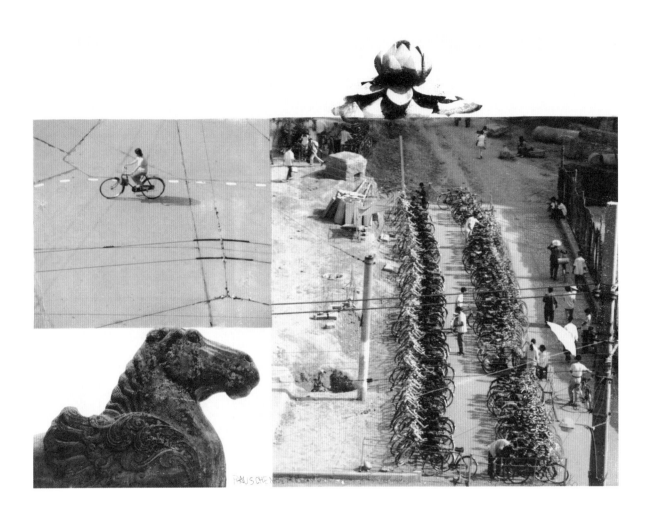

*Lotus VI* from *The Lotus Series.* 2008

**Robert Rauschenberg**

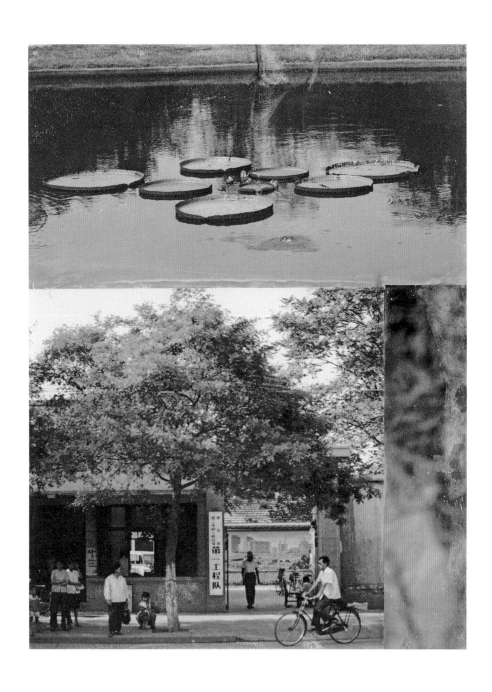

*Lotus Bed II* from *The Lotus Series*. 2008

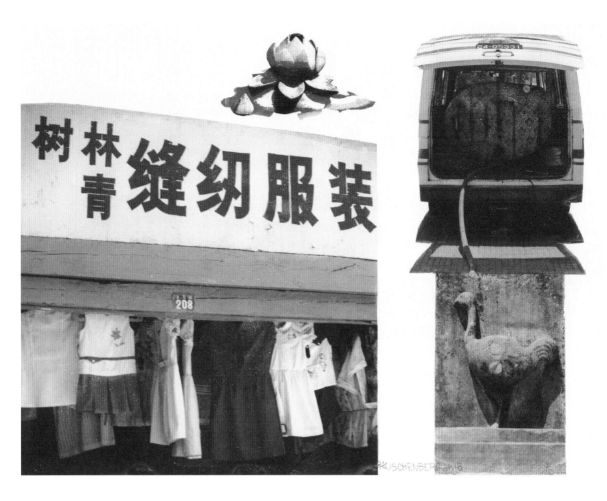

*Lotus VIII* and *Lotus III* from *The Lotus Series*. 2008
**Robert Rauschenberg**

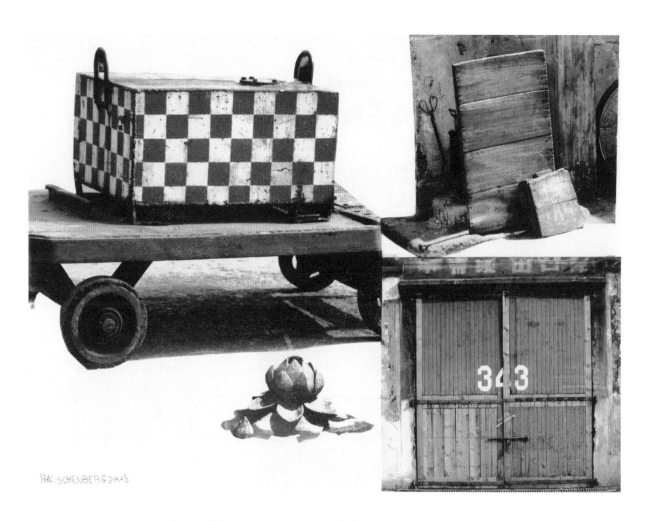

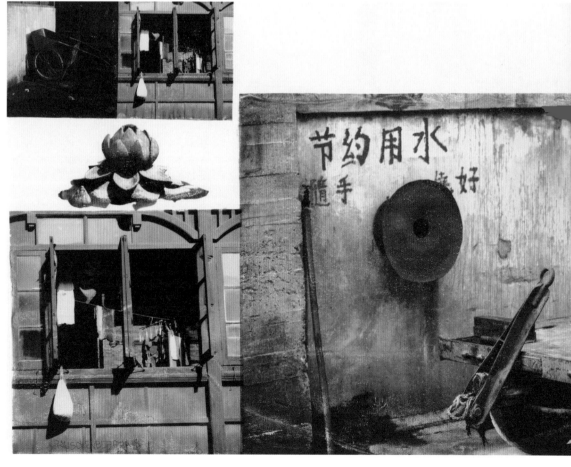

*Lotus I* and *Lotus V* from *The Lotus Series.* 2008

rendering of these in digitally enhanced colors and high-resolution output on paper. With this series, Rauschenberg blends tradition with innovation, prompting the viewer to look at the receding past with the hyperclarity that today's technology has made possible. Together, the twelve prints encourage a multilayered reflection on our very ability, or inability, to function in a constantly changing and developing environment.

—Christophe Cherix

Note

1   Robert Rauschenberg, quoted in Edward A. Foster, "Introduction," in *Robert Rauschenberg: Prints 1948/1970* (Minneapolis: The Minneapolis Institute of Arts, 1970), [6].

## Works in the Exhibition

The following is a list of works planned to be included in the exhibition *Print/Out*. Works followed by a page reference are reproduced in this volume. For dimensions, height precedes width precedes depth (where applicable), and all measurements refer to sheet size unless otherwise noted.

**MARINA ABRAMOVIĆ**
(Yugoslav, born 1946)

*Spirit Cooking.* 1997. Portfolio of eight etchings (four with aquatint and one with gold leaf), four aquatints with chine collé, and twenty-five letterpress prints, each 12 3/8 x 10 15/16" (31.5 x 27.8 cm). Publisher and printer: Edition Jacob Samuel, Santa Monica. Edition: 21. The Museum of Modern Art, New York. Monroe Wheeler Fund, 2011 (pp. 131–34)

References:
Biesenbach, Klaus. *Marina Abramović: The Artist Is Present.* Exh. cat. New York: The Museum of Modern Art, 2010.

Celant, Germano, ed. *Marina Abramović: Public Body: Installation and Objects, 1965–2001.* Milan: Charta, 2001.

**AI WEIWEI**
(Chinese, born 1957)

*The Black Cover Book.* 1994. Artist's book, page: 9 x 7" (22.9 x 17.8 cm); overall (closed): 9 x 7 3/16 x 3/8" (22.9 x 18.2 x 1 cm). Editors: Ai Weiwei, Xu Bing, and Zeng Xiaojun. Publisher: Tai Tei Publishing Company Limited, Hong Kong. Printer: unknown, Hong Kong. Edition: 3,000. The Museum of Modern Art, New York. Gift of the artist, 2011 (pp. 51–53)

*The White Cover Book.* 1995. Artist's book, page: 9 x 7" (22.9 x 17.8 cm); overall (closed): 9 x 7 3/16 x 1/2" (22.9 x 18.2 x 1.2 cm). Editors: Ai Weiwei and Zeng Xiaojun. Publisher: Tai Tei Publishing Company Limited, Hong Kong. Printer: unknown, Hong Kong. Edition: 3,000. The Museum of Modern Art, New York. Gift of the artist, 2011 (pp. 54–55)

*The Grey Cover Book.* 1997. Artist's book, page: 9 x 6 7/8" (22.8 x 17.5 cm); overall (closed): 9 x 7 x 7/16" (22.8 x 17.8 x 1.1 cm). Editors: Ai Weiwei and Zeng Xiaojun. Publisher and printer: unknown. Edition: 3,000. The Museum of Modern Art, New York. Gift of the artist, 2011 (pp. 56–57)

*Fuck Off.* 2000. Exhibition catalogue, page: 9 3/4 x 8 3/16" (24.8 x 20.8 cm); overall (closed): 9 3/4 x 8 1/4 x 11/16" (24.8 x 21 x 1.8 cm). Editors: Ai Weiwei, Feng Boyi, and Hua Tianxue. Publisher: Eastlink Gallery, Shanghai. Printer: unknown, Shanghai. Edition: 10,000. The Museum of Modern Art, New York. Gift of the artist, 2011 (p. 58)

References:
Merewether, Charles, ed. *Ai Weiwei. Works: Beijing 1993–2003.* Hong Kong: Timezone 8, 2003.

Smith, Karen. *Ai Weiwei.* London: Phaidon, 2009.

Thea, Carolee. "Making Everything: A Conversation with Ai Weiwei." *Sculpture* 27, no. 10 (December 2008): 24–29.

Tinari, Philip. "Some Simple Reflections on an Artist in a City, 2001–2007." *Parkett,* no. 81 (2007): 110–21.

**CHRIS BURDEN**
(American, born 1946)

*Coyote Stories.* 2005. Portfolio of ten etchings (five with aquatint) and twenty-five digital prints with chine collé, each 14 15/16 x 12 3/8" (38 x 31.5 cm). Publisher and printer: Edition Jacob Samuel, Santa Monica. Edition: 18. The Museum of Modern Art, New York. Monroe Wheeler Fund, 2011 (pp. 136–39)

Reference:
Hoffman, Fred, ed. *Chris Burden.* Newcastle upon Tyne: Locus Plus, 2007.

**MAURIZIO CATTELAN** (Italian, born 1960) with **DOMINIQUE GONZALEZ-FOERSTER** (French, born 1965; issues 1–2) and **PAOLA MANFRIN** (Italian, born 1960)

*Permanent Food.* 1996–2007. Magazine (issues 1–12, 14–15, and special issue 634), issue 1: 10 x 7" (25.4 x 17.8 cm); issues 2–11, 14: 9 1/4 x 6 3/4" (23.5 x 17.1 cm); issue 12: 11 x 8" (27.9 x 20.3 cm); issue 15: 10 3/4 x 8" (27.3 x 20.3 cm); special issue: 10 3/4 x 8 1/4" (27.3 x 21 cm). Publishers: A&M Bookstore, Milan, L'Association des Temps Libérés, and Le Consortium, Dijon (issue 1); L'Association des Temps Libérés (issues 2–5); Les Presses du réel, Dijon (issues 6–15, special issue 634). Collection of Philip Aarons and Shelley Fox Aarons, New York (p. 165)

References:
Aletti, Vince. "Hunting and Gathering: Plundering the Image Bank with Cattelan and Feldmann." *Village Voice* (April 17–23, 2002): 55.

Brand, Victor. "Permanent Food." In *In Numbers: Serial Publications by Artists Since 1955,* edited by Philip E. Aarons and Andrew Roth, 306–13. Zurich: PPP Editions in association with Andrew Roth Inc., 2009.

Cattelan, Maurizio. "Magnetism and Drama: A Conversation with Maurizio Cattelan." Interview by Andrea Bellini. *Sculpture* 24, no. 7 (September 2005): 54–59.

Gioni, Massimiliano. "Permanent Food: What Do Pictures Want?" In Nancy Spector, *Theanyspacewhatever*, 160–66. Exh. cat. New York: Solomon R. Guggenheim Museum, 2008.

Manfrin, Paola. "Permanent Food." Interview by Robert Bagatti. *Shift Magazine*. Accessed August 15, 2011. http://www.shift.jp.org/en/ archives/2004/06/ permanent_food.html.

**TRISHA DONNELLY**
(American, born 1974)

*Satin Operator*. 2007. Thirteen digital prints, each 62 1/2 x 44" (158.8 x 111.8 cm). Edition: 3. Publisher and printer: the artist, New York and San Francisco. The Museum of Modern Art, New York. The Print Associates Fund and General Print Fund, 2011 (pp. 66–67, 124–25, 146–47, 152, 168, 181, 198–99, 202–03)

References:
Hoptman, Laura. "Electricity." *Parkett*, no. 77 (September 2006): 67–69.

Obrist, Hans-Ulrich. "Trisha Donnelly: She Said." *Flash Art* 39 (March–April 2006): 58–60.

Ou, Arthur. "Trisha Donnelly: The Orbiter." *Aperture*, no. 203 (Summer 2011): 60–65.

Porter, Jenelle. *Trisha Donnelly*. Exh. cat. Philadelphia: Institute of Contemporary Art, 2008.

Ruf, Beatrix. "Trisha Donnelly." *Parkett*, no. 77 (September 2006): 92–99.

**CARROLL DUNHAM**
(American, born 1949)

*Female Portraits*. 2000. Portfolio of thirteen lithographs, each (orientation varies) 17 1/8 x 13 1/4" (43.5 x 33.6 cm). Publisher and printer: Universal Limited Art Editions, Bay Shore, New York. Edition: 23. The Museum of Modern Art, New York. Gift of Emily Fisher Landau, 2001 (pp. 41, 66–67, 108, 121, 126, 200)

*The Sun*. 2000–01. Digital print, 43 1/8 x 53 9/16" (109 x 136 cm). Publisher and printer: Universal Limited Art Editions, Bay Shore, New York. Edition: 23. The Museum of Modern Art, New York. Gift of Emily Fisher Landau, 2001

References:
Hirsch, Faye. "Dunham's Demonology." *Art in America* 91, no. 1 (January 2003): 66–73.

Kemmerer, Allison N., Elizabeth C. DeRose, and Carroll Dunham. *Carroll Dunham: Prints Catalogue Raisonné 1984–2006*. New Haven, Conn.: Yale University Press; Andover, Mass.: Addison Gallery of American Art, Phillips Academy, 2008.

Tallman, Susan. "Carroll Dunham." *Print Quarterly* 26, no. 1 (March 2009): 84–86.

– – –. "Hot Pink Souls Ice: The Printed Work of Carroll Dunham." *Art on Paper* 5, no. 4 (March–April 2001): 44–53.

**ELLEN GALLAGHER**
(American, born 1965)

*DeLuxe*. 2004–05. Portfolio of sixty photogravure, etching, aquatint, and drypoints with lithography, screenprint, embossing, tattoo-machine engraving, laser cutting, and chine collé; some with additions of Plasticine, paper collage, enamel, varnish, gouache, pencil, oil, polymer, watercolor, pomade, velvet, glitter, crystals, foil paper, gold leaf, toy eyeballs, and imitation ice cubes, each 13 x 10 1/2" (33 x 26.7 cm); overall 7' x 13' 11" (213.4 x 424.2 cm). Publisher and printer: Two Palms Press, New York. Edition: 20. The Museum of Modern Art, New York. Acquired through the generosity of The Friends of Education of The Museum of Modern Art and The Speyer Family Foundation, Inc. with additional support from the General Print Fund, 2004 (pp. 24, 111–14)

References:
" 'eXelento' & 'DeLuxe.' " Interview with Ellen Gallagher. Art21. Accessed September 22, 2011. http:// www.pbs.org/art21/artists/ gallagher/clip1.html.

Gerson, Scott, and Sarah Suzuki. "Ellen Gallagher's *DeLuxe*: An Investigation of the Materials and Techniques of Contemporary Printmaking." In *Printed on Paper: The Techniques, History and Conservation of Printed Media*, edited by Jane Colbourne and Reba Fishman Snyder, 157–64. Newcastle upon Tyne: Arts and Social Sciences Academic Press, Northumbria University, 2009.

Goodeve, Thyrza Nichols. "The History Lesson: Flesh Is a Texture as Much as Color." *Parkett*, no. 73 (2005): 39–53.

"Hand Work." *Art on Paper* 8, no. 1 (September/October 2003): 34–35.

Hudson, Suzanne P. "Ellen Gallagher Talks about Pomp-Bang, 2003." *Artforum* 42, no. 8 (April 2004): 128–31.

Marcoci, Roxana. "From Face to Mask: Collage, Montage, and Assemblage in Contemporary Portraiture." In *Modern Women*, edited by Cornelia Butler and Alexandra Schwartz, 462–79. New York: The Museum of Modern Art, 2010.

## GENERAL IDEA
Artists' group (AA Bronson [Canadian, born 1946]; Felix Partz [Canadian, 1945–1994]; and Jorge Zontal [Canadian, born Italy. 1944–1994]), active 1968–1994

*Magi© Bullet*. 1992. Installation of custom-shaped Mylar balloons, dimensions variable. Edition: 3. The Museum of Modern Art, New York. Gift of Mark Krayenhoff, 2008 (p. 127)

References:
Bonnet, Frédéric, ed. *General Idea: Haute Culture: A Retrospective, 1969–1994*. Exh. cat. Zurich: JRP/Ringier, 2011.

Fischer, Barbara, ed. *General Idea Editions, 1967–1995*. Mississauga, Ontario: Blackwood Gallery, 2003.

Gallo, Peter. "Multiples: The Enduring Ephemera of General Idea." *Art in America* 93, no. 3 (March 2005): 80–83.

## LIAM GILLICK
(British, born 1964)

*Guide*. 2004. Portfolio of five screenprints, 46 3/4 x 33 1/16" (118.7 x 84 cm). Publisher: Sabine Knust/Maximilian Verlag, Munich. Printer: Christian Zickler, Frankfurt. Edition: 20. The Museum of Modern Art, New York. Donald B. Marron Fund, 2008 (pp. 43, 81, 161, 187, 197)

*See also museum in progress*

References:
Bourriaud, Nicolas, Liam Gillick, and Isabelle Moffat. *Liam Gillick: ein langer Spaziergang—zwei kurze Stege (One Long Walk—Two Short Piers)*. Cologne: Snoeck, 2010.

Bovier, Lionel, ed. *Proxemics: Selected Writings, 1988–2006/Liam Gillick*. Zurich: JRP/Ringier; Dijon: Les Presses du réel, 2006.

Estep, Jan. "Negotiating the Built World: A Conversation with Liam Gillick." *New Art Examiner* 29, no. 5 (May/June 2002): 52–65.

Szewczyk, Monika, and Stefan Kalmár, eds. *Meaning Liam Gillick*. Exh. cat. Zurich: Kunsthalle Zurich; Cambridge, Mass.: The MIT Press, 2009.

## FELIX GONZALEZ-TORRES
(American, born Cuba. 1957–1996)

*"Untitled"*. 1991. Billboard, dimensions vary with installation. The Museum of Modern Art, New York. Gift of Werner and Elaine Dannheisser, 1996 (p. 185)

*See also museum in progress*

References:
Ault, Julie, ed. *Felix Gonzalez-Torres*. New York and Göttingen, Germany: SteidlDangin, 2006.

Elger, Dietmar, ed. *Felix Gonzalez-Torres: Catalogue Raisonné*. 2 vols. Ostfildern, Germany: Cantz Verlag, 1997.

Spector, Nancy. *Felix Gonzalez-Torres*. Exh. cat. New York: Solomon R. Guggenheim Museum, 1995.

Umland, Anne. *Projects 34: Felix Gonzalez-Torres*. Exh. brochure. New York: The Museum of Modern Art, 1992.

## DAMIEN HIRST
(British, born 1965)

*The Last Supper*. 1999. Portfolio of thirteen screenprints, each (orientation varies) 60 x 40" (152 x 101.5 cm). Publisher: The Paragon Press, London. Printer: Coriander Press, London. Edition: 150. The Museum of Modern Art, New York. Monroe Wheeler Memorial Fund, Roxanne H. Frank Fund, and partial gift of Charles Booth-Clibborn, 1999 (pp. 41, 42, 46, 48, 65, 102, 106, 108, 121, 123, 126, 128, 150)

References:
Burn, Gordon, and Damien Hirst. *On the Way to Work*. New York: Universe, 2002.

*Cornucopia: Damien Hirst*. London: Other Criteria, 2010.

Lewison, Jeremy. "Contemporary British Art in Print?" In *Contemporary Art in Print: The Publications of Charles Booth-Clibborn and His Imprint The Paragon Press, 1995–2000*, edited by Patrick Elliot, 13–21. London: Booth-Clibborn Editions, 2001.

Pelzer-Montada, Ruth. "The Discursivity of Print: Damien Hirst's Series The Last Supper (1999)." *Visual Culture in Britain* 9, no. 1 (2008): 81–100.

## MARTIN KIPPENBERGER
(German, 1953–1997)

*Inhalt auf Reisen (Content on Tour)*. 1992. Screenprints mounted on plywood, each with unique alterations by the artist, in four sizes: 70 7/8 x 59" (180 x 150 cm); 47 1/4 x 39 3/8" (120 x 100 cm); 35 7/16 x 27 1/2" (90 x 70 cm); and 23 5/8 x 19 11/16" (60 x 50 cm). Publisher: Edition Artelier, Graz, Austria. Edition: 3 of largest size, 5 of other sizes. Estate of Martin Kippenberger, courtesy Galerie Gisela Capitain, Cologne (pp. 35–37)

References:
Goldstein, Ann. *Martin Kippenberger: The Problem Perspective*. Exh. cat. Los Angeles: The Museum of Contemporary Art, 2008.

Grässlin, Karola, ed. *Kippenberger: Multiples*. Cologne: Verlag der Buchhandlung Walther König, 2003.

Graw, Isabelle. "Der Komplex Kippenberger." *Texte zur Kunst* 7, no. 26 (June 26, 1997): 44–73.

Krystof, Doris, and Jessica Morgan, eds. *Martin Kippenberger*. Exh. cat. London: Tate Publishing, 2006.

**GUILLERMO KUITCA**
(Argentine, born 1961)

*Cuarta Pared* (*Fourth Wall*). 1997. Lithograph and etching, 22 1/4 x 30 1/8" (56.5 x 76.5 cm). Publisher and printer: Polígrafa Obra Gráfica, Barcelona. Edition: 35. The Museum of Modern Art, New York. Committee on Prints and Illustrated Books Fund, 2011
(p. 83)

*Doble Teatro* (*Double Theater*). 1997. Lithograph and etching, 22 5/16 x 30 5/16" (56.8 x 77 cm). Publisher and printer: Polígrafa Obra Gráfica, Barcelona. Edition: 35. The Museum of Modern Art, New York. Committee on Prints and Illustrated Books Fund, 2011
(p. 83)

*Sin título 1* (*Untitled 1*). 1997. Lithograph and etching, 22 5/16 x 30 5/16" (56.8 x 77 cm). Publisher and printer: Polígrafa Obra Gráfica, Barcelona. Edition: 35. The Museum of Modern Art, New York. Committee on Prints and Illustrated Books Fund, 2011
(p. 83)

*Sin título 2* (*Untitled 2*). 1997. Lithograph and etching, 22 7/16 x 30 1/4" (57 x 76.8 cm). Publisher and printer: Polígrafa Obra Gráfica, Barcelona. Edition: 35. The Museum of Modern Art, New York. Committee on Prints and Illustrated Books Fund, 2011
(p. 83)

References:
Barlow, Stephen. *Guillermo Kuitca: Stage Fright*. New York: Sperone Westwater, 2007.

Dreishpoon, Douglas. *Guillermo Kuitca: Everything, Paintings and Works on Paper, 1980–2008*. London: Scala, 2009.

**CHRISTIAN MARCLAY**
(American, born 1955)

*Graffiti Composition*. 2002. Portfolio of one hundred fifty digital prints, each 13 x 8 7/16" (33 x 21.5 cm). Publisher: Paula Cooper Gallery, New York. Printers: Muse X Editions, Los Angeles; Star Link Company, Torrance, California; Meridian Printing, East Greenwich, Rhode Island. Edition: 25. The Museum of Modern Art, New York. Donald B. Marron Fund, 2003
(selected prints p. 201)

References:
Ferguson, Russell. *Christian Marclay*. Exh. cat. Los Angeles: UCLA Hammer Museum, 2003.

González, Jennifer, Kim Gordon, and Matthew Higgs. *Christian Marclay*. London: Phaidon, 2005.

Mavridorakis, Valérie, and David Perreau. *Christian Marclay: Snap!* Dijon: Les Presses du réel, 2009.

Tallman, Susan. "Always This Tüdelditüt: Christian Marclay's 'Graffiti Composition.'" *Art on Paper* 4, no. 6 (July–August 2000): 28–33.

**DANIEL JOSEPH MARTINEZ**
(American, born 1957)

*If Only God Had Invented Coca Cola, Sooner! Or, The Death of My Pet Monkey*. 2004. Portfolio of twenty-three screenprints with letterpress, each 27 15/16 x 21 15/16" (71 x 55.8 cm). Publishers: the artist, Los Angeles, and San Juan Triennial, La Perla, Puerto Rico. Printer: Colby Poster, Los Angeles. Edition: 5. The Museum of Modern Art, New York. Committee on Prints and Illustrated Books Fund, 2011
(pp. 67, 81, 83, 85, 87, 104, 125, 146, 150, 163, 164, 181, 182, 184, 188, 199, 200, 202)

References:
Brenson, Michael, et al. *Daniel Joseph Martinez: A Life of Disobedience*. Ostfildern, Germany: Hatje Cantz Verlag, 2009.

Bui, Phong. "In Conversation: Daniel Joseph Martinez with Phong Bui." *Brooklyn Rail* (March 2010): 26–29.

Kinney, Tulsa. "Daniel Joseph Martinez: Interview." *Artillery* 5, no. 3 (January/February 2011): 28–35.

**LUCY MCKENZIE**
(Scottish, born 1977)

*Aesthetic Integration Scotland*. 2001. Linoleum cut with banknote collage addition, 16 9/16 x 11 11/16" (42 x 29.7 cm). Publisher and printer: the artist, Glasgow. Edition: unlimited. The Museum of Modern Art, New York. Fund for the Twenty-First Century, 2007

*Global Joy IV*. 2001. Linoleum cut, 11 11/16 x 16 9/16" (29.7 x 42 cm). Publisher and printer: the artist, Glasgow. Edition: unlimited. The Museum of Modern Art, New York. Fund for the Twenty-First Century, 2007

*Olympic Dames*. 2002. Lithograph, offset printed, 31 7/16 x 46 13/16" (79.8 x 118.9 cm). Publishers: Cabinet Gallery, London, and Galerie Daniel Buchholz, Cologne. Printer: Gefeller Siebdruck, Neuss, Germany. Edition: 50. The Museum of Modern Art, New York. Fund for the Twenty-First Century, 2007
(p. 171)

*Flourish Night Posters*. 2002–03. Series of seven screenprints and one with stamp and conté crayon (with Linder Sterling [British, born 1954]), each 23 1/4 x 16 9/16" (59 x 42 cm). Publisher and printer: the artist, Glasgow. Edition: unlimited. The Museum of Modern Art, New York. Fund for the Twenty-First Century, 2007
(pp. 172, 175)

*1928*. 2003. Screenprint, 23 3/8 x 16 9/16" (59.4 x 42 cm). Publisher and printer: the artist, Glasgow. Edition: 35. The Museum of Modern Art, New York. Fund for the Twenty-First Century, 2007

Lucy McKenzie with Paulina Olowska (Polish, born 1976). *Nova Popularna*. 2003. Series of six screenprints, each approx. 26 x 15 15/16" (56 x 40.5 cm). Publisher: Foksal Gallery Foundation, Warsaw. Printer: Lucy McKenzie, Warsaw. Edition: 10. The Museum of Modern Art, New York. Fund for the Twenty-First Century, 2007 (pp. 176–77)

*Untitled*. 2003. Lithograph, offset printed, 16 9/16 x 23 7/16" (42 x 59.5 cm). Publisher: Texte zur Kunst, Berlin. Printer: unknown, Cologne. Edition: 50. The Museum of Modern Art, New York. Fund for the Twenty-First Century, 2007

*Untitled*. 2003. Screenprint, 16 9/16 x 23 3/8" (42 x 59.4 cm). Publisher and printer: the artist, Glasgow. Edition: 10. The Museum of Modern Art, New York. Fund for the Twenty-First Century, 2007

*Nova Popularna*. 2004. Screenprint, 23 7/16 x 16 1/2" (59.5 x 41.9 cm). Publisher: Decemberism, Glasgow. Printer: the artist, Glasgow. Edition: unlimited. The Museum of Modern Art, New York. Fund for the Twenty-First Century, 2007

*Untitled* (for *Parkett* no. 76). 2006. Screenprint, 28 9/16 x 22 1/16" (72.6 x 56.1 cm). Publisher: Parkett Publishers, Zurich and New York. Printer: Bernie Reid, Edinburgh. Edition: 60. The Museum of Modern Art, New York. General Print Fund, 2006 (p. 178)

References:
Engelbach, Barbara. *Lucy McKenzie: Editionen*. Exh. brochure. Cologne: Strzelecki Books, 2010.

McKenzie, Lucy. *Chêne de Weekend: Lucy McKenzie, 2006–2009*. Cologne: Verlag der Buchhandlung Walther König, 2009.

Seewald, Jan, and Stephan Urbaschek, eds. *Noël sur le balcon/HOLD THE COLOR: Paulina Olowska/Lucy McKenzie*. Munich: Sammlung Goetz, 2007.

**JULIE MEHRETU**
(American, born Ethiopia 1970)

*Rouge Ascension*. 2002. Lithograph on three sheets, 24 9/16 x 32" (62.4 x 81.3 cm). Publisher: The New Museum of Contemporary Art, New York. Printer: Derrière L'Étoile Studios, New York. Edition: 35. The Museum of Modern Art, New York. Acquired through the generosity of Marian and James Cohen in memory of their son Michael Harrison Cohen, 2002

*Landscape Allegories*. 2004. Series of seven etching, engraving, drypoint, and aquatints, each 19 x 21 3/4" (48.3 x 55.2 cm). Publishers: The Project Gallery, New York, and Ridinghouse Editions, London. Printer: Burnet Editions, New York. Edition: 35. The Museum of Modern Art, New York. Anna Marie and Robert F. Shapiro Fund, Miranda Kaiser Fund, Marnie Pillsbury Fund, and Patricia P. Irgens Larsen Foundation Fund, 2004 (pp. 44–45)

References:
Allen, Siemon, Rebecca R. Hart, and Kinsey Katchka. *Julie Mehretu: City Sightings*. Exh. cat. Detroit: Detroit Institute of Arts, 2007.

Chua, Lawrence, Cay Sophie Rabinowitz, Marcus Steinweg, and Augustín Pérez Rubio. *Julie Mehretu: Black City*. Exh. cat. Léon: MUSAC, Museo de Arte Contemporáneo de Castilla y León; Ostfildern, Germany: Hatje Cantz Verlag, 2006.

Mehretu, Julie, and Siri Engberg. *Excavations: The Prints of Julie Mehretu*. Minneapolis: Highpoint Editions, 2011.

Young, Joan. *Julie Mehretu: Grey Area*. Exh. cat. New York: The Solomon R. Guggenheim Foundation, 2009.

**ALEKSANDRA MIR**
(American and Swedish, born Poland 1967)

*Naming Tokyo (part I)*. 2003. Double-sided lithograph, offset printed, 27 9/16 x 39 3/8" (70 x 100 cm). Publishers: the artist and Palais de Tokyo, Paris. Printer: unknown, Paris. Edition: 10,000. The Museum of Modern Art, New York. General Print Fund, 2007 (pp. 192–93)

*Naming Tokyo (part II)*. 2003. Double-sided lithograph, offset printed, 27 9/16 x 39 3/8" (70 x 100 cm). Publishers: the artist and Swiss Institute, New York. Printer: unknown, New York. Edition: 5,000. The Museum of Modern Art, New York. General Print Fund, 2007 (pp. 192–93)

*Please Be Gentle in Fallujah*. 2005. Digital print, 62 3/16 x 44 1/8" (158 x 112 cm). Publishers: the artist and Andrew Roth Inc., New York. Printer: Top Notch Graphics, New York. Edition: 15. The Museum of Modern Art, New York. General Print Fund, 2007 (p. 191)

*Venezia (all places contain all others)*. 2009. Series of one hundred postcards, each (orientation varies) 4 1/4 x 6" (10.8 x 15.2 cm). Publisher: the artist, Palermo. Printer: Ringier, Zurich. Edition: 10,000 each (1,000,000 total). Courtesy the artist (pp. 19, 194)

References:
Bollen, Christopher. "Aleksandra Mir." *The Believer* 1, no. 9 (December 2003–January 2004): 81–90.

Brand, Victor. "Living & Loving." In *In Numbers: Serial Publications by Artists Since 1955*, edited by Philip E. Aarons and Andrew Roth, 244–47. Zurich: PPP Editions in association with Andrew Roth Inc., 2009.

Kastner, Jeffrey. "Aleksandra Mir, Swiss Institute." *Artforum* 24, no. 6 (February 2004): 152–53.

Laster, Paul. "Aleksandra Mir: Naming Tokyo." *ART AsiaPacific*, no. 41 (Summer 2004): 24–25.

Mir, Aleksandra. "Venice Biennale 2009: Interview with Aleksandra Mir." By Roberto Capanni and Roberto Balo Lorenzo. ADGBlog, May 28, 2009. http://www.adgblog.it/2009/05/28/venice-biennale-2009-interview-with-aleksandra-mir.

## MATT MULLICAN
(American, born 1951)

*88 Maps*. 2010. Unbound illustrated book with twenty-eight graphite rubbings, fourteen with screenprint additions, page (folded): 24 7/8 x 12 3/4 x 1 5/16" (63.2 x 32.4 x 3.3 cm); page (unfolded): dimensions vary. Publisher and printer: Three Star Books, Paris. Edition: 20. The Museum of Modern Art, New York. Monroe Wheeler Fund, 2010
(pp. 62–63)

References:
Griffin, Tim, and Clifford Passen. "What Is That Person Thinking: An Interview with Matt Mullican." *Artforum* 47, no. 5 (January 2009): 178–86.

Princenthal, Nancy. "Matt Mullican's Etchings: Rereading the Looking Glass." *Print Collector's Newsletter* 20, no. 5 (November–December 1989): 166–68.

Rollig, Stella. *Matt Mullican: Model Architecture.* Ostfildern, Germany: Hatje Cantz Verlag, 2006.

## MUSEUM IN PROGRESS
Vienna-based arts association, founded 1990 by Kathrin Messner and Josef Ortner

Selected projects by Werner Büttner (German, born 1954); Claude Closky (French, born 1963); Roberto Cuoghi (Italian, born 1973); Hans-Peter Feldmann (German, born 1941); Liam Gillick (British, born 1964); Felix Gonzalez-Torres (American, born Cuba. 1957–1996); Aleksandar Battista Ilić (Croatian, born 1965) in collaboration with Ivana Keser (Croatian, born 1967) and Tomislav Gotovac (Croatian, born Serbia. 1937–2010); IRWIN (Slovenian artists' group, founded 1983); Andreas Slominski (German, born 1959); Rirkrit Tiravanija (Thai, born Argentina 1961); Kara Walker (American, born 1969); and Heimo Zobernig (Austrian, born 1958), among others. Archive of newspaper and magazine projects, dimensions vary. The Museum of Modern Art, New York. Linda Barth Goldstein Fund, 2006
(projects by artists listed above, pp. 71–78)

References:
Birnbaum, Daniel, and Hans-Ulrich Obrist. "Museums on the Move." *Artforum* 48, no. 10 (Summer 2010): 301–06.

Fleck, Robert. "Museum und Concept Art." *Museum in Progress*, 1992. http://www.mip.at/attachments/234.

Messner, Kathrin, and Josef Ortner, eds. *museum in progress.* Vols. 1.1–1.3. Vienna: museum in progress, 2000.

## YOSHITOMO NARA
(Japanese, born 1959)

*Become to Thinker*. 2002. Etching, aquatint, and drypoint, 19 5/16 x 14 15/16" (49 x 37.9 cm). Publishers: the artist and Kido Press, Tokyo. Printer: Kido Press, Tokyo. Edition: 35. The Museum of Modern Art, New York. Katsko Suzuki Memorial Fund, 2002
(p. 64)

*Green Eyes*. 2002. Etching, aquatint, and drypoint, 19 3/16 x 14 15/16" (48.8 x 37.9 cm). Publishers: the artist and Kido Press, Tokyo. Printer: Kido Press, Tokyo. Edition: 35. The Museum of Modern Art, New York. Katsko Suzuki Memorial Fund, 2002
(p. 65)

*Haze Day*. 2002. Etching, aquatint, and drypoint, 19 1/4 x 14 15/16" (48.9 x 37.9 cm). Publishers: the artist and Kido Press, Tokyo. Printer: Kido Press, Tokyo. Edition: 35. Collection of John Silberman and Elliot Carlen, New York

*Night Walker*. 2002. Etching, aquatint, and drypoint, 19 1/4 x 14 15/16" (48.9 x 37.9 cm). Publishers: the artist and Kido Press, Tokyo. Printer: Kido Press, Tokyo. Edition: 35. Courtesy of Marianne Boesky Gallery, New York
(p. 64)

*N.Y. (Self-Portrait)*. 2002. Etching and aquatint, 19 1/4 x 14 15/16" (48.9 x 38 cm). Publishers: the artist and Kido Press, Tokyo. Printer: Kido Press, Tokyo. Edition: 35. The Museum of Modern Art, New York. Katsko Suzuki Memorial Fund, 2002
(p. 65)

*Spockie*. 2002. Etching and aquatint, 19 5/16 x 14 15/16" (49 x 38 cm). Publishers: the artist and Kido Press, Tokyo. Printer: Kido Press, Tokyo. Edition: 35. The Museum of Modern Art, New York. Katsko Suzuki Memorial Fund, 2002
(p. 64)

*Stay Good*. 2002. Etching, aquatint, and drypoint, 19 1/4 x 14 15/16" (48.9 x 37.9 cm). Publishers: the artist and Kido Press, Tokyo. Printer: Kido Press, Tokyo. Edition: 35. Collection of Michelle Levy, Brooklyn

References:
Chambers, Kristin, ed.
*Yoshitomo Nara: Nothing
Ever Happens.* Exh. cat.
Cleveland: Museum of
Contemporary Art, 2003.

Nara, Yoshitomo, ed.
*Yoshitomo Nara:
The Complete Works.*
San Francisco: Chronicle
Books, 2011.

**THOMAS NOZKOWSKI**
(American, born 1944)

*Untitled.* 2006. Series of five
etching, aquatint, and
drypoints, each 10 13/16 x
13 11/16" (27.4 x 34.7 cm).
Publisher and printer:
Simmelink/Sukimoto
Editions, Kingston, New York.
Edition: 25. The Museum of
Modern Art, New York. Gift
of the Associates of the
Department of Prints and
Illustrated Books, in honor of
Wendy Weitman, 2007
(pp. 45, 103, 127, 150, 186)

*Flare.* 2009. Illustrated book
with ten etchings, page:
8 7/16 x 12 13/16" (21.5 x
32.5 cm); overall (closed):
8 9/16 x 3 1/16 x 7/8" (21.7 x
33.2 x 2.3 cm). Publishers:
Beinecke Rare Book and
Manuscript Library and Yale
University Art Gallery, New
Haven, Conn. Printers:
Simmelink/Sukimoto
Editions, Kingston, New York,
and The Grenfell Press, New
York. Edition: 20. The
Museum of Modern Art, New
York. Gift of Yale University
Art Gallery, 2010

References:
Mayer, Marc. *Thomas
Nozkowski.* Exh. cat.
Ottawa: National Gallery
of Canada, 2009.

Nozkowski, Thomas.
"Thomas Nozkowski in
Conversation with Garth
Lewis." In *Thomas
Nozkowski.* New York:
The Pace Gallery, 2010.

Yau, John. "Abstraction in the
Everyday." *Art on Paper* 7,
no. 3 (2002): 36–41.

**JORGE PARDO**
(American, born 1963)

*Dodgers.* 1995. Artist's book,
page: 9 1/16 x 9 1/16" (23 x
23 cm). Publisher: Le
Consortium, Dijon. Edition:
unknown. The Museum of
Modern Art, New York. Gift
of Laura Hoptman, 2001

*Eukalyptus* (*Eucalyptus*).
1997. Portfolio of nine
unique screenprints, each
13 3/8 x 8 15/16" (34 x
22.7 cm). Publisher: Los
Angeles Contemporary
Exhibitions, Los Angeles.
Printer: Christian Zickler,
Frankfurt. Edition: 15 sets of
9 unique prints, 135 in total.
The Museum of Modern Art,
New York. Gift of Marc A.
Schwartz and Sarah C.
Epstein Fund, 2001
(p. 64)

*Jorge Pardo.* 1997. Artist's
book, in two variations;
constructed (closed): 8 1/4 x
9 7/16 x 4 1/8" (21 x 24 x
10.5 cm); unconstructed
(irreg.): 25 3/16 x 19 1/8"
(64 x 48.5 cm). Publishers:
The Museum of Contempo-
rary Art, Los Angeles, and
Museum of Contemporary
Art, Chicago. Edition: un-
known. The Museum of
Modern Art, New York.
Monroe Wheeler Fund, 2000

*Untitled* (for *Parkett* no. 56).
1999. Multiple of digital
print, foam core, and staples,
approx. 2 1/16 x 7 13/16 x
8 5/8" (14 x 24.7 x 19 cm).
Publisher: Parkett Publishers,
Zurich. Printer: the artist, Los
Angeles. Edition: 55, each
with unique variations. The
Museum of Modern Art, New
York. Linda Barth Goldstein
Fund, 1999

*Untitled.* 2001. Series of three
screenprints, each 21 3/4 x
29 3/4" (55.2 x 75.6 cm).
Publisher and printer: the
artist, Los Angeles. Edition:
44 unique variants. The
Museum of Modern Art, New
York. Lily Auchincloss Fund,
2001

References:
Antonelli, Paola, and
Christiane Schneider. *Jorge
Pardo.* Exh. cat. Philadelphia:
The Fabric Workshop and
Museum, 1999.

Ferguson, Russell. "What Is
Lost for Art is Gained for
Life." *Parkett,* no. 56 (1999):
123–25.

Schafaff, Jörn, and Barbara
Steiner. *Jorge Pardo.*
Ostfildern, Germany: Hatje
Cantz Verlag, 2000.

Végh, Christina. "The Tonality
of Contradictory Settings."
*Parkett,* no. 56 (1999): 137–41.

**PHILIPPE PARRENO**
(French, born 1964)

*Space World, Kitakyushu
2003* from *Fade to Black.*
2003. Screenprint, printed
in phosphorescent ink,
6' 13/16" x 47 1/4" (185 x
120 cm). Publisher: the artist,
Paris. Printer: Atelier Arcay,
Paris. Edition: 6. The Museum
of Modern Art, New York.
Riva Castleman Fund, 2011
(p. 167)

*The Day After, Kitakyushu
2003* from *Fade to Black.*
2003. Screenprint, printed in
phosphorescent ink,
6' 13/16" x 47 1/4" (185 x
120 cm). Publisher: the artist,
Paris. Printer: Atelier Arcay,
Paris. Edition: 6. The Museum
of Modern Art, New York.
Riva Castleman Fund, 2011

*Argentina vs. Netherlands
1978, Medina 2003* from
*Fade to Black.* 2003. Screen-
print, printed in phosphores-
cent ink, 6' 13/16" x 47 1/4"
(185 x 120 cm). Publisher: the
artist, Paris. Printer: Atelier
Arcay, Paris. Edition: 6. The
Museum of Modern Art, New
York. Riva Castleman Fund,
2011
(p. 166)

*The winter of 1996 as it has
been reported by Pierre
Huyghe* from *Fade to Black.*
2003. Screenprint, printed in
phosphorescent ink,
6' 13/16" x 47 1/4" (185 x
120 cm). Publisher: the artist,
Paris. Printer: Atelier Arcay,
Paris. Edition: 6. The Museum
of Modern Art, New York.
Riva Castleman Fund, 2011
(p. 166)

*In 1993 Rirkrit Tiravanija made a SCI-FI artwork for me from Fade to Black.* 2003. Screenprint, printed in phosphorescent ink, 6' 13/16" x 47 1/4" (185 x 120 cm). Publisher: the artist, Paris. Printer: Atelier Arcay, Paris. Edition: 6. The Museum of Modern Art, New York. Riva Castleman Fund, 2011

References:
Bossé, Laurence, Hans-Ulrich Obrist, and Angeline Scherf, eds. *Philippe Parreno: Alien Affection.* Paris: Paris-Musées; Dijon: Les Presses du réel, 2002.

Gonzalez-Foerster, Dominique, et al. *Dominique Gonzalez-Foerster, Pierre Huyghe, Philippe Parreno.* Paris: Paris-Musées, 1998.

Lind, Maria. *Philippe Parreno.* New York: Sternberg Press; Annandale-on-Hudson, New York: Center for Curatorial Studies, Bard College, 2010.

Obrist, Hans-Ulrich, and Daniel Birnbaum. "Philippe Parreno: Dust." In Nancy Spector, *Theanyspacewhatever,* 98–104. Exh. cat. New York: Solomon R. Guggenheim Museum, 2008.

## ROBERT RAUSCHENBERG
(American, 1925–2008)

*The Lotus Series.* 2008. Series of twelve digital prints, ten with photogravure, *Lotus I–X:* 45 3/4 x 60 3/4" (116.2 x 154.3 cm); *Lotus Bed I–II:* 60 3/4 x 5 3/4" (154.3 x 116.2 cm). Publisher and printer: Universal Limited Art Editions, Bay Shore, New York. Edition: 50. The Museum of Modern Art, New York. Gift of Emily Fisher Landau, 2009 (pp. 207–14)

References:
Fine, Ruth E., and Mary Lee Corlett. "Chinese Summerhall, 1982–1983." In Ruth E. Fine and Mary Lee Corlett, *Graphicstudio: Contemporary Art from the Collaborative Workshop at the University of South Florida,* 252–55. Exh. cat. Washington, D.C.: National Gallery of Art, 1991.

Hopps, Walter, and Susan Davidson. *Robert Rauschenberg: A Retrospective.* Exh. cat. New York: Solomon R. Guggenheim Museum, 1997.

Joseph, Branden W. *Random Order: Robert Rauschenberg and the Neo-Avant-Garde.* Cambridge, Mass.: The MIT Press, 2003.

## THOMAS SCHÜTTE
(German, born 1954)

*Wattwanderung* (*Low Tide Wandering*). 2001. Portfolio of one hundred thirty-nine etchings, each (orientation varies) 12 11/16 x 17 5/8" (32.2 x 44.7 cm). Publisher: the artist, Düsseldorf. Printer: Atelier Till Verclas, Hamburg. Edition: 12. The Museum of Modern Art, New York. Sue and Edgar Wachenheim III Fund and Gift of the Contemporary Arts Council of The Museum of Modern Art, 2011 (pp. 17, 42, 43, 44, 46–47, 64–65, 66, 81, 82, 85, 86, 88, 102–03, 106–07, 122–23, 124–25, 126, 128, 147, 149, 151, 163, 164, 168, 181, 184, 186–87, 197, 198–99, 202, 204)

References:
Heynen, Julian, James Lingwood, and Angela Vettese, eds. *Thomas Schütte.* London: Phaidon, 1998.

Loock, Ulrich. *Thomas Schütte.* Cologne: DuMont Literatur und Kunst Verlag, 2004.

Reust, Hans Rudolf, and Thomas Schütte. *Thomas Schütte: Wattwanderung 2001.* Düsseldorf: Thomas Schütte, 2002.

Schwarz, Dieter, ed. *Thomas Schütte: Kreuzzug 2003–2004.* Exh. cat. Winterthur: Kunstmuseum, 2003.

## JAMES SIENA
(American, born 1957)

*Nine Prints.* 1999–2000. Portfolio of eight etchings and one engraving, each 12 7/8 x 10 13/16" (32.7 x 27.5 cm). Publisher and printer: Harlan & Weaver, New York. Edition: 28. The Museum of Modern Art, New York. Acquired through the generosity of Mrs. Richard Savitt in honor of Anna Marie Shapiro, 2001 (p. 107)

*Upside Down Devil Variation.* 2004. Engraving, 26 5/8 x 22 1/4" (67.6 x 56.5 cm). Publisher and printer: Harlan & Weaver, New York. Edition: 42. The Museum of Modern Art, New York. Gift of the Young Print Collectors of The Museum of Modern Art, 2004

*Sequence One.* 2009–10. Illustrated book with thirty-six woodcuts, page: 16 15/16 x 13 7/16" (43 x 34.1 cm); overall (closed): 17 x 13 7/16 x 1 1/8" (43.2 x 34.2 x 2.8 cm). Publisher and printer: Flying Horse Editions, Orlando. Edition: 20. The Museum of Modern Art, New York. General Print Fund, 2011

References:
Fyfe, Joe. "Strange Loops." *Art on Paper* 7, no. 4 (January–February 2003): 44–49.

Westfall, Stephen. "James Siena's Linear Cosmos." *Art in America,* part 4 (April 2006): 120–23.

Yau, John. *Sets, Series, and Suites: Contemporary Prints.* Exh. brochure. New York: Pace Wildenstein, 2005.

## SLAVS AND TATARS
Artists' group, established 2005

*Nations.* 2007. Series of five screenprints, each 48 13/16 x 34 5/8" (124 x 88 cm). Publisher: the artists, Berlin, Brussels, and Moscow. Printer: PlaatsMaken, Arnhem, The Netherlands. Edition: 50. The Museum of Modern Art, New York. General Print Fund, 2008 (pp. 45, 104, 163, 182, 200)

*Romantics Love Violence, Too.*
2007. Screenprint, 48 13/16 x
34 5/8" (124 x 88 cm). Pub-
lisher: the artists, Berlin,
Brussels, and Moscow.
Printer: PlaatsMaken,
Arnhem, The Netherlands.
Edition: 50. The Museum of
Modern Art, New York.
General Print Fund, 2008
(p. 184)

*Sad Sciences, Happy Maths.*
2007. Screenprint, 48 13/16 x
34 5/8" (124 x 88 cm). Pub-
lisher: the artists, Berlin,
Brussels, and Moscow.
Printer: PlaatsMaken,
Arnhem, The Netherlands.
Edition: 50. The Museum of
Modern Art, New York.
General Print Fund, 2008
(p. 186)

References:
Azimi, Negar. "I Often
Dream of Slavs." *Bidoun
Magazine*, no. 16 (Winter
2009): 54–57.

Chu, Ingrid, and Slavs and
Tatars. "Rebuilding the
Pantheon." *Fillip*, no. 8 (Fall
2008): 3, 15.

Cullinan, Nicholas. "Group
Think: The Collaborative Art
of Slavs and Tatars and Chto
Delat?" *Artforum* 49, no. 6
(February 2011): 162–71.

Slavs and Tatars. "Interview
with Slavs and Tatars." By
Federica Bueti. ARTslant,
August 17, 2010. http://www
.artslant.com/ew/articles/
show/18294.

JOSH SMITH
(American, born 1976)

*Untitled.* 2000–06. Bookcase
with set of sixty-eight artist's
books and two stools, overall
48 x 11 x 7 5/8" (121.9 x
27.9 x 19.4 cm). The Museum
of Modern Art, New York.
Gift of Luhring Augustine
Gallery, 2007

*Untitled.* 2007. Bookcase
with set of twenty-eight
artist's books, overall 10 x
24 x 6" (25.4 x 61 x 15.2 cm).
Publisher and printer: the
artist, New York. Edition: 50.
The Museum of Modern Art,
New York. Monroe Wheeler
Fund, 2007

*Untitled.* 2008. One hundred
monotypes in wooden case,
each sheet 22 x 15" (55.9 x
38.1 cm). Publisher and
printer: the artist, New York.
Edition: unique. Collection of
Martin and Rebecca Eisenberg
(selected prints p. 105)

References:
Cherix, Christophe. "Painting
Stripped Bare." *Parkett*,
no. 85 (2009): 188–92.

Ruf, Beatrix, ed. *Josh Smith.*
Zurich: JRP/Ringier, 2009.

Sanders, Jay. "Loose Canon
(Copier)." In *Guyton Price
Smith Walker*, edited by
Beatrix Ruf, 103–34. Zurich:
JRP/Ringier, 2007.

Smith, Josh. "1000 Words:
Josh Smith Talks about
'Currents,' 2008– ." *Artforum*
47, no. 6 (February 2009):
160–63.

SUPERFLEX
Artists' group (Bjørnstjerne
Christiansen [Danish, born
1969]; Jakob Fenger [Danish,
born 1968]; and Rasmus
Nielsen [Danish, born 1969]),
established 1993

*Copy Light/Factory.* 2008.
Manual, contract, and digital
and printed images to create
a lamp production workshop,
dimensions variable.
Publisher: SUPERFLEX,
Copenhagen. Edition: 3. The
Museum of Modern Art, New
York. Fund for the Twenty-
First Century, 2011
(pp. 155–58)

References:
Bradley, Will, et al. *Self-
Organisation/Counter-
Economic Strategies.* New
York: Sternberg Press, 2006.

Conkelton, Sheryl.
"Superflex." In José Roca
et al., *The Graphic Uncon-
scious*, 216–17. Exh. cat.
Philadelphia: Philagrafika,
2011.

Mir, Aleksandra. "Superflex."
In Aleksandra Mir, *Corporate
Mentality*, 30. New York:
Lukas & Sternberg, 2003.

Nacking, Åsa, and SUPERFLEX.
"An Exchange Between Åsa
Nacking and Superflex."
*Afterall*, no. 0 (1998–99):
52–60.

Steiner, Barbara. *Superflex:
Tools.* Cologne: Verlag der
Buchhandlung Walther
König, 2002.

RIRKRIT TIRAVANIJA
(Thai, born Argentina, 1961)

*Untitled, 1992 (Red, Yellow,
Green Curry).* 1992. Three
tins of curry paste, each 1
1/2 x 3 x 3" (3.8 x 7.6 x 7.6
cm). Publisher: Gavin
Brown's Enterprise, New
York. Fabricator: the artist.
Edition: 10. Collection Walker
Art Center, Minneapolis. T. B.
Walker Acquisition Fund,
1996
(p. 97)

*Untitled (apron and Thai pork
sausage).* 1993. Brown paper
apron with string, tape, and
decal, and Xeroxed recipe,
apron: 41 1/4 x 28 1/16"
(104 x 71.3 cm). Publisher:
Brain Multiples, Santa Monica.
Fabricator: the artist. Edition:
25. The Museum of Modern
Art, New York. Acquired
through the generosity of
Linda Barth Goldstein, 1995

*Untitled (rucksack
installation).* 1993. Backpack,
map, camping stove, dishes,
can opener, and ingredients
for a Thai rice meal,
backpack: 15 3/4 x 12 9/16 x
11 7/16" (40 x 32 x 29 cm);
map: 76 5/16 x 68 1/8"
(193.9 x 173 cm). Publisher:
Helga Maria Klosterfelde
Edition, Hamburg. Fabricator:
the artist. Edition: 6. The
Museum of Modern Art, New
York. Acquired through the
generosity of Linda Barth
Goldstein, 1995
(p. 96)

*Atlas I–VI.* 1995–2007.
Six multiples of photographs
and photocopies collaged
on linen, each (folded): 6 x
4 1/8" (15.2 x 10.5 cm); each
(unfolded): 20 1/4 x
17 15/16" (51.5 x 45.6 cm).
Publisher: Helga Maria
Klosterfelde Edition,
Hamburg. Printer: Klaus
Winterscheidt, Hamburg.
Edition: 30. The Museum of
Modern Art, New York.
General Print Fund, 2008
(p. 94)

*Untitled (lunch box)*. 1996. Stainless steel container, Thai newspaper, and menu, container: 12 3/8 x 6 5/16 x 7 1/16" (31.5 x 16 x 18 cm). Publisher: Brain Multiples, Santa Monica. Fabricator: the artist. Edition: 108. The Museum of Modern Art, New York. Linda Barth Goldstein Fund, 1997 (p. 97)

*CATALOGUE (BACK OF POSTCARD READS) MEMORIES*. 1997. Mixed media in box, closed: 13 x 9 1/2 x 2 1/2" (33 x 24.1 x 6.4 cm). Publisher: Walker Art Center, Minneapolis. Fabricator: the artist. Edition: 16 (artist's proof outside the edition). Collection Walker Art Center, Minneapolis. Commissioned with funds provided in part by the Surdna Foundation, 1997 (p. 95)

*Untitled, 1999 (the power of cheese)*. 1999. Resin and enamel paint, 13 x 17 3/4 x 13 3/4" (33 x 45.1 x 34.9 cm). Publisher and fabricator: unknown. Edition: 5. Collection Walker Art Center, Minneapolis. T. B. Walker Acquisition Fund, 2000 (p. 97)

*Untitled, 1999 (flags from the 1. royal thai pavilion, 48. Esposizione Internazionale d'Arte, La Biennale di Venezia)*. 1999. Vinyl appliqué and satin, 21 1/4 x 33 1/2" (54 x 85.1 cm) and 21 1/2 x 33" (54.6 x 83.8 cm). Publisher: unknown. Fabricator: unknown, Chiang Mai, Thailand. Edition: 3. Collection Walker Art Center, Minneapolis. T. B. Walker Acquisition Fund, 2000 (p. 98)

*Young man, if my wife makes it. . . .* 2000. Wooden chopsticks, plastic, and metal bowl, 7 1/4 x 12 x 9 1/2" (18.4 x 30.5 x 24.1 cm). Publisher and fabricator: unknown. Edition: 27. Collection Walker Art Center, Minneapolis. T. B. Walker Acquisition Fund, 2001 (p. 97)

*Untitled 2008–2011 (the map of the land of feeling) I–III*. 2008–11. Three scrolls with digital printing, lithography, chine collé, and screenprint, each approx. 36" x 27' 10 1/2" (91.4 x 849.6 cm). Publisher and printer: LeRoy Neiman Center for Print Studies, Columbia University, New York. Edition: 40. The Museum of Modern Art, New York. Acquired through the generosity of Marie-Josée and Henry R. Kravis in honor of Paul Emile Cherix, 2011 (pp. 91–93)

References:
Boeri, Stefano, and Hans-Ulrich Obrist. "The Land: The Agriculture of Ideas." In Nancy Spector, *Theanyspacewhatever*, 193–98. Exh. cat. New York: Solomon R. Guggenheim Museum, 2008.

Coulson, Amanda. "Consulting the Atlas: Rirkrit Tiravanija's Infinite Multiple." *Art on Paper* 12, no. 3 (January–February 2008): 33–34.

Hirsch, Faye. "Multiplicity: Passport, Please." *Art in America* 99, no. 6 (June/July 2011): 79–83.

Sterling, Bruce, Rirkrit Tiravanija, and Philippe Parreno, eds. *Rirkrit Tiravanija: A Retrospective (Tomorrow Is Another Fine Day)*. Exh. cat. Rotterdam: Museum Boijmans Van Beuningen, 2004.

## GERT AND UWE TOBIAS
(German, born Romania, 1973)

Gert and Uwe Tobias. *Untitled*. 2011. Portfolio of eleven aquatints (seven with etching) and one etching, each 16 x 14" (40.6 x 35.6 cm). Publisher and printer: Edition Jacob Samuel, Santa Monica. Edition: 17. Courtesy the artists and Edition Jacob Samuel (pp. 141–42)

References:
Coulson, Amanda. "Double Pass." *Art on Paper* 12, no. 1 (September–October 2007): 28–29.

Gronert, Stefan, and Matthia Löbke, eds. *Gert & Uwe Tobias*. Cologne: Snoeck, 2008.

Nickas, Bob. *Gert & Uwe Tobias*. Exh. cat. Los Angeles: UCLA Hammer Museum, 2006.

Spieler, Reinhard, and Alexander B. Eiling, eds. *Gert & Uwe Tobias: Drawings and Collages*. Bielefeld, Germany: Kerber; Manchester: Cornerhouse, 2010.

## KARA WALKER
(American, born 1969)

*Harper's Pictorial History of the Civil War (Annotated)*. 2005. Portfolio of fifteen lithograph and screenprints, each (orientation varies) 53 x 39" (134.6 x 99.1 cm). Publisher and printer: LeRoy Neiman Center for Print Studies, Columbia University, New York. Edition: 35. The Museum of Modern Art, New York. General Print Fund and The Ralph E. Shikes Fund, 2005 (pp. 43, 62, 86, 103, 106, 121, 128, 161, 187, 197, 203, 204)

*See also museum in progress*

References:
Berry, Ian, Darby English, Vivian Patterson, and Mark Reinhardt, eds. *Kara Walker: Narratives of a Negress*. Exh. cat. New York: Rizzoli, 2007.

Shaw, Gwendolyn Dubois. *Seeing the Unspeakable: The Art of Kara Walker*. Durham, N.C., and London: Duke University Press, 2004.

Vergne, Philippe, et al. *Kara Walker: My Complement, My Enemy, My Oppressor, My Love*. Exh. cat. Minneapolis: Walker Art Center, 2007.

## KELLEY WALKER
(American, born 1969)

*Beogram 4000 Hi Fi System*. 2002. Digital print with CD-ROM, dimensions variable. Publisher and printer: the artist, New York. Edition: 5. The Museum of Modern Art, New York. Anna Marie and Robert F. Shapiro Fund, 2005

*The Marantz Turntable.* 2002. Digital print with CD-ROM, dimensions variable. Publisher and printer: the artist, New York. Edition: 5. The Museum of Modern Art, New York. Anna Marie and Robert F. Shapiro Fund, 2005

*Pioneer.* 2002. Digital print with CD-ROM, dimensions variable. Publisher and printer: the artist, New York. Edition: 5. The Museum of Modern Art, New York. Anna Marie and Robert F. Shapiro Fund, 2005

*Andy Warhol Doesn't Play Second Base for the Chicago Cubs.* 2010. Series of thirty-nine screenprints on MDF panels, each 17 1/4 x 13 x 3/4" (43.8 x 33 x 1.9 cm). Publisher and printer: the artist, New York. Edition: 2. The Museum of Modern Art, New York. Committee on Prints and Illustrated Books Fund with additional support from Katharina Faerber and the Print Associates Fund in honor of Deborah Wye, 2010 (pp. 21, 46–47, 86, 145, 149, 150–51, 182)

References:
Aupetitallot, Yves, and Anne Pontégnie, eds. *Kelley Walker.* Zurich: JRP/Ringier, 2007.

Pécoil, Vincent. "Kelley Walker: Printed Matter." *Flash Art* 39, no. 247 (March–April 2006): 62–64.

Rasmussen, John, ed. *Guyton\Walker: The Failever of Judgment.* Zurich: JRP/Ringier, 2005.

Smith, Josh. "(When You Got It, Flaunt It.) The Art of Kelley Walker." In *Guyton Price Smith Walker*, edited by Beatrix Ruf, 135–60. Zurich: JRP/Ringier, 2007.

**DAN WALSH**
(American, born 1960)

*1/2 Round.* 2008. Artist's book, page: 9 5/16 x 12 3/16" (23.7 x 31 cm); overall (closed): 9 7/16 x 12 3/8 x 3/8" (24 x 31.4 x 1 cm). Publisher and fabricator: the artist, New York. Edition: 12. The Museum of Modern Art, New York. Fund for the Twenty-First Century, 2009

*Screens.* 2008. Artist's book, page: 7 9/16 x 9 7/16" (19.2 x 24 cm); overall (closed): 7 13/16 x 9 7/16 x 1/2" (19.8 x 24 x 1.2 cm). Publisher and fabricator: the artist, New York. Edition: 6. The Museum of Modern Art, New York. Fund for the Twenty-First Century, 2009

*Textiline.* 2008. Artist's book, page: 13 x 12 11/16" (33 x 32.3 cm); overall (closed): 13 x 12 5/8 x 9/16" (33 x 32 x 1.5 cm). Publisher and fabricator: the artist, New York. Edition: 30. The Museum of Modern Art, New York. Fund for the Twenty-First Century, 2009

*V>Y.* 2008. Artist's book, page: 9 1/2 x 9 15/16" (24.2 x 25.3 cm); overall (closed): 9 9/16 x 10 1/16 x 1/2" (24.3 x 25.6 x 1.2 cm). Publisher and fabricator: the artist, New York. Edition: 10. The Museum of Modern Art, New York. Fund for the Twenty-First Century, 2009

*Folio B.* 2010. Series of five aquatints (one with drypoint, two with etching and drypoint) and one etching, each 20 x 20" (50.8 x 50.8 cm). Publisher: Pace Editions, New York. Printers: Pace Editions Ink, New York, and Watanabe Press, Brooklyn. Edition: 35. The Museum of Modern Art, New York. Committee on Prints and Illustrated Books Fund, 2010 (p. 145)

References:
de Chassey, Eric, Stephen Ellis, and Bob Nickas. *Dan Walsh: Paintings.* New York: Paula Cooper Gallery; Paris: Xippas Gallery, 2007.

Cherix, Christophe. *Dan Walsh: Recycling.* Geneva: Cabinet des estampes du Musée d'art et histoire, 2002.

Yau, John. "In Conversation: Dan Walsh with John Yau." *Brooklyn Rail* (March 2010): 24–27.

**FRANZ WEST**
(Austrian, born 1947)

*Konventionelle Dichotomie* (*Conventional Dichotomy*). 1990. Portfolio of six double-sided screenprints (orientation varies), 30 3/8 x 41 5/16" (77.1 x 105 cm), 24 1/2 x 40 15/16" (62.2 x 104 cm), 30 3/8 x 43" (77.1 x 109.2 cm), 24 3/4 x 39 3/8" (62.8 x 100 cm), 30 3/16 x 40 15/16" (76.6 x 104 cm), and 45 15/16 x 26 9/16" (116.7 x 67.5 cm). Publishers: Jänner Galerie and Galerie and Edition Artelier, Graz, Austria. Printer: Galerie and Edition Artelier, Graz, Austria. Edition: 30. The Museum of Modern Art, New York. Mary Ellen Oldenburg Fund, 2005 (pp. 68, 87, 101, 122, 148, 188)

References:
Badura-Triska, Eva. *Franz West: Proforma.* Cologne: Oktagon, 1996.

Fleck, Robert. *Franz West.* London: Phaidon, 1999.

Mehring, Christine. "Tools of Engagement: The Art of Franz West." *Artforum* 47, no. 2 (October 2008): 320–29, 407.

**PAE WHITE**
(American, born 1963)

*Untitled.* 1999. Portfolio of six screenprints, each approx. (orientation varies) 24 x 36" (60.9 x 91.4 cm). Publisher: 1301PE, Los Angeles. Printer: Wasserman Silkscreen, Santa Monica. Edition: 20. The Museum of Modern Art, New York. Howard Johnson Fund, 2001 (pp. 47, 88, 104, 107, 152)

References:
Burke, Gregory, ed. *Pae White: Ghost Towns.* Exh. cat. New Plymouth, New Zealand: Govett-Brewster Art Gallery, 2003.

Coblentz, Cassandra, Marilu Knode, and Susan Krane. *Pae White: Lisa, Bright & Dark.* Exh. cat. Scottsdale, Arizona: Scottsdale Museum of Contemporary Art, 2008.

**CHRISTOPHER WOOL**
(American, born 1955)

*Untitled.* 2006. Screenprint, 6' x 55 1/4" (182.9 x 140.3 cm). Publisher and printer: the artist, New York. Edition: unique. Collection of Seth and Cori Berger, New York
(p. 162)

*Untitled.* 2007. Enamel on linen, 9 x 9' (274.3 x 274.3 cm). The Museum of Modern Art, New York. Nina and Gordon Bunshaft Bequest Fund
(p. 20)

*Untitled.* 2008. Screenprint, 6' x 55 1/4" (182.9 x 140.3 cm). Publisher and printer: the artist, New York. Edition: unique. Collection of Sarah and Gary Wolkowitz, New York
(p. 61)

*Untitled.* 2008. Screenprint, 6' x 55 1/4" (182.9 x 140.3 cm). Publisher and printer: the artist, New York. Edition: unique. Kravis Collection
(p. 183)

References:
Friedrich, Julia, and Ulrich Loock, eds. *Christopher Wool 2006–2008/Christopher Wool Porto—Cologne.* Cologne: Verlag der Buchhandlung Walther König, 2009.

Funcke, Bettina. "Revealed in Reproduction." *Tate Etc*, no. 9 (Spring 2007): 36–41.

Goldstein, Ann. *Christopher Wool.* Exh. cat. Los Angeles: The Museum of Contemporary Art, 1998.

Paz, Marga, ed. *Christopher Wool.* Exh. cat. Valencia: IVAM; Strasbourg: Musées de Strasbourg, 2006.

Smith, Josh. "I, Robot." *Texte zur Kunst* 18, no. 71 (September 2008): 195–97, 251–52.

**XU BING**
(Chinese, born 1955)

*Series of Repetitions.* 1987–88. Series of ten woodcuts, each approx. 26 x 35 13/16" (66 x 91 cm). Publisher and printer: the artist, Beijing. Edition: varies. The Museum of Modern Art, New York. Riva Castleman Endowment Fund, 2010
(pp. 82, 84–85)

References:
Erickson, Britta. *The Art of Xu Bing: Words without Meaning, Meaning without Words.* Washington, D.C.: Arthur M. Sackler Gallery, 2001.

Harper, Glenn. "Exterior Form Interior Substance: A Conversation with Xu Bing." *Sculpture* 22, no. 1 (January–February 2003): 46–51.

Lui, Claire. "Being & Nothingness." *Print* 58, no. 2 (March–April 2004): 90–95.

Nakatani, Hajime. "Imperious Griffonage: Xu Bing and the Graphic Regime." *Art Journal* 68, no. 3 (Fall 2009): 6–29.

**LISA YUSKAVAGE**
(American, born 1962)

*The Bad Habits: Asspicking, Foodeating, Headshrinking, Socialclimbing, Motherfucker.* 1996–98. Series of five etching and aquatints (four with drypoint), each 15 1/16 x 11" (38 x 28.1 cm). Publisher: Marianne Boesky Gallery, New York. Printer: Burnet Editions, New York. Edition: 25. The Museum of Modern Art, New York. John B. Turner Fund, 1999
(pp. 48)

References:
Close, Chuck, Faye Hirsch, and Lisa Yuskavage. *Lisa Yuskavage.* Santa Monica: Smart Art Press, 1996.

Gould, Claudia. *Lisa Yuskavage.* Exh. cat. Philadelphia: Institute of Contemporary Art, University of Pennsylvania, 2000.

# Selected References

## GENERAL BIBLIOGRAPHY

Aarons, Philip E., and Andrew Roth, eds. *In Numbers: Serial Publications by Artists Since 1955*. Zurich: PPP Editions in association with Andrew Roth Inc., 2009.

Ackley, Clifford S. *Photo-Image: Printmaking 60s to 90s*. Boston: Museum of Fine Arts, 1998.

———. *The Unique Print, 70s into 90s*. Boston: Museum of Fine Arts, 1990.

Box, Rowland. *In-print: Evolution in Contemporary Printmaking*. Kingston upon Hull, England: Hull Museums & Art Gallery, 2001.

Buchholz, Daniel, and Gregorio Magnani, eds. *International Index of Multiples from Duchamp to the Present*. Tokyo: Spiral/Wacoal Art Center; Cologne: Verlag der Buchhandlung Walther König, 1993.

Bury, Stephen. *Artists' Books: The Book as a Work of Art, 1963–1995*. Brookfield, Vermont: Scolar, 1995.

———. *Artists' Multiples 1935–2000*. Aldershot, England, and Burlington, Vermont: Ashgate, 2001.

Castleman, Riva. *A Century of Artists Books*. New York: The Museum of Modern Art, 1994.

———. *Printed Art: A View of Two Decades*. New York: The Museum of Modern Art, 1980.

Chahroudi, Martha. *New Art on Paper 2: Acquired with Funds from the Hunt Manufacturing Co., 1989–1995*. Philadelphia: Philadelphia Museum of Art, 1996.

Cherix, Christophe, ed. *25th International Biennial of Graphic Arts, Ljubljana*. Ljubljana: International Centre of Graphic Arts, 2003.

Delleaux, Océane. *Le multiple d'artiste: Histoire d'une mutation artistique, Europe/Amérique du Nord de 1985 à nos jours*. Paris: L'Harmattan, 2010.

Drucker, Johanna. *The Century of Artists' Books*. New York: Granary Books, 2004.

Frank, James. *Contemporary British Printmaking*. Purchase, N.Y.: Brownson Gallery, Manhattanville College, 2005.

Jule, Walter, ed. *Sightlines: Printmaking and Image Culture. A Collection of Essays and Images*. Edmonton: University of Alberta, 1997.

Keller, Christoph, and Michael Lailach. *Kiosk: Modes of Multiplication: A Sourcebook on Independent Art Publishing 1999–2009*. Zurich: JRP/Ringier, 2009.

Klima, Stefan. *Artists' Books: A Critical Survey of the Literature*. New York: Granary Books, 1998.

Lauf, Cornelia, and Clive Phillpot. *Artist/Author: Contemporary Artists' Books*. New York: Distributed Art Publishers (D.A.P.) and The American Federation of Arts, 1998.

Leiber, Steven, et al. *Extra Art: A Survey of Artists' Ephemera, 1960–1999*. San Francisco: California College of Arts and Crafts; Santa Monica: Smart Art Press, 2001.

Mathieu, Didier. *La Collection du Centre des livres d'artistes, Pays-Paysage*. Saint-Yrieix-la-Perche, France: Centre des Livres d'Artistes, Pays-Paysage, 2001.

Obrist, Hans-Ulrich. *do it*. New York: Independent Curators Incorporated, 1997.

Perrée, Rob. *Cover to Cover: The Artist's Book in Perspective*. Rotterdam: NAi, 2002.

Phillpot, Clive, and Sune Nordgren, eds. *Outside of a Dog: Paperbacks and Other Books by Artists*. Gateshead, England: Baltic, The Centre for Contemporary Art, 2004.

Platzker, David, and Elizabeth Wyckoff. *Hard Pressed: 600 Years of Prints and Process*. New York: Hudson Hill Press, 2000.

Roca, José, et al. *The Graphic Unconscious*. Philadelphia: Philagrafika, 2011.

Rypson, Piotr. *Books and Pages: Polish Avant-garde and Artists' Books in the 20th Century*. Warsaw: Center for Contemporary Art, 2000.

Saunders, Gill, and Rosie Miles. *Prints Now: Directions and Definitions*. London: Victoria and Albert Museum, 2006.

Spector, Nancy. *Theanyspacewhatever*. New York: Solomon R. Guggenheim Museum, 2008.

Suzuki, Sarah. *What Is a Print?* New York: The Museum of Modern Art, 2011.

Tallman, Susan. *The Contemporary Print: From Pre-Pop to Postmodern*. London: Thames & Hudson, 1996.

Tannenbaum, Judith, and Marion Boulton Stroud. *On the Wall: Contemporary Wallpaper*. Providence: Museum of Art, Rhode Island School of Design; Philadelphia: Fabric Workshop and Museum, 2003.

Weibel, Peter, ed. *Kunst ohne Unikat: Multiple und Sampling als Medium, Techno-Transformationen in der Kunst*. Cologne: Verlag der Buchhandlung Walther König, 1999.

Weitman, Wendy. *Pop Impressions: Europe/USA, Prints and Multiples from The Museum of Modern Art*. New York: The Museum of Modern Art, 1999.

Wye, Deborah. *Artists & Prints: Masterworks from The Museum of Modern Art*. New York: The Museum of Modern Art, 2004.

———. *Committed to Print*. New York: The Museum of Modern Art, 1988.

———. *Thinking Print: Books to Billboards, 1980–95*. New York: The Museum of Modern Art, 1996.

Wye, Deborah, and Wendy Weitman. *Eye on Europe: Prints, Books, Multiples / 1960 to Now*. New York: The Museum of Modern Art, 2006.

## LIST OF PUBLISHERS

This list provides references on the publishers of works in the exhibition, including websites and, when available, additional bibliographic information.

**1301PE / BRAIN MULTIPLES, LOS ANGELES**
www.1301pe.com

Tumlir, Jan. "Jorge Pardo: The Butler Did It." *Flash Art* 35, no. 227 (November–December 2002): 90–93.

**FLYING HORSE EDITIONS, ORLANDO**
www.flyinghorse.cah.ucf.edu

**GALERIE AND EDITION ARTELIER, GRAZ, AUSTRIA**
www.galerie-edition-artelier.at

Ripley, Deborah. "Snob Appeal: Edition Artelier Graz." *Artscribe*, no. 86 (March–April 1991): 94–95.

Weibel, Peter, and Friedrich Tietjen. *Kunst ohne Unikat: Edition Artelier, 1985–1998.* Graz: Neue Galerie am Landesmuseum Joanneum; Cologne: Verlag der Buchhandlung Walther König, 1998.

**GEMINI G.E.L., LOS ANGELES**
www.geminigel.com

Ritchie, Charles. *Gemini G.E.L.: Online Catalogue Raisonné.* Washington, D.C.: National Gallery of Art, 2001. www.nga.gov/gemini.

Rosenthal, Mark. *Artists at Gemini G.E.L: Celebrating the 25th Year.* New York: Harry N. Abrams, 1993.

**HARLAN & WEAVER, NEW YORK**
www.harlanandweaver.com

Kerr, Merrily. "Twenty Years in the Making: Talking with Print Publishers Harlan and Weaver." *Art on Paper* 10, no. 2 (November–December 2005): 37–38.

**KIDO PRESS, TOKYO**
www.kidopress.com

**HELGA MARIA KLOSTERFELDE, HAMBURG**
www.klosterfelde.de

**SABINE KNUST/MAXIMILIAN VERLAG, MUNICH**
www.sabineknust.com

**LOS ANGELES CONTEMPORARY EXHIBITIONS, LOS ANGELES**
www.welcometolace.org

Cooper, Jaqueline. "Growing Pains: Los Angeles Contemporary Exhibitions at 22." *New Art Examiner* 28, no. 3 (November 2000): 42–43.

Stakenas, Carol A., and Lisa Carlson, eds. *LACE: Living the Archive.* Los Angeles: LACE; Santa Monica: RAM Publications, 2010.

**MUSEUM IN PROGRESS, VIENNA**
www.mip.at

*See also Works in the Exhibition*

**LEROY NEIMAN CENTER FOR PRINT STUDIES, NEW YORK**
www.columbia.edu/cu/arts/neiman

*A Decade of Printmaking: 1999–2009.* New York: LeRoy Neiman Center for Print Studies, School of the Arts, Columbia University, 2009.

**ONESTAR PRESS/THREE STAR BOOKS, PARIS**
www.onestarpress.com
www.threestarbooks.com

Boutin, Christophe. "Onestar Press, Paris, 2000–2003." Interview by Philippe Buschinger. In *25th International Biennial of Graphic Arts, Ljubljana,* edited by Christophe Cherix, 166–71. Ljubljana: International Centre of Graphic Arts, 2003.

Princenthal, Nancy. "Artist's Book Beat." *Art on Paper* 6, no. 5 (May–June 2002): 96–97.
*Three Star Books Are Artworks.* Exh. cat. Paris: Three Star Books, 2011.

**PACE EDITIONS, NEW YORK**
www.paceprints.com

Pollock, Lindsay. "We Don't Have to Be Stodgy." *Artnews* 104 (October 2005): 106–08.

Solomon, Dick. "A Family Business." *Art on Paper* 8, no. 2 (November–December 2003): 24–25.

Solomon, Richard. *Pace Prints.* Exh. brochure. Knoxville: Ewing Gallery of Art and Architecture, University of Tennessee, 1995.

**THE PARAGON PRESS, LONDON**
www.paragonpress.co.uk

Booth-Clibborn, Charles. "From Hirst to Eternity." Interview by Richard Clarke. In *Printmaking Today* 13, part 1 (Spring 2004): 10–12.

Elliott, Patrick, ed. *Contemporary Art in Print: The Publications of Charles Booth-Clibborn and His Imprint The Paragon Press, 1986–1995.* Edinburgh: Scottish National Gallery of Modern Art; London: The Paragon Press, 1995.

———. *Contemporary Art in Print: The Publications of Charles Booth-Clibborn and His Imprint The Paragon Press, 1995–2000.* London: Booth-Clibborn Editions, 2001.

Lullin, Etienne, and Florian-Oliver Simm. *Contemporary Art in Print: The Publications of Charles Booth-Clibborn and His Imprint The Paragon Press 2001–2006.* London: The Paragon Press and Contemporary Editions Ltd, 2006.

**PARKETT, ZURICH**
www.parkettart.com

Wye, Deborah, and Susan Tallman. *Parkett: Collaborations & Editions Since 1984.* Zurich and New York: Parkett Publishers, 2001.

———. *200 Artworks, 25 Years: Artists' Editions for Parkett*. Zurich and New York: Parkett Publishers, 2009.

**POLÍGRAFA OBRA GRÁFICA, BARCELONA**
www.poligrafa.net

**RIDINGHOUSE EDITIONS, LONDON**
www.ridinghouse.co.uk

**SALON VERLAG & EDITION, COLOGNE**
www.salon-verlag.de

Brittain, David. "An Interview About Salon Art Magazine." In *Salon: Limited Reprint-Edition/Salon 1–12 + Supplement*, edited by Gerhard Theewen, n.p. Cologne: Salon Verlag, 2007.

Speck, Reiner, and Gerhard Theewen. *Edition Séparée 1996–2006*. Cologne: Salon Verlag, 2009.

**EDITION JACOB SAMUEL, SANTA MONICA**
www.editionjs.com

Burlingham, Cynthia, Leslie Jones, and Britt Salvesen. *Outside the Box: Edition Jacob Samuel, 1988–2010*. Exh. brochure. Los Angeles: Hammer Museum, 2010.

Reynard, Melanie. "Print-maker Jacob Samuel Works 'Outside the Box' to Capture Artists' Visions." *The Jewish Journal*, July 6, 2010. http://www.jewishjournal.com/arts/article/printmaker_jacob_samuel_works_outside_the_boxto_capture_artists_visions_201.

**SIMMELINK/SUKIMOTO EDITIONS, KINGSTON, NEW YORK**
www.simmelinksukimoto.com

Hirsch, Faye. "Bob and Sylvia and Chris and Doris: A Collaboration." *Art on Paper* 5, no. 2 (November/December 2000): 68–73, 106–07.

**TWO PALMS PRESS, NEW YORK**
www.twopalms.us

Schwabsky, Barry. *Under Pressure: Prints from Two Palms Press*. New London, Conn.: Lyman Allyn Museum of Art, 2000.

**ULAE (UNIVERSAL LIMITED ART EDITIONS), WEST ISLIP AND BAY SHORE, NEW YORK**
www.ulae.com

Cowart, Jack, et al. *Proof Positive: Forty Years of Contemporary American Printmaking at ULAE, 1957–1997*. Washington, D.C.: Corcoran Gallery of Art, 1997.

# Index

# Copyright and photographic credits